KAPKA KASSABOVA was born in Bulg... Edinburgh and the Scottish Highlands. She is the author of two poetry collections, two travel guides, numerous travel essays, and the mystery novel *Villa Pacifica* (2011). She made her non-fiction debut with the acclaimed childhood memoir *Street Without a Name* (2008). She has written for the *Sunday Times*, the *Guardian*, *Vogue*, *Psychologies*, *Wanderlust* and Granta.com.

WWW.KAPKA-KASSABOVA.COM

From the international reviews of *Twelve Minutes of Love*:

'She gives us a clear account of the history of tango and her own emotional journey on and off the dance floor. Kassabova gets the drug-like quality of tango across, with ferocious vividness . . . I find myself liking [her] a lot.' *Independent*

'[Kassabova] skilfully weaves her evolution as a dancer around the history and meaning of the dance as well as around her private dramas . . . Her narrative, bubbly and brisk as it is, will entertain fellow dancers and fellow wanderers' *TLS*

'Kassabova wears her obvious intellect lightly and her writing style is akin to sitting across a wine glass from your most entertaining friend . . . I reach the last page with a pang of sadness as I realise that, while I have sated my curiosity about tango, I'll miss this lively voice.' *Herald*

'A touching and insightful chronicle of a ten-year obsession that dragged her around the world and back again by the heartstrings. Kassabova is that rare thing, an author who excels in every genre.' *Scotsman*

'This is a strangely moving book, Kassabova's sensibility running throughout the pages like a melancholy tango melody. The author is intelligent, sensitive and romantic, and colours the content with her own

elegiac perspective. Nothing is under- or over-stated . . . Kassabova is expert at interspersing history with her personal life, the movement like the intricate dance steps of the tango. One seems to reinforce and shed light on the other [and] she has a perfect sense of timing. But above all this book is . . . an entertaining hymn to her individual addiction: to tango and to romantic love.' *Scottish Review of Books*

'An exquisitely crafted blending of travelogue, memoir, dance history and some seriously good writing on the human condition, it delves deep into the obsessive nature of tango fanatics and vividly depicts a world full of beauty and heartbreak, of love and loss . . . Kassabova brings the people and places she encounters to life with vivid precision, and strikes a near perfect balance between her own personal experiences and the wider context of the dance. The complex psychology of tango is picked apart, and the combination of physical, mental and emotional extremes on display on the world's tango dancefloors is startling. The book is also very funny – not least for the occasional appearances of Clive James, a long-time friend of Kassabova's and an equally fanatical tango fan. Ultimately, it is a tale of obsession, a quest for happiness and a look at the contrariness of the human psyche all rolled into one.' *Independent on Sunday*

'A beautiful book, beautifully written. Best of all, Kassabova is brilliant on why we dance the Argentine tango, discussing the sense of melancholy and yearning experienced by anyone who has danced its steps or indeed listened to its music; the heartache inherent in tango relationships; and the arduous, sometimes painful, process of learning the dance. *Twelve Minutes of Love* is an exquisitely written love story about, as one dancer puts it, "The love affair with tango . . . the only one that matters."' *Dance Today*

'From New Zealand, to Edinburgh, Berlin and Buenos Aires, part travelogue, part memoir, this is a sexy step through the myths around tango and its physical, emotional and psychological layers. You will want to learn.' *GQ*

'Kapka Kassabova is one of those annoyingly talented writers who can turn her hand to anything. She's a novelist, poet, travel writer and memoirist, and she employs many of those skills in her fantastic, engaging book... The depictions of place and character are sumptuous and intense.' *Big Issue*

'Three reasons to read *Twelve Minutes of Love*: 1. For an insight into a hobby that turns into an obsession . . . 2. To go on an emotional journey. It isn't just about the tango. Here is a woman discovering herself over a decade, growing up and changing in an understated, unassuming and unusual memoir . . . 3. For a searing account of heartbreak. She more than proves her point that the tango "wounds us and heals us at once".' *Psychologies*

'A book about obsession and the need to belong, *Twelve Minutes of Love* takes us across the globe on a quest that goes beyond just dance. It is a book about life.' *Guardian* Review's 'Your Books of the Year'

'Like the famous dance it depicts, this is a tale simmering with passion, love and trouble, with a strutting cast of likely and unlikely types to match.' *The Age*

'Kassabova's poetry explores exile, disconnection and loss; her novels and travel writings are rich in imagery and insight, conjuring unsettling worlds. She brings these elements together in this exhilarating account of tango's addictive character . . . In this beautifully crafted book, she expresses tango's power and ritual, and its ability to reveal each person's unique dance personality. With a neat twist, she ultimately exposes its illusions, locating its place in a journey that is both personal and universal.' *The NZ Listener*

KAPKA KASSABOVA

TWELVE
MINUTES
OF
LOVE

A TANGO STORY

Portobello
BOOKS

First published by Portobello Books 2011
This paperback edition published 2012

Portobello Books
12 Addison Avenue
London
W11 4QR
United Kingdom

Permission for Milan Kundera quote on page ix
kindly granted by the Wylie Agency

The Feet: image on p.5 © Maria Falconer
Dancers: Jenny Frances and Ricardo Oria
from www.rumbosdetango.com

The Heart: image on p.61 © Brian Windrim
Dancers: Dominika Bijos and Toby Morris

The Mind: image on p.141 © Brian Windrim
Dancer: Siobhan Dougherty from www.lasrosasdeltango.net

The Embrace: image on p.229 © Pablo Rincon
Dancers: Maria Mondino and Ismael Ludman
from www.tangodinamia.com.ar

A CIP catalogue record is available from the British Library

2 4 6 8 9 7 5 3 1

ISBN 978 1 84627 285 1

www.portobellobooks.com

Typeset in Bembo by Patty Rennie

Printed and bound by CPI Group (UK) Ltd,
Croydon, CR0 4YY

THIS STORY IS DEDICATED TO ALL MY FELLOW TANGUEROS
IN THE GLOBAL TANGO VILLAGE WHO ARE DANCING,
EACH IN THEIR OWN WAY, FOR A BETTER WORLD

'Man desires eternity, but all he can get is its imitation: the instant of ecstasy'

— Milan Kundera

CONTENTS

TANDA THREE: THE MIND

In Search of Home

TANDA FOUR: THE EMBRACE

In Search of Transcendence

SOME TANGO TERMS

This is a story of *Argentine tango* which, as far as history is concerned, is the original tango and, as far as I'm concerned, the only tango.

A social tango event is a *milonga*.

A set of three or four songs is a *tanda*. A tanda must have a certain style. You normally dance a tanda with the same partner.

Twelve minutes is the duration of the average tanda.

A break or 'curtain' in between tandas is a *cortina*.

Every chapter in this book takes its name from a tango song.

Porteño refers to all things that originate in Buenos Aires, including the people.

Tangoholics, be warned: this is a human story, not a dance manual or a milonga guidebook. The mechanics of the dance and the milonga circuit have been simplified, in order not to bore normal people to death.

PRELUDE TO THE CYCLICAL NIGHT

All Latin American dance, and all couple dance around the world and through the ages, celebrates happiness through the human body. Couple dancing is joyful, relaxed, extroverted, uncomplicated and upbeat. Moving to it makes you laugh and forget your troubles.

Not so with the tango. The tango is all *about* your troubles. It's where you go to process your troubles. Tango is one big trouble with a twenty-four-hour soundtrack. Tango reminds you that if you don't currently have troubles of a romantic, existential, financial or any other kind – well, sooner or later, you will. Believe me, you will. The good news is, tango makes trouble exciting. You want to be part of the action, no matter how troubled.

What is tango like?

Tango is introverted, brooding, physically controlled, mentally involved, musically complex and emotionally dark. It does for you and to you a number of things that pretty much cover the entire human experience. Here are a few.

It sings of the passing of time and the wreckage it leaves in its wake. It speaks of home, heartbreak, the city, the drunken night, and your mother.

It ruminates on the catastrophes of yesterday and anticipates the disasters of tomorrow.

It sums up, more concisely than any epic poem or philosophical tract, the mystery of passionate love.

Is there happy love in tango music? Yes – the one you had in the past. OK, I exaggerate, but not much.

It breeds fever in your feet, longing in your heart, cities in your mind and a place in your soul that you can call home, if all else fails. Which, sooner or later, it does. Because tango is, above all, *realistic*.

It converts outrage into music, in the words of the great Argentinian writer Borges.

It is a sad thought that can be danced, in the famous words of Argentine poet Discépolo.

It is the vertical expression of horizontal desire, in the even more famous words of an unknown dancer.

Tango is also, let's cut to the chase here, the copulation of sex and death, which is why it casts an ecstatic spell over us. It hypnotizes us and then swallows us whole, like a boa with rabbits.

People disappear into tango for years, lifetimes. It happened to me, but I have now returned to civilian life to tell the tale.

The basic facts are well known. Tango was born in the nineteenth century in the Rio de la Plata, at the confluence of Argentina and Uruguay, the Old World and the New. In a short time, it became a universal urban dance. Today, it is danced and heard in every part of

the urban world – from Scotland to New Zealand, from Ecuador to Bulgaria.

In 2009, the tango was consecrated as Intangible Cultural Heritage of Humanity by UNESCO. This book is a tangible attempt to describe the thrill of tango, and to find out why tens of thousands of aficionados across the global village of the twenty-first century have been certified with incurable tango addiction.

I am one of them, and this is my search for everything precious in life through tango. It is a true story, and it mirrors the story of tango itself, which has one foot in fact, another in fable; one hand in gain, another in loss; one hemisphere in desire, another in death.

I have been completely faithful to the emotional truth of all my experiences – the good, the bad and the ridiculous. It hasn't been my aim to expose or ridicule anybody, except myself, where necessary. However, to protect private truths, many names have been changed, some identities concealed, and some people and events amalgamated and toned down. Reality, especially someone else's version of it, can be too harsh to contemplate face-on, like staring at the sun.

And anyway, in tango the sun comes out at midnight.

TANDA ONE

THE FEET

In Search of Authentic Tango

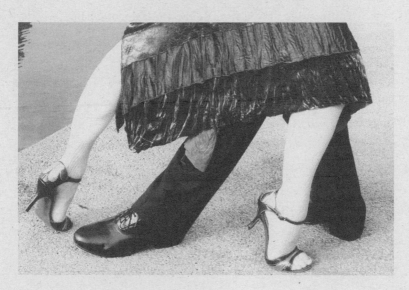

ONE

Just a Tango

TANGO LESSON: FASCINATION

One muggy Antipodean evening at the dawn of this millennium, I walked down an empty street and into an empty tapas bar called Fuego (Fire). It had black walls, a gilded rococo mirror and a single couple on the dimly lit floor.

To the sound of drastic accordion music in a minor key, they clung to each other, their arms and legs twitching, as if drowning. Except they weren't, because their faces were haloed with the kind of sublime light Jehovah's Witnesses acquire shortly after being in touch with God.

I perched on a velvet stool to watch. I don't know if it was premonition or déjà vu, but the whole scene felt familiar and personal.

The sides of their faces were glued together with sweat, and so were their chests, which fitted naturally, since the woman was busty and the man hollow-chested. The woman's eyes were closed. They danced as if for the last time. And they were not doing it for me or

for some imaginary audience. They were doing it for themselves. They were dancing an entire lifetime into a few minutes.

I didn't know it yet, but the reason why this looked like the main event of their lives was because it was. Then I suddenly saw that I wasn't the only onlooker. An aged couple were watching from behind the bar, but they were so small that I hadn't spotted them before. They had that slightly dishevelled, how-did-I-wash-up-here look of the Antipodean émigré.

'What is this?' I asked them.

'Tango,' the man said.

'Argentinian tango,' the woman specified. She was wiping glasses with a cloth.

'Well,' the man said, 'some people say that tango come from Uruguay.'

'But we are from Chile,' the woman explained.

'We dance too, you know,' the man said.

'When there isn't nobody watching,' the woman smiled coyly.

That sealed it – I was a convert. The kindly Chileans went bankrupt shortly after, but that night altered the course of my life. For the next decade, I would breathe tango, dream tango, love-and-hate tango. I would dance tango for a thousand and one nights straight – then collapse and start all over. My love life, my social life, my whereabouts, my sleep patterns and my posture would be dramatically affected – and not always for the better.

I would criss-cross the globe in search of the authentic tango experience. I would live, in the first person singular, the timeless story of tango: a story of exile and longing, dance-hall heaven and its ugly Siamese twin – dance-hall hell.

Yes, I would take tango to its fullest cliché, and far beyond. Tango would give me everything I wanted and didn't have that night of the new millennium – friendship, love, beauty, meaning, adventure, ecstasy, home – then it would take it all away and break my heart. Then it would heal me again, and give me even more, but not in the ways I expected. I would try to quit, and fail – because the spaces tango opens up inside you never close up. Tango is like heroin – it changes you metabolically.

I said first person singular, but that's only half the truth. The other half is of course tango's most famous cliché: it takes two. The question is which combination of two, exactly. And how many thousands of 'twos' are possible before you find the one for you, the one with whom you can have what this couple in the empty bar were having. Or was I just watching a fantasy?

Please, don't let it be a fantasy, I prayed on my bar stool that night. And if it is, please let me live this fantasy, too. I prayed to the unknown god of tango, wondering if he even exists. He does, and he heard me, and he is a shifty bastard, as I found out.

Even as I was sitting on my stool, and even as you read this, hundreds of couples are tangoing somewhere in the world, somewhere out of sight. They tango in the southern hemisphere until dawn, and they tango at dusk in the northern hemisphere. There is a point somewhere between the sun and the moon when, for a short while, everyone is dancing at the same time.

Like the subconscious, tango may be out of sight, but it never sleeps.

And if it's out of sight, that's only because you don't know where to look. You haven't been initiated into the ways of the global tango village. You haven't had your twelve minutes. Yet.

Tango is the Masonic club of the dance world. If you make it, at some point the coveted secret handshake will come your way. It's called the *cabeceo*, a barely perceptible nod of the head from across the dance hall, inviting you to a dance, and signalling that you are in business.

Who, me?

TWO

Barbarous Tango

TANGO LESSON: INFATUATION

'Yes, you. I don't see anyone else here.'

It wasn't a nod, it was a proffered hand.

'But I can't dance,' I said, and shrunk on my bar stool.

'Everyone can dance,' the man said. He had a bulbous nose and a smile like a sunset. His name was Geoff and he was an IT consultant. His partner had a handsome face shiny with sweat and make-up, and she was married to someone else, though she didn't tell me that straight away. She was wearing black, down to her stockings and high-heeled shoes, and she was now having a drink next to me at the bar.

'He's a very good leader,' she said. 'Even a beginner can follow a good leader.'

'But I can't dance,' I said again.

'Let's just give it a try.' Geoff wasn't giving up. 'We need more ladies.'

We? Perhaps there was some sort of underground Tango Vista

Social Club in Auckland – a city that died a death as soon as business hours were over.

'How did you hear about this place?' he wanted to know.

'Well,' I said, 'my friend James told me to meet him here tonight, but didn't say why. And now he's not here.'

James was my only friend in Auckland, where I'd been living for the past year. 'Let's have a go, before the others arrive.' Geoff extended a gentlemanly hand again, to help me off my stool. 'You might even enjoy it.'

What the hell – I hadn't enjoyed anything for some time now, so what was the worst that could happen? I could trip over and fall on my face, and then the Chileans and Geoff's partner would laugh at me. It wouldn't be the end of the world.

So, before I knew what had hit me, I was dancing my first tango. OK, *dancing* isn't the word. I was hanging on to Geoff's neck and my body was doing a good imitation of a rag doll suddenly come to life.

I remembered that scene in *Scent of a Woman* where the girl 'spontaneously' dances with a blind Al Pacino. 'There are no mistakes in tango,' he says in that husky voice of his, and I wanted to believe him. I also wanted to spontaneously look as good as she did. After all, I didn't even have to do the silly head dips.

(*Pausa*: You don't do head dips in Argentine tango, only in ballroom tango. And, by the way, it's impossible to look good dancing the tango when you've never done it before.)

'Just relax and follow me,' Geoff said in my ear. Our faces were suddenly very close, which was a bit disturbing, but not as disturbing as the sudden closeness of our bodies. I could feel his body heat. It had been some time since I'd last felt the heat of a man's body.

12

'Don't worry about what your feet are doing, that's my job,' Geoff continued. 'And don't look down.'

Easier said than done, of course. I continued clinging to him from the waist up, and flopping from the waist down. I had no idea whether we were following the music, which featured a soulful accordion and a low-pitched violin. There was no beat to it, it was pure melody in a minor key. It was overflowing with a melancholy of the kind that would, under normal circumstances, lodge itself in your throat and stay there for hours, like an existential nasal drip. But these were not normal circumstances. I was moving with the music, *we* were moving with the music; the closeness wasn't so disturbing any more. In fact, it was beginning to feel natural. What we were doing was the only sensible response to music like this. And instead of choking me, the melancholy notes ran through me in delicious rivulets, like rainwater in parched earth.

By the end of the dance, I had a dreamy smile on my face, or possibly a dopey grin. I hadn't fallen over, nobody was laughing at me, and I hadn't even noticed that 'the others' had arrived. True, the others consisted just of my friend James, but he is the kind of guy who arrives and fills up the bar.

'KK!' he exclaimed with a conspiratorial smirk. 'I knew you'd take to tango like a fish to water. Geoff, we've got a new recruit.'

'And she's got promise,' Geoff grinned.

And before James whisked me off for another dance – goodness, I was already popular! – I asked Geoff what we'd just danced to. Piazzolla, came the answer. I assumed that was the name of the piece – it sounded right somehow, elegant and dangerous and instrumental – just as I assumed the button instrument to be an accordion.

I made a lot of assumptions in the next year or so – always a bad idea, but especially with couple dancing, where everything is so unpredictable. I found out that Piazzolla wasn't a title, it was a man. A man who had wrenched tango from the dusty belle-époque corner where it was languishing, and manoeuvred it into the centre stage of late twentieth-century music. Astor Piazzolla wrote violent, gorgeous orchestral scores. The second thing I found out was that the quintessential tango instrument is the bandoneon. It doesn't sound anything like the accordion, which by comparison is the happy village idiot. No; it sounds like black velvet. It is perversely difficult to play, and in a maestro's hands, it produces a sound somewhere between high art and low life. It is the king of street retro, and with his 'diabolical' bandoneon Piazzolla became the godfather of modern tango music. It was far too early for me to question whether you can, or *should*, dance to Piazzolla. I was too busy being swept off my feet.

That night, I danced to a couple more Piazzollas with James, whose frantic style made me think of a cheerful tractor ploughing the expanse of the bar floor. The tempo of the music was increasing to a demented crescendo, and by the time we crashed into a grand finale with the violent 'Libertango', the Chileans behind the bar were looking mildly alarmed.

Then James explained the move he'd done repeatedly, which consisted of me stepping backwards as his hand pressed insistently into the small of my back.

'It's the backward *ocho*,' he demonstrated. 'Tango's most common figure. It means "eight" in Spanish because your feet are describing an invisible number eight on the floor.' That was a pleasant explanation of why I felt like a tripped-up horse. There was also the forward ocho,

where you are stepping forwards as your partner steps back, to give you space. Except in James's case, he was dragging me forth. But tango was like that, wasn't it? Forceful, majestic, dangerous!

(*Pausa*: If the leader makes you feel like a tripped-up horse, it's not your fault. It's his, even if *you* are the beginner. But, in this case, we were both beginners, so do take pity on us.)

I asked James the name of the mellow tune we'd danced to. It was 'Años de soledad' ('Years of Loneliness'). Of course. It could have been the soundtrack for my life.

My years of loneliness had started with my sudden arrival in New Zealand from Bulgaria as a teenager in the early 1990s. Our family was swept up in the great exodus that flowed to the four corners of the world from post-Berlin Wall Eastern Europe. For reasons that were bewildering even to us but involved post-Communism, desperation and a university job for my scientist father, we had ended up here, at the bottom of the map: two adults and two teenagers, plus a piano.

These days, my twenty-six-year-old life was housed in a small, suburban rented flat with motel curtains and mouldy corners. I spent my days writing a commissioned travel guide on India, which I had recently visited with the hope of 'finding' myself. Why do we expect to find ourselves in India? It's already overcrowded. I came close to losing myself, along with much of my body weight, to intestinal para-sites and culture shock. I returned to Auckland two months later, sick, disoriented, jobless and broke.

But my chief difficulty in life was that I had a problem with 'reality'. I just couldn't see the point of it – not unless you could *do something*

interesting with it. This is why, after graduating from university, I had turned to writing full-time, resulting in a couple of books, no regular income, no chance of normal employment and a lifestyle more solitary than that of a monk in a hilltop monastery. I was living in a suburban Pacific city where the people were friendly and sunburnt, and spoke in pinched vowels, and the beaches were vast and empty like the ocean and the sky that locked them in from all sides. It had nice weather, though, and under the unblinking Antipodean sun, you could revel in an orgy of colours – green volcanic hills, blue ocean studded with the thousand white sails of boats. This was, after all, the City of Sails, host of the America's Cup this same year, and home to great champions of the physical world. If you liked sailing, rugby and reality, and if you had your own house with a garden, you were in paradise.

I didn't, and I wasn't. I was stuck somewhere between the old country and the New World, no longer East European, but not a 'fush and chups' Kiwi either. Maybe this is what James meant about tango being my element. I had no other elements here.

'I feel like the important things are happening elsewhere, far from here,' I said to James that week. 'Like I'm at the end of the world and the world is just a rumour. Like my life is passing me by.'

'No,' James cut me off. 'The important things happen right where you are. There's no epicentre of importance; that's an illusion. Life is where you are. You've got a case of Chronic Longing, KK, that's your problem. You've got a dose of Slavic melancholy, plus a dollop of Balkan fatalism, plus you're an old soul. Result: you're like Chekhov's three sisters. Always talking of going to Moscow.'

He was right. I had always wanted to be *elsewhere*, since my early teens in Communist Bulgaria. Don't all teenagers want to be elsewhere? Normal teenagers grow out of it, though. I didn't – with me, the syndrome evolved. And emigrating to the other side of the world made it worse rather than better. Now, in my suburban Auckland life, I felt the same as before, but more so. I was looking for something, anything, that would make me feel as though I belonged. Had there been a knitting circle in Bar Fuego that night, I would have joined up. Belly dancing? I'd roll with it. Satanic worship? Hell, yes.

But it was tango. And how fortuitous, how tailor-made, because the tango was invented by people like me, for people like me. Everyone afflicted by *tanguitis* has a story of how they got bitten by the tango bug.

You walked into a bar and ... yes, there was a couple entwined with violin strings, barely moving. We've met them already.

Come to tango classes, a friend said to you, there's this really hot girl/guy. So you went along, but it wasn't the hot girl/guy you fell for. It was the dance itself.

You were walking down a street, heard 'La Cumparsita', peeked into a doorway, went up some stairs and saw a dance floor full of couples doing interesting things. You were desperate to join them.

You signed up to a Latin dance course. The cha-cha was OK, but it left you cold. The lambada made you hot, but it's for dimwits. The salsa was fun, but it didn't grab you. But, oh my God, the tango! The tango made you feel things that other dances didn't.

A friend dragged you along to a dance show called 'Tango Pasión', or 'Tango Argentino', or 'Tanguera'. You couldn't get it out of your mind afterwards.

17

You went to a Piazzolla concert, after which you wanted to feel like this again. So you Googled 'Tango Piazzolla', and a new world opened up.

You saw *Evita* with Madonna and Antonio Banderas doing their best with the tango. Their best is good enough to make you want to do it, too.

Or perhaps you saw *The Tango Lesson* and wanted to swirl, like Sally Potter, in snow-struck Paris with a troubled man, and whisper things like, 'Two is one and one is two . . .'

Or maybe, in your childhood, you saw your grandparents tangoing in the kitchen to some radio song. The image is seared into your mind with the sepia ink of nostalgia.

Whichever way it happens, you end up in a tango studio.

There were two dance studios in Auckland where you could learn tango, and the next day I signed up for both of them. But what I didn't expect was the brute, sharp, terrifying

Gancho!

The *gancho* is a leg hook. It's a sudden, lightning-flash invasion of your partner's body. It can be done by either partner to the other, and sometimes simultaneously – but let's hold our horses here and take it one at a time. And so: the woman flexes her leg at the knee under her partner's outstretched leg. Their bodies fan out from each other, still joined at the sides, their legs interlock for a second, they are two tense, giant insects about to mate – then she whips her leg out and it's all over. Or is it?

Not in Dan Green's dance studio. Dan has been teaching Argentine tango since 1989, and his slogan is WE TEACH YOU RIGHT THE

FIRST TIME! Here in his central city studio lined with giant mirrors, the gancho reigns supreme, right first time.

'And . . . gancho! And . . . gancho!' Dan Green shouts cheerfully and rolls his partner from one of his legs over to the other, then back, then repeats the whole thing until the world becomes a woman's leg endlessly hooking a man's leg.

'And gancho! And gancho!'

Dan is leathery-skinned, and a charmer to boot. His wife Mel is taller than him. I'm taller than the man I'm gripping, too. His name is Gavin, he has a shaved head and wears a gangster's ring and a hobbit's grin.

'Go on, Kapka,' Gavin says, 'Gancho me. I'm ready.'

He flexes his short legs, but I'm terrified that my gancho might misfire and get him in the groin. Ganchoing your partner in the groin is even worse than falling on your face. The groin is pretty close to the thigh, and the thigh is really close to the knee, which is what you're aiming for with your leg. But Gavin's lead is firm and my gancho is well aimed. Not so with everyone else. Giggles, groans and gasps come from all sides, as people of various sizes, ages and inhibitions lock and unlock their legs. There are perhaps a dozen of us in the sweaty studio with wall-to-wall mirrors, and if you could see us, you'd be forgiven for thinking that we're practising some weird kind of football move in mixed-gender pairs. The only thing missing is the soccer ball.

'Change partners!' Dan Green calls out – tango's mating call – and we disengage from whatever deadlock our legs are in and stumble to the next sweaty person.

After an hour of double ganchos, none of the men has been accidentally sterilized, the women's stockings are only slightly laddered

and we all feel pretty pleased with ourselves. Why, with the double gancho under control, we look almost proficient. Proficient at *what*, we might have asked. But there's no time for self-analysis. Things move at a cracking pace at Dan Green's studio. Apparently, we're going to learn to tango in just six weeks. And one thing looks obvious to us all today: the gancho is a 100 per cent tango step. Even if you can't tango, flicking a confident gancho makes it look like you can.

'Next week, the *sandwich*!' Dan announces, and puts on some videos of athletic Argentinian dancers. We gulp down water from our bottles and flock to the screen, goggle-eyed. How could we ever match this dazzling virtuosity? The gancho is the simplest thing these dancers are doing. There are gravity-defying jumps from the woman here, heavy lifting from the man, the flashing of impossible legs, even the splits.

'Fency thet!' Gavin flashes a golden tooth. 'Anyone for splits, ladies?'

For Gavin, tango is fun. But on the faces of the more highly strung among us there are signs of incipient panic. We all want to look like that couple. I want to do those things with my legs, with a man who looks like a gaucho in a suit. There's a mad whisper inside my head: I want to, I want to, I want to!

And then, my very first *milonga*. (*Pausa*: Milonga, confusingly, means two things: one, a social tango event; two, a rhythmic, syncopated cousin of the tango. In this case, it's the former.) The lights are dimmed; it's night time and the studio feels more intimate. There is a long table with soft drinks and crackers in the corner, where on screen the unbearably glamorous couple continue to flash their collective legs like some surreal centipede. I'm doing the gancho with James –

gancho, gancho – then, what is this? Oh, the backward ocho. My feet step back in a vague diagonal line, and I'm wondering whether they really are doing a figure eight. I suspect not. I suspect they are doing an impression of a herd of buffalo running backwards.

The ocho is widely considered to be tango's most feminine step, because of the way your hips turn to step back or forth as your man advances or retreats. Your chest is facing him, your left hand is on his bicep or his neck, but your legs are doing their own thing. But I have no idea whether my chest is facing anything at all, because I still haven't been properly taught the ocho, or anything else essential for that matter. The sandwich, however, becomes a staple of our tango diet. In the sandwich, the woman's foot is trapped between the man's feet. And then I'm doing the gancho with Max, who is Asian, always fragrant, and drives you purposefully like a turbine across the factory floor at the end of his shift. He is in a hurry. Even his sandwiches are put together in a rush.

As we spin around the studio, I catch a glimpse of someone in the mirrors: an almost glamorous-looking woman in heels and a knee-length skirt. I'm startled to realize that it's me. I don't think I've ever worn high heels before, and these are special tango heels I just bought at a dance-shoe shop called Ballet Bar. They have closed toes, suede soles and a thin strap that snakes around the ankle twice and, although I can't actually walk in them, I feel grown-up and feminine.

So, despite my worries about never achieving acrobatic virtuosity as a dancer, I'm beaming tonight. True, there are only half a dozen men to dance with, and they are all rank beginners, like me – except Dan himself, of course, who glides around so smoothly you'd think there was butter on the floor – but just putting my arm around a man's

shoulder and moving more or less in tune with him makes me happy. It doesn't matter if the man is short, bald and damp. We're in this together, and that's what counts. It's sultry in the studio, the windows are misted up and the city glitters outside.

When I drive home to the empty suburbs, down the immaculate roads, past immaculate houses, the city is beautiful and dead like a postcard. The only sign of life is my dance shoes, satisfyingly battered and scraped, in the passenger seat.

The following week, these same shoes take me to Dan Green's rival – a swanky dance studio where a dancer called Tim Sharp has set up shop.

Tim is a former ice-skating champion with ice-blue eyes. For him, tango is no laughing matter. He has no dance partner, so he teaches alone. I'm mesmerized by his razor-swift moves and the laboratory atmosphere of the studio. His scalpel-like gaze cuts the fat away from our movements. You can't survive in Tim's studio if you're lazy. We spend each class on a particular sequence of steps, which we repeat over and over, with different partners, until our faces glisten with sweat and it feels like there are no other possible ways of moving in the world except by forcefully taking out your partner's legs; in other words

Sacada!

To *sacada* your partner, you have to be a man, at least in Tim Sharp's studio. You (the man) twist from the waist and quickly place your foot in the spot her foot is about to vacate. It looks like you are giving her ankle or shin a little kick to displace her foot. To the sacadee (me), it looks *and* feels like a kick when I practise it with the sweating, stiff men in the mirrored studio. But I just assume this is part of what tango is

– pain, force, resistance, the man pitted against the woman, who maintains a stony face throughout.

The expressionless face was a trademark of early tango. When you look at old photos of couples dancing, their faces are frozen and formal, as if afraid of giving away emotion. This is how tango was danced in Europe up until the First World War. Things facial livened up after that, but the parodic cliché of the severe-faced tango couple persisted in popular culture. This is why you find the ghastly, mannequin-like ballroom tango couples in *Last Tango in Paris*, and a fish-faced Catherine Deneuve dancing with a young woman in *Indochine*. Even in my twenty-first-century mind, tango is still stiff-faced. Why is that?

Ignorance is the answer. I'm moving in a happy fog of ignorance, kicked by fellow ignoramuses and anaesthetized by the endorphins released during couple dancing. And no wonder we're ignorant: no-one has told us yet where these moves are going and where they come from.

This is where. Invasive moves like the gancho and the sacada were invented by men dancing with each other in the slums of Buenos Aires at the end of the nineteenth century: unwashed men with knives and cowboy boots, dispossessed gauchos from the Pampa, deracinated working-class immigrants from Europe, desperado sailors and the descendants of slaves. They did this in a sweaty melting pot of hope and despair, butchered cows and brilliantined hair. These new Argentines were inventing the dance of their lives, because there was no dance that spoke for them. It's not as if they could dance polka and mazurka. You needed money and women for that. Unlike the cows, the women in this society of immigrant labourers were thin on the ground, and the money was even thinner.

So, accidental kicks to the ankles and shins were the least of these men's worries in the dingy alleys where they practised daring steps and stabbed each other over petty disputes, which increasingly involved pretty women. Over the last decade of the century, these men eventually got to dance with prostitutes and *compadronas* – tough working-class girls who sometimes carried knives into the dance halls and cafés. You just never knew. An arrogant stranger might walk into a packed milonga, challenge the local strongman, and walk off with his woman – the kind of woman whose looks 'wouldn't let a man sleep', like the one in the tango story by Jorge Luis Borges, 'Man on Pink Corner'. Borges's story has a classic vendetta denouement, in which the stranger comes to a sticky end with the fatal woman, and not the kind of sticky end he hoped for. Borges himself wasn't a dancer, but he was spot-on about just how sex and death were sublimated in tango in those frank early days: very *thinly* sublimated.

No wonder that in its first decades, tango was considered lewd and was rejected outright by a newly hatched Argentinian bourgeoisie desperate to take on Europhile airs. And while the rich danced at an arm's length in gilded halls, the first *tangueros* danced in the dead-end streets of the port. In this urban Wild West, steps like the gancho and the sacada made up in thrill and sleaze what they lacked in ballroom subtlety.

'Next week, the triple sacada!' Tim Sharp announces in his urgent voice, and we all look at each other, proud to have graduated with a single sacada, and too bruised to investigate why there isn't a double one before the triple.

All you need to know about the triple sacada is that it's three times

the thrill of a single sacada, and three times the pain when you prac-tise it with other clueless beginners. My advice about the sacada is: don't do it in your first year. You'll never need it on the dance floor anyway, unless the dance floor is a stage and you are performing on it. But that's exactly what is happening here, in Tim Sharp's studio. We are beginners who can't yet do the tango walk properly, but we are already learning impossibly difficult steps that require good balance and posture, good body coordination, good timing with the music and general personal perfection. None of us has even one of these qualities.

And then, a few months into my tango life, perfection arrives in the form of Argentine maestro Carlos Rivarola, taking sips through a metal straw from a small leather gourd of *mate*. (*Pausa*: Mate is the national hot drink of Argentina and Uruguay. It's pronounced 'ma-teh' and tastes like a cross between tea and cocaine.) Carlos is on a tour of Australia, Japan and now New Zealand. We can't believe our luck – he is one of tango's younger living legends.

He is also the star of Carlos Saura's film *Tango, no me dejes nunca* (*Tango: Don't Ever Leave Me*), and more times than I care to admit I've watched the sequence where his pack of dancers face off another man's pack – Carlos in black singlet leading, and Julio Bocca following, in white singlet and transparent trousers. The other hunks synchronize behind them. It's a highly stylized business that represents the early days of street tango. Here, machismo meets homoeroticism, accom-panied by a Piazzolla tune called 'Calambre' ('Electric Shock'). Right now, Carlos is explaining how '. . . the fingers of your feet must grip the floor'.

'Toes!' someone corrects him and everyone laughs, charmed by his English. Carlos is not just darkly handsome and sleek, he also has an

all-round, nice-guy disarming manner. Too disarming, in fact. Just watching him walk disarms me so much, I forget to breathe. I try to stop thinking about dancing with him. But after the workshop, there is a studio milonga in his honour, the lights are dimmed, and suddenly, I am.

Or, rather, I'm not. I'm just standing there, my body against his, my heart pounding in my throat. And I'm not moving. I can't. I seem to be paralysed from the waist down. Horrified, I look down at my feet and his. Well, they're still there: two pairs of black shoes.

'Don' look down,' Carlos says with a smile that manages not to be patronizing. 'Jus' follow my breast.'

And suddenly, it's happening. We're moving, he forwards and I backwards, even though it feels as if he's not actually doing anything. He is just gliding across the floor, and I'm gliding with him. I don't even know if we're doing any figures. It feels effortless.

'Jus' walking,' Carlos says, and his finely chiselled face with a blueish eight-o'clock shadow is so close to mine, I'm hyperventilating. 'You walk, you don' run.'

The dance is over, and we've just done that: we've walked. No ganchos, no sacadas, no sandwiches.

'Thank you,' he smiles courteously.

'So, how was it?' Geoff grins at me at the side of the dance floor.

'It was . . .' I start, but I choke on it. I can't think of any words. Meanwhile, James is dancing with an Argentine woman called Cecilia. She has been helping Carlos to teach the workshops, and it turns out she has been living in New Zealand for a decade and is a dance choreographer. She has a luscious smile and body, and a cascade of black curly hair. Her black shoes have tiny toe openings.

26

'How was it?' I ask James afterwards.

'Jesus,' he says, and he looks the way I feel – stricken.

After five minutes with Carlos, going back to dancing with mere mortals is painful – physically and spiritually painful. I can't say what is wrong with the way they move, and the way they *move me around*, but I know it's just not right. I now know what tango can feel like, and I want more of that.

By now, my dance schedule is packed. Between Dan Green's studio, Tim Sharp's studio, the weekly milonga at Bar Fuego and the back of a restaurant called Bodrum, I'm dancing four nights a week. So are James and Geoff, and together we observe the hairline cracks that begin to appear in our fragile tango world. Dan Green and his wife are never seen at milongas organized by Tim Sharp, and I get the feeling that Tim Sharp would rather be seen dead than dancing in Dan Green's studio. Gradually, two separate little subsets form in each camp. Already, there's a Tango Schism. There are now two milongas on the same night, and I flit between the two, because I can't get enough of this stuff.

In fogged-up studios, in near-bankrupt gilded bars, in echoing church halls, we dance. In our black clothes we look like the family of the deceased after the burial. We move abstractly to the abstract music of Piazzolla with titles like 'Pulsación 1', 'Solitude', 'Libertango', 'Violentango', 'Pulsación 2', 'Pulsación 3' . . . couples pulsate like jellyfish in some underwater dream. But we don't care about the music because we're deaf. We're too busy watching our feet and *executing* steps. In that sense, we are not far from the early days of tango outside the suburban slaughterhouses. The level of improvisation is similar, and

so is the level of brutality as we inflict on each other our newly learnt ganchos and double ganchos, sandwiches, sacadas and triple sacadas.

Life is worth living again. I have met new people and begun to make new friends. Tango and its nascent community here accepts everyone as they come. Even James points out that I seem 'almost happy'.

Tango is already giving me a glimpse into a world of beauty that is just out of reach, but only just. Tango is becoming the first great infatuation of my life.

And, I swear on the spelling of Piazzolla, my Years of Loneliness are over.

This is How You Tango

TANGO LESSON: REVELATION

One evening at the end of a class, James asked me if I'd join him and a group of other tangueros on a trip to Buenos Aires for the 3rd Congreso Internacional del Tango Argentino.

'Sounds like something for professionals,' I said.

'We *are* professionals, KK,' James said. 'Professional tango fanatics.'

I checked my diary but there was no need: I knew it was empty. I checked my bank account, which was equally empty. I booked my ticket that same week – on credit. I'd only been dancing for six months, but it could be years before I became a good dancer or had any money, so what was the point of waiting?

This is how I find myself cramped in an Argentine airport minivan with five Kiwi tangueros: a total beginner called Gretel; a prim teacher couple from Wellington; my friend James; and a Wellingtonian called Nathan, of whom everyone said you had to be 'Nathaned' to know

what *real* tango felt like. Well, I looked forward to that because, truth be told, I was scared of dancing with Argentinian men. I had a deep suspicion that something was wrong with my dancing, and that something about it wouldn't stand up to scrutiny, even though I'd been scrutinizing my feet for a while now.

The slums of the outer city flash past us – corrugated iron, shabby shacks hung with laundry – and then the city itself, with its chipped belle-époque buildings and well-dressed people rushing about looking sleek. Our Kiwi contingent is wearing trainers and fleeces.

'Wow, man.' Gretel peers out at the streets. She is from the South Island, famous for *The Lord of the Rings* and the fact that sheep outnumber people by three to one. 'Never seen anything like it.'

'Like what?' I say. Her lack of cool is cramping our collective style. OK, my style.

'Like, all this stuff, it's so different.'

The truth is, I don't actually have a style. What I do have is a cringe. I've taken on the Antipodean, end-of-the-world cringe, added it to my own poor-cousin, former-Eastern-bloc complex, and, hey presto – here I am, a marvel of cultural neurosis. And I'd turn out to be wrong about Gretel. Gretel ended up staying in South America and learning Spanish, and a year later she organized New Zealand's first tango festival.

But right now, our group's collective knowledge of Spanish amounts to *hola*, *gracias*, and *una cerveza por favor*, which may get us a beer, but it doesn't help us to get a grip on the cacophony of streets and avenues. Our Hotel Oriental – a little tenement building with airless rooms – is barely a hotel and definitely not oriental. It is located in a street called Bartolomé Mitre, which reminds me of the Kiwi

hardware store chain Mitre 10, but is revealed to be one of Argentina's few liberal presidents, thus confirming me to be as much a provincialist as Gretel.

There is a brash, exciting energy in the streets. Buildings and faces are either magnificent or magnificently ruined. The high cupolas bristle with dreams of glory, and the gutters bristle with the dregs of those dreams. Buenos Aires pulls me in like a childhood memory I've suddenly recalled. I feel as if I've always known this place, just as I've always known tango.

We arrive at the grandiose multi-storeyed venue of the Congreso, which promises a frenetic programme of workshops and master classes and milongas and glamour events. The stocky bods behind the Congreso are Fabian Salas and Gustavo Naveira and their sinuous women Carolina del Rivero and Giselle Anne – but the women seem a mere detail. The women, no matter how amazing, are a mere doodle in the grand design of the maestro's distended ego. The two dudes are tango stars because they've appeared in Sally Potter's *The Tango Lesson*. Now they are cashing in on the fortunate double bill of their film-star status and the new rise in tango's popularity. They've called their venture ®Cosmotango, and ®Cosmotango's brainchild is this Congreso, which proclaims to be THE WORLD'S LARGEST AND MOST IMPORTANT TANGO EVENT IN THE WORLD SINCE 1999!

The Congreso is aimed at gringos interested in new tango trends. *Moneyed* gringos, that is. Gringos with US dollars, which I don't have. I realize, belatedly and with a shock, that the Congreso's price tag is so far beyond my means that not even my tango obsession can fuel me to bridge the gulf that separates me from a ten-day pass. I can only

31

afford a single Congreso workshop, and I desperately want to experience two hours with Chicho Frumboli and Lucia Mazer.

I am drawn to their fluid style of leg movements, which makes Lucia look like a cat stretching on a rooftop. Chubby Chicho dances in trainers and sports the image of a new-generation tango slacker. He is the new rising star of the Salas-Naveira school, and a self-confessed tango fanatic who dances 'from Sunday to Sunday'. The couple perform to abstract music. Chicho's big-cheeked face is framed by curly black locks and a sculpted beard. Lucia's body is supple and narrow, and at the end of a swan's neck is a face that the French would call *une jolie laide*. They are an odd pairing, but when they dance, their combined oddness fuses into pure magic. Inside the dance, their bodies are constantly reconfiguring themselves, but only for a second before everything shifts again, and again, and again. It's spellbinding stuff, like a Picasso painting animated to the sound of Piazzolla.

True to the Congreso spirit of giving gringos what gringos tend to want the most – flash – Chicho and Lucia are teaching a class on something called *desplazamientos*. This sounds to me like some sort of existential condition, but it turns out to be our old friend, the sacada. More sacadas. Dozens and hundreds of sacadas, which James and I inflict on each other among couples from Germany, Holland, Canada, the US, Australia, France, Sweden.

I think of myself as an old sacada foot, but I'm just as ignorant about it as about everything else in tango, and here are two reasons why. One, the sacada is just one of the better-known 'displacement' moves in tango, which are based on the same principle: one dancer places their foot in the spot the other dancer is about to leave.

Two, it turns out the woman can be sacada-ed (passive) or sacada

the man (active), meaning she can displace her partner's legs in a cicada-like movement as she fans out her legs. This mirror-reflection of a move is a revelation. On closer inspection, I see that only a few moves in tango are gender-specific – the ocho, for example, which is purely feminine with its pinched-waist shape. Almost everything – even the gancho – can be swapped between leader and follower, which are the words some English tango teachers use instead of 'man' and 'woman'.

Chicho and Lucia's sacadas are feather-light, barely there, a suggestion of moving legs.

'You sacada her very, very, very delicately,' Chicho says, and invites Lucia to move her leg out of the way, out of the way, out of the way.

Multiple sacada, soft and gorgeous as a peacock's tail. No bruises. No pain. No resistance. This is one of the tango couple's memento mori moves. It says, 'The moment I touch you, you slip away, slip away, slip away.'

'Wow,' James whispers to me, 'this is real tango Nuevo. This is the real deal.'

'Yeah,' I agree, but I feel very vague about it all. In fact, it's only just beginning to dawn on me that there are different *styles* of Argentine tango, not just different *steps*.

'How do you know it's Nuevo?' I whisper back.

'Watch the open embrace. The fluidity of movement. They're taking big steps. Huge steps!'

The nature of 'new tango' is a bone of contention that gets gnawed and then tossed from one tango pack to another. Some, like Chicho Frumboli here, believe that new tango is anything that great dancers come up with, now. But in reality, new tango is about the music

(Piazzolla is the name most closely associated with new tango) and how the couple's bodies are in relation to each other. In Nuevo, the woman's hand is not on the man's neck. It's on his bicep or on his back, keeping him at half an arm's distance. There is space between them, almost big enough for a third person to slip in. This space creates the need for fancy moves.

(*Pausa*: Some bulls of tradition mistake Nuevo for a red flag and charge at you when you mention it. This is modern tango's great divide, and I'm not quite sure which side I'm on.)

'So,' I say to James while we practise the latest sacada, 'what sort of tango do we learn in Auckland?'

'Nuevo.'

'So what's the difference between Nuevo and show tango?'

'You can do Nuevo at your own risk, but with show tango, you have an audience, so it's twice as embarrassing!'

Later, I get to practise a sacada with Lucia, whose bones are so frail, you might mistake her for a bird until you experience her iron grip as she swerves you around on stiletto heels that seem welded to the ground.

'Good,' she smiles approvingly, and it's like a tango blessing.

By the end of the class, I'm pretty sure that I could sacada and be sacada-ed by anything and anyone without injury. I haven't actually tested that certainty because there is no partner-swapping in this class, for some reason. Nor are there any locals in the class, except the teachers themselves.

'I wonder why,' I say to James.

'Because they're not idiots. They can have classes with these teachers any other time, at half the price.'

This strengthens my resolve to defect from the gringo-land of the Congreso and strike out into the heart of the city's tango scene. Every single milonga, *practica* and class appears in a monthly magazine called *El Tangauta*. Venues, hours, teacher names, milonga names and tango classifieds appear under each day of the week. So on Thursday, for instance, you can take classes with a series of different teachers, starting at noon and ending at 10 p.m. Then you can move on to any one of a dozen different milongas around the city, each with its own ambiance, style of dancing, live music programme and habitués. There is only one way to get a foothold in this wilderness of dance venues: by recommendation. Someone has to tell you where to go, and luckily, none other than Lucia has told me to go to El Beso tonight, for a taste of traditional tango.

It's just around the corner from our hotel, in a club known simply as a street number – Riobamba 416. When I arrive at the venue and examine the poster of events outside, I become even more confused: there are different milongas here almost every night of the week, with different names. Never mind. Tonight is the night of The Kiss.

I go up the stairs and through the red plush curtain, into my first authentic Argentinian milonga. My legs are shaking on my modest heels. Shaking legs are not ideal for dancing, but I have plenty of time to calm my nerves, because once I've paid at the door and joined the ranks of women sitting by the wall, nobody is asking me to dance anyway.

Yes, women and men sit at opposite ends and face each other off like two warring tribes. The war paint is lipstick and the signal for attack is the *cortina*, when couples change. This pleasurable tug-of-war between the sexes is ritually re-enacted here every Thursday. It is a

highly codified space, and the first giveaway is when the hostess, a bleach-headed, neck-plunging woman of a certain age, shows me to a table at the back of the women's flanks. It's the least visible table, but I'm grateful to be out of scrutiny's way. I need time to acclimatize. There is a smattering of ages here, but it's generally *old* – which to my young eyes means anything over forty. The women are all long-haired and their skirts and tops cling to their bodies fetchingly. They wear beautiful shoes of different colours, some of them open-toed. And me? I have short hair, a tight denim skirt whose initially shy split keeps cracking higher along my thigh as the week progresses, and a T-shirt. I may as well be wearing a hijab – my get-up instantly marks me out as a foreigner. First of all, nobody in their right mind wears tight denim skirts in the milongas here. Second, the women are all – with no exception made for age, good taste or droopiness – revealing vast expanses of upper-body flesh. In Auckland, I felt provocative. Here, I'm overdressed, right down to my closed-toe shoes.

(*Pausa*: To the novice, open-toe shoes are a daring gesture of exposure. The open toe says to your partner: 'I am showing you my big toe because it's cheeky and you might like it, but I also trust you not to step on it and rip off my toenail.' The open toe is to tango what the bikini is to swimwear, and there are variations of exposure, culminating with the G-string of the tango world, the tango sandal. This consists of a few straps perched on a stiletto between 7 centimetres and 9 centimetres high. In the first year of your practice, peep-hole toes are more or less safe, but the tango sandal is suicide).

The music is different from the milongas in Auckland, too. There's no sign of Piazzolla here. Instead, hour after hour, I hear traditional *orquestas típicas* – typically with four bandoneons – from the 1930s and

1940s. The floor gets denser with moving bodies as we edge closer towards midnight. And still, nobody has edged closer to me.

I sit at my little table, cradling a bottle of Coke, cultivating a vaguely disinterested look and anxious thoughts, such as: what if I just don't cut it in this nocturnal kingdom of eagle-eyed men and hard-nosed women? What if foreigners don't get asked to dance as a matter of principle here? What if all my sacadas and ganchos have been for nothing? What if I'll never dance with an Argentinian man? My mood is wilting at the speed of a wallflower.

Then suddenly – just as a new *tanda* of waltzes begins, and expired couples from the previous tanda unform while new couples form – just then, I catch a man's eye. Is he giving me the nod? He could just be being friendly, or have a tic. But he inclines his head more perceptibly. Yes, this is an invitation to a dance. This is my first cabeceo! My heart skips a beat.

We meet halfway, on the edge of the dance floor, which already seems too full to accommodate us. He says something in Spanish that I don't understand.

'I am try to catch your look,' he translates, 'all the evening.'

He is a small man of about thirty-five, with a groomed little beard and a tang of body odour, and I will never forget him even though he exited my life half an hour later. This is my historic moment, my crossing of frontiers, and I'm happy beyond words – literally – to be standing and not sitting, dancing and not waiting.

And then we get down to business. Seamlessly, he slips me into the mass of moving bodies. And we're dancing. I can't tell if he is a good dancer or not, because he is doing something unfamiliar. That is, he isn't doing anything much at all. He just holds me very close and walks

37

with me in circles, quietly, keeping in perfect beat with the music, and not once bumping into another couple. And then he is gently leading some little step that I have no trouble following, but I have trouble naming.

What is it? It seems very simple. It definitely isn't a sacada or a gancho. But I can't look down because our embrace is too tight. This worries me, and I feel the sweat dripping down my back. But he doesn't stop to analyse my dancing and bark instructions at me (double sacada, gancho, bend your leg, put your foot here, no there, no, not like that) as we do in Auckland. No, he just keeps dancing, and I keep doing my best to follow without anticipating, and there's no denying it: in the brief moments when I stop worrying, I'm enjoying myself in a completely new way. Except it's not new. It's what I had with Carlos Rivarola. It's blissful simplicity. It's authentic social Argentinian tango.

And it all happens to the beat of the music. They actually dance *to* the music here, not *next* to it. If you're a follower, this is vital, because you can only be as musical as your leader, no more.

In my nervousness, I expect him to drop me after the first song, or after the customary tanda of three songs, but he does neither. We dance a second tanda, and a third. During the loud cortinas we try to talk, but soon exhaust our topics of conversation (Where are you come from? New Zealand. Uh-huh. But actually I come from Bulgaria. Uh-huh . . . so, first time in Buenos Aires? Yes. You like? Yes. Is very nice for you. Yes.) and just stand there smiling at each other and waiting for the next piece to begin. And even when it does, we don't resume our dance straight away. The etiquette here requires couples to keep chatting into the music – a remnant from the days back at the dawn of tango when respectable ladies came to milongas with chaperones, and

their only chance of talking to a man was during cortinas. So the cortinas were stretched to breaking point.

At the end of the third tanda, he wipes our combined sweat from his brow and says, 'Thank you. I want to dance with you again.'

Or perhaps he is saying, 'I won't dance with you again' – but it's difficult to clarify such things without becoming linguistically entangled, so I just thank him. I actually feel like kissing him with gratitude for bringing me out of my tango wilderness and announcing to the other men that I'm in business.

Because, clearly, one dance is enough to put you in circulation. After that, I don't sit down all night. I dance with three other compact men of different ages, and with all of them I do the same tiny, basic, but delighting steps. Eventually, I figure out the mysterious step that the dark eyes has been leading and which is such common currency here: it's the humble

Giro (pronounced 'hero')

and simply means a turn or spin. With a slight twist of the hips, the woman steps one foot back and moves around her partner's axis, encircling him with three steps. While he pivots, she hums a little tune around him. Wordlessly, she tells him about herself, but above all she tells him that no matter what went on before, she is here now, with him. This is one of tango's emblematic and essential steps. It's also the step most frequently used in waltz, Argentine style.

I didn't recognize it, although I'd learnt it before. Why? Because it's not the sweeping, performative, big-striding HERO we'd been taught in the Auckland studios. No, this is a delicate, small *giro* tailored for a busy dance floor, designed not to impinge on other people's space. In this giro, your chests and faces are always turned to each other, and

39

not passing each other like ships in the night – which is how I had been dancing until now.

Until now, I hadn't been *connecting* with any of my partners. I had been *using* them as something to keep me from falling over, and they had used me for the same purpose. I had been dancing a barbarous tango. And like every tango barbarian, I had been learning moves and steps, but not the language of intimacy.

When the milonga starts petering out, I walk back to the hotel in a state of exhausted bliss. I'm too sweaty and high on tango-adrenaline to know what has just taken place, but I know this much: I've turned a corner, and my tango life will never be the same.

The following night, Friday, I go to a milonga called La Viruta. It is one of the pearls in the city's tango crown. It's been around for ages and is enormously popular. The huge floor is teeming with couples, the music is orchestral and gorgeous, and you can have *medialuna* croissants for breakfast here if you want to, at 6 a.m. – and still be dancing.

I walk up the palatial marble steps of what used to be an Armenian Community Hall, complete with plaques on the walls and that musty nostalgia that haunts all buildings where exiled communities huddled. But it is here that I experience my first moment of tango happiness. Not almost-happiness – complete happiness.

It takes the unlikely shape of a small, pot-bellied man with a bald pate and a grey suit. He gives me a dignified cabeceo from the bar, and I try not to push the table over in my eagerness to join him.

(*Pausa*: The cabeceo makes even a little man with a pot belly look simultaneously dignified and smooth, but its roots are deep inside the macho psyche, past and present. Nodding at the woman or eyeing her

up makes sure you don't lose face by walking over to invite her or, God forbid, verbally asking her. What if she says no? You'd have to disembowel yourself with your gaucho knife on the spot. Or the other compadres will toss coins at you from their tables and whistle: you're a loser, *papi*. Best to nod casually, and if she ignores you, at least no-one will know except you and the snooty bitch.)

The DJ is playing a Di Sarli tanda, which means that for about twelve minutes the music will be bittersweet, perfectly balanced between bandoneon and violin, and highly danceable. My partner props me up on his belly and the crowd absorbs us.

I can't see my legs – his paunch is in the way – but by now I've worked out that in the milonga etiquette here, to look at your feet is an insult to your partner. It's as if you were doubting him. And the truth is, with the pot-bellied man, there is no need to look at anything at all. I glide across the hot night, surrounded by a blur of couples and lights. This man is as grounded as the boards of the floor, as packed with history as this city. I feel just how the music runs inside his blood, and I understand why he has been dancing all his life.

We are dancing a perfectly symmetrical *milonguero* style: small steps, lots of small giros, lots of walking, a solid embrace. And we have not once bumped into another couple, although we are surrounded, with barely any room to move. This is a new species of experience for me.

After our second tanda (seven dances in total, I'm pleased to count), I'm so transported, I almost expect him to propose marriage. But he just thanks me in Spanish, wipes his shiny head with a faded hand-kerchief and gallantly escorts me to my table. I don't know his name, but after dancing with this son of poor Italian immigrants who came

41

to Buenos Aires with big hopes and small suitcases, I feel changed. I'm somehow feeling *more myself*.

I stand at the bar and watch the couples revolve. The high ceilings of the Armenian Community Hall hum with the simultaneous pleasure of two hundred souls. Or I should say one hundred souls, because there are one hundred couples – and the true tango couple has one sole heartbeat. And I am part of this, as of tonight. I have been initiated.

Within forty-eight hours of arriving, I have established a daily routine – or rather a nightly routine, because I spend at least half of each day sleeping the previous night off in my cavernous room, while my damp clothes and shoes dry off.

In the afternoons, I take classes with a young couple known as Gabriel and Natalia. Everybody in the tango world here seems to go just by their first name. Sometimes it's not even their real name. But Gabriel and Natalia are real – real stars, it turns out – who teach an elegant balance of traditional and Nuevo tango.

The class is made up of their regular pupils, plus me and the world's thinnest man, who has stumbled in here by accident, like me. Jesus is from Rio de Janeiro, and he is so skinny, he looks like his namesake shortly before the crucifixion. As the only foreigners here, we find ourselves in a default couple for the pre-class warm-up dance.

Jesus's ribs poke through his T-shirt and his bony hand clutches mine shakily. I'm afraid his hand will snap if I squeeze it too hard – which I tend to do with a new partner, because new partners make me tense. In a mixture of Spanglish and Portuñol, Jesus and I establish that he is a car mechanic but wants to become a tango teacher in

Rio. That's why he's living here for a year, to learn tango. But it's expensive.

'I don't spend money on anything, just rent and tango lessons,' he says. 'All I can afford to eat is empanadas.' (*Pausa*: The empanada is Argentina and Uruguay's national dish – a small, stuffed pastry parcel.)

Today's lesson is milonga (the dance) with *traspié*.

Milonga is part of what we might call the *holy trinity of tango*: tango, waltz and the holy ghost of milonga. Each of these music genres has a different beat and emotional range.

Milonga (one-two-three-four, one-two-three-four, with a stress on the ONE and the THREE) is cheeky and playful, and it makes couples giggle helplessly at the end of a dance.

Waltz (one-two-three, one-two-three) is lyrical, and it makes you want to spin with your partner and smile dreamily.

Tango (one-two-three-four, one-two-three-four, with pauses) covers everything from the wrist-cuttingly sad to the mildly splenetic.

Surprisingly, the more cheery milonga and waltz are less popular than tango. Something to be said about the relationship of tango dancers with masochism, perhaps? Yes – quite a lot, actually, but not yet for me. Back at the milonga class with Gabriel and Natalia, sweat is already pouring down Jesus's face and mine.

I've never been taught milonga before. In tango communities outside of Argentina, the milonga is neglected because it's so hard. As a result, all I know is that it's rhythmic, it uses small steps and one of its signature steps is the traspié, or the quick double-time step.

The group is separated by gender and I glance nervously at Jesus before joining the pod of gazelle-like creatures, with our queen Natalia

at the front demonstrating a complex step that involves . . . she does it so fast that I have no idea what it involves, and then she counts: '*Uno, dos, tres, y . . .*' and we're all doing it together. I am swept along to the right, then to the left. Everyone is crossing and uncrossing their legs in a zigzag embroidery, fast, very fast, then the other way. Except me – I'm just stumbling to the side trying not to fall over. I clench my jaw and stop breathing, and try harder to sort out my legs, first to the left, then to the right, but it's not working. The wires in my brain short-circuit together with my legs.

The key thing about milonga is that it's unrelenting. It's the ultimate litmus test of: 1. your musicality; 2. your body coordination; 3. your general fitness; and 4. your mental stability.

Unlike in tango, where you are allowed meaningful pauses and convenient languors, especially if you're dancing to something more modern like Piazzolla and have one deaf ear, milonga is a dance of beats, which means it cuts you no slack. If you miss a beat, you miss another beat, and then you've dropped out.

This is because milonga, with its perky rocking motions and lively tempo, is a compadre of the *candombe*. And the candombe is black – black, trippy and sexual, a throbbing of drums in your blood. But we'll come to that later.

Right now, I have a body block. Right now, I'm all clamminess and clumsiness. I've given up and retreated to the back while the gazelles practise their tiny zigzags and airy jumps. My clothes stick to me with sweat, and I'm trying hard to keep the tears of frustration in. Fortunately, nobody is looking – except Jesus, who is also standing apart from the stags.

'This is too hard for me,' Jesus says with a wilted face.

'Me too,' I say. Milonga misery loves company. 'Is this really an intermediate class?' I ask in mangled Spanish. 'It looks very advanced.'

He smiles. 'I think they don't have the word "advanced" in tango here.'

This puts into perspective the categories of beginner, intermediate and advanced that tango amateurs are so fixated on everywhere outside of Argentina. Fledgling dancers rush through the 'beginner' phase, eager to graduate into the fancy steps of 'intermediate' (after two years) and be admitted into the giddy ranks of the 'advanced' (after five). The phrase 'shoot up through the ranks' is heard in tango communities all over Europe and North America. You shoot up through the ranks when you've taken lessons with famous dancers.

But let's be honest here: after two years and two thousand ganchos, you can still be a health hazard on the floor. After five years and five thousand sacadas, you might still be a bobber sailing over choppy seas and crashing into other vessels. And if you are tone-deaf and can't tell a waltz from a headache — well, then, I feel sorry for all the unfortunate people who have partnered you while you shot through the ranks. I have been one of your partners, so I know. The only truly advanced dancers are people like Natalia and Gabriel, who have danced for twenty years, or since childhood, whichever comes first.

This is the last time I see Jesus, because I decide to quit Natalia and Gabriel's 'intermediate' workshops, and go eat humble empanada in another, more accessible venue.

And not just any venue, but the legendary cake-shop-turned-tango-salon Confitería Ideal in calle Suipacha. Confitería Ideal is legendary for being itself, which means being in perpetual grand decline, like

the Argentine economy. As you go through the marble façade and up the stairs to the main hall, you'd have to be a boor not to be enchanted at what you see. And what you see is colonnades propping a decadent ceiling and glass-encased Viennese cakes that must have sat there since the place opened in 1912, and, yes – an afternoon tango class. The elderly waiters, pinched into faded red waistcoats, move slowly, like extras in a Bertolucci film.

I change my shoes and observe. There are perhaps ten couples here, mostly middle-aged or aged. I can't immediately spot the teachers, because everyone is either dancing or sitting at one of the small tables. There's a timeless carefree vibe in the Confitería, a belle-époque indolence that says, 'There is nothing more important in life than to eat cakes and tango the afternoon away.'

Eventually, I figure out that the teacher is a tiny, stocky guy called Diego. But this is not a class, it's a practica, a silk-cravated gent with liver-spotted hands informs me. What is a practica? I want to ask, but I don't want to identify myself as a tango barbarian, so I just nod – of course it's a practica. I dance with the courteous gent, who smells of leafy neighbourhoods and perfumed old age, and for some reason makes me think of Jorge Luis Borges. But, unlike Borges, who talked about tango without dancing it, my gent leads without talking. His touch is delicate and his timing is impeccable, like his tailored suit with a red hanky pointing out of his breast pocket. After three dances, he asks me where I'm from, and is so stunned to hear there is tango in New Zealand that he sits down and wipes his face with the hanky.

'New Zealand.' He points at me when Diego comes our way. Diego, with his shaved cranium and gaucho moustache, looks like a man with a past. To my delight, he promptly takes me for a spin

around the legendary dance floor. So, that's practicas for you – they are somewhere between a class and a milonga.

'OK,' Diego says afterwards, and his impassive face cracks into a smile so warm I want to tickle his moustache with gratitude. 'You can dance. You listen to the music, nice, musical, but! You are not *wolking*! You are not *using the floor*. Wolking. Now!'

And he points under my feet. I stare at the floor. It's the colour of vanilla ice cream. Nobody until now has told me anything about the floor, or walking. I've come all this way, from Bulgaria via New Zealand, to dance tango in Confitería Ideal, and all Diego can offer me is this: I'm not using the floor. I feel upset and misunderstood.

'Dancing?'

The man is middle-aged, with a wide, warm face that's impossible not to like instantly. His name is Guillermo d'Alio and there is nothing subtle about his dancing or his personality. He shoves me around affably.

'I don't take classes,' he informs me. 'I only dance socially and some-times come to practicas. I teach myself how to tango.'

Well, I want to say, it shows. But I don't, because I'm the last person who can hand out judgements around here. I've just been told that I can't even use the floor. Guillermo, on the other foot, *specializes* in using the floor. He tells me that he's a tango artist. This means that he dips his shoes in paint and dances on a canvas.

'Come to my studio and I'll show you what I mean,' he says, and somehow, coming from Guillermo, this doesn't sound sleazy.

'I do tango art shows with my daughter. We dance together, and that is a painting. Two arts in one. We go to the US a lot, California. And France, Holland . . .'

I'm so intrigued that the next day I sacrifice my afternoon tango class in order to venture out to Guillermo's studio in La Boca district, so called because it sits at the mouth (*la boca*) of the Riachuelo river.

The Riachuelo looks and smells the way it sounds – a polluted estuary afloat with the oily dregs of past industries. And it was here that it all started, and where all terrible things came and left, in the rapacious centuries that made Buenos Aires its dodgy fortune and fate: contraband, cargo, meat, money, slaves, prostitutes.

People have warned me not to stray off the only pretty drag of the neighbourhood – the picturesque and romantically cobbled Caminito (Little Road), named after the famous nostalgic tango song from the 1920s. Or is it vice versa – did the song commemorate this street? Tango songs are part of the texture of Buenos Aires and they came of age together with the city, so for a newcomer like me, it's impossible to separate the two.

Although Caminito looks like a quaint street museum with its artists and their kitsch drawings of street tango, the past is not dead here in La Boca. It breathes down your neck with the toxic tang of the river, through the yellow teeth of the sailors and opportunists and dealers in human lives who haunted these dark alleys. In the corner of my mind's eye, I glimpse the cold steel of their knives, the rotten breath of their illnesses, the desperation of their shady deals, the dress-rustling of the women who died young. I hear the rankle of the million chained slaves who disembarked here at the end of a nightmare journey from Africa, and at the start of another horror trip into the bowels of this hungry continent on the make. I sniff the bloody stench of the animals that got hit over the head with hammers in slaughterhouses, then packed in warehouses and sailed off on the

cargo ships that once made Argentina one of the world's richest countries.

But there was something else, too. Out of all that meat and blood, from the children of the African slaves and the dirt-poor Italian and Spanish immigrants, from the misery and the artistry, the sex and the violence, the contraband and the backbreaking labour, the home-sickness for the Old World and the hope of the New, was born a wunderkind of cultural mutation: the tango.

Then, at the end of the nineteenth century, it travelled from the slums to working-class neighbourhoods like La Boca. Inside the twilight of Buenos Aires, the poet Lorca said on his visit here, tango opened up its great fans of tears.

'Ah, Kapka, darling, you made it! Just in time for lunch.'

Guillermo greets me at the door of his street-level studio and I step in. It's all turpentine fumes and creative mania in here. Strange, chunky tango-dancing figures and lone bandoneon players look down at us from the walls as he unfolds salami, cheese and bread, and we sit down at his paint-smeared work bench to eat off old newspapers.

'How long has it been for you, this love affair?' Guillermo asks with a full mouth.

'What love affair?' I stop chewing.

'The love affair with tango,' he says. 'It's the only one that matters.'

'Is it?' I chuckle.

'Of course.' He chews on, his clownish face dead serious. 'All other affairs pass.'

We chew on in silence for a while.

'You'll see,' he says, and wraps up the remains of our lunch. 'You're

too young now, but come back in ten years' time and we'll talk again. See this.' He waves at his tango-encrusted studio. '*This* is my life. *This* is my lover. I don't want to die lying down. I want to die on my feet. And now let's dance.'

He puts on a tango by the daddy of sung tango, Gardel. I recognize it from its giveaway opening word – Caminito. Of course! We bumble around his sticky, smelly studio. Guillermo is not a dancer, he's an artist, so I forgive him the lever-like hand at my back and the 'step here' instructions. The song tells a melancholy story of a little road that's been effaced by time – just like the poet's past, when he would walk here with his beloved, in a better time. The past is always a better time in tango songs. But Guillermo is focused on the present and the future.

'Here, to remind you of me until next time.' He sketches a tango couple on a napkin.

'I don't know if there will be a next time,' I say.

'Why, do you intend to settle down in New Zealand, marry a farmer and forget about Argentina?' Guillermo's Pagliaccio eyebrows go up.

'No,' I laugh.

'I didn't think so.'

He walks me to the bus stop and we part with a hug, like old friends.

My ten days are almost up, and the only non-tango-related thing I've managed to do is accidentally get a haircut at San Telmo's oldest barber salon. Barber? That's right.

OK, I shouldn't need Spanish to work out a barber from a hair-dresser, but there I am, inside an old-fashioned salon with leather

chairs from the 1900s and two very old men staring kindly at me. I point at my short hair and say, helpfully, 'Hair?'

'No.' They smile and shake their hairless heads, and I blush with embarrassment, and the rest of it is lost on me, except one word – *muñeca*, which means 'doll', a dated *porteño* endearment for 'girl'.

'Tango,' I say, as if that will help me, 'I'm here for tango,' and I point at the square where tango music is playing and a tall man with a pony-tail dances with a woman in black and red. He is el Indio, a famous milonguero-about-town and something of a heart-throb. The old man's face cracks into an all-forgiving smile.

'*Ah sí, el tango*,' he says.

I fumble for my sweaty pocket dictionary, but I don't need it any more because one of the brothers – that's what they are – cuts my hair anyway. He does it very slowly with his shaky, liver-spotted hands, as if each hair on my head is precious. His brother takes a nap in one of the leather chairs. He looks like a giant lizard basking in the afternoon sun. The awake brother refuses to take any money from me, and before I leave he kisses my hand and waves goodbye.

I am so choked with gratitude, I rush off to buy some flowers for them, but when I come back later, the big shutter is rolled down. I put the flowers on the pavement, but that looks oddly like putting flowers on a premature grave, so I pick them up and walk around the city with them, looking like a woman who is loved, which is how I feel, for the first time in ages.

On the way home I buy two pairs of closed-toe tango shoes from a shop called Flabella, both of which are the wrong shape for my bird-narrow feet and will give me nights of agony. I also choose a stack of

Piazzolla CDs from the music shops along Avenida Corrientes, where tango music oozes out of every doorway.

That evening, James and I grab the rare chance to see a performance of Piazzolla's 'Concerto for Bandoneon and Orchestra' at the resplendent Teatro Colón. We sit in the gilded hall, dressed in our earnest-smelling evening clothes, because after ten days of dancing non-stop there is nothing clean left in the collective Kiwi wardrobe. I've heard this concerto before – but to hear it live, to see the solo bandoneonist sitting on his stool centre stage and the black bandoneon breathing like a magical lung . . . well, it does something to me. I don't know what it's saying, or rather I couldn't translate it into words, but its semi-human voice is speaking directly to me. It's like conversing with the soul of Astor Piazzolla. He understands what a long road I've travelled, and what a long road lies ahead of me. He senses, from inside that bandoneon, how much longing I am lugging around in my invisible suitcase, how alone I've been, how lost in the world.

'There's only one Piazzolla, eh, KK?' James is passing me something. It's a hanky.

I've forgotten that he is sitting next to me. I've forgotten everything. I look at him and catch something strange in his eye. It's . . . a tear. I look again to make sure, but everything is blurred. I wipe my face with the hanky.

And thus subdued by our musical epiphany, James and I walk to our shabby non-oriental hotel, sniffing here and there the grilled meat and boiled mate of the nation.

'I want to be on the inside,' I say to James. 'But I know that I'll always be an outsider here.'

'KK, you're an outsider everywhere.'

'Thanks, James. You know how to cheer me up.'

'Any time, KK. Any time.'

We get lost, or rather we realize we've been walking in the wrong direction. But being lost in central Buenos Aires is a ritual that every visitor must go through. And anyway, just walking down the endless Avenida Corrientes with its flashy billboards of spectacles and cabarets, its giant, lit-up late-night cafés with names like El Opera, fills me with a cosmopolitan thrill. It's a feeling at once happy and sad, past and present.

It's a feeling we shall call *tanguidad*. Some experts say that tango goes far beyond the music and the dance. There are tango *feelings*, tango *language*, tango *places* and even tango *people*. You don't have to know tango in order to experience the world in a tango way. That's tanguidad.

It is my final day in Buenos Aires, and I decide to blow the last of my spending money on a private lesson with a teacher called Oscar. Oscar has a fierce face, and he is the tallest man I've met here. When I arrive at his bare street-level studio in San Telmo, he wastes no time in niceties. He produces four coins and places them on the floor to make a small square.

'Tango is complicated, no?' he says. 'But is too very easy. Everything happens around this *cuadrado* . . . how do you say . . .'

'Square?'

'Yes, square.'

'Everything?' I say, sceptical and, as always, opinionated.

'Everything. Look.'

He stands inside the square.

'Imagine a chair. I am chair. *Salida*.' And he leads me into the basic exit step to the side.

'Ocho.' And I do an ocho.

'Backward ocho.' And I follow, no problem. I can feel the pinched, lovely waist of my ocho – for the first time. Tango's most feminine move.

'Giro.' And I turn around him – once, twice, then I'm dizzy, but with these few steps I've managed to tell him a little story.

We continue like this for some time – and he is still inside the square, and I am turning around him. In my mind, though, tango is still a tangle of dismembered, tortured leg sequences that have to be learnt in portions, and then stitched together – and bingo, you have a Frankenstein choreography.

'What about the sacada?' I challenge Oscar.

'Sacada,' he says, and we do it, easy. And he's still inside the square.

'Sacada is just a big giro, for you. A giro with, how do you say, with some *adornos*.'

'Embellishments?'

'Sí. Everything in tango is variation of something other. Everything is connected.'

And I see it now – the crystalline simplicity of the dance, how it evolved from a few basic steps, how each loop of the lace-work leads to the next, how the whole beautiful pattern of feet holds together. It's as if a blindfold has fallen from my eyes, and – as in that Henry James mystery story – I have seen 'The Figure in the Carpet'.

Tango is organic. There are no pre-set, rote-learned sequences. There is just one step that flows into the next, and the next, and the

next, in the most untortured, natural way. My discovery feels at once monumental and intimate.

I glance at Oscar, who is picking up the coins, and in a split second I recognize him. He is the man in the video we watched back at Dan Green's studio. He is the gaucho with the woman doing the splits. I now remember his name – Oscar – from the credits.

'You got other question?' he asks, spotting my goggle-eyed look.

'Umm, yes,' I say, thinking of the flashy steps he and his woman did in that show. 'What do you prefer, tango Nuevo or traditional tango?'

'Let's dance, and I explain after,' he says, and puts on something rhythmic, perhaps Pugliese. We dance, and even though Oscar is towering above me, and he looks distracted, I'm gliding around, euphoric with clarity of mind and crispness of step in the declining afternoon of San Telmo.

I blink and it's over, and I'm giving my next week's groceries' worth to Oscar, whose face is darkened by a moody smile, his only conces- sion to friendliness. I don't need to repeat my question about stylistic preferences, because he has just demonstrated the answer: we have danced the traditional close embrace. Definitely no splits.

'Are you going to the Congreso ball tonight?' I say.

'No.' His smile is gone. 'I'm not invited to Congreso, and I don't want no invitation. I just dance tango, OK? *Adiós.*'

He sees me off and shuts the door. By tomorrow, I won't even be a memory for him. But his four-coin square on the humble floor will remain lit up in my mind like a light-box for the next ten years, and help guide me through the maze of my own life, which, for better or for worse, is already being measured out not in calendar years, but in private tango events – like this one. Like Piazzolla's concerto in the

Teatro Colón with James. Like Guillermo's studio in La Boca. Like my first night at La Viruta. Like the barber brothers.

The Congreso ball is supposed to be the crowning moment in our collective visit. But it turns out to be the nail in the coffin of my previous tango self. The self that dreams of being dazzled and dazzling. The self that turns up to the ball dressed in a black tasselled dress and black fishnet stockings and new, wine-red suede shoes, because that's what the tango look requires. Isn't it?

The ball is a grand, glitzy affair, as befits the first global tango event of the new century. Here are American women, wearing faux 1930s pearly headdresses and living out some exotic scenario on the floor. Here are European men in their prime, politely groping for a perfect embrace with some strange woman from another continent, and their only common language is the giro, the ocho, the sacada. Here are ambitious young dancers from Switzerland and Holland and Germany who aspire to be tango teachers back home and ditch the nine-to-five. Here are Swedes and Danes with practical bodies trying out the complicated steps learnt at great expense this week, and kicking in the shins the person behind them (me).

We are all together, but each of us is dancing out some private fantasy. We all want *something* from tango – glamour, melancholy, erotic thrills, some other thing without a name.

'Good evening, lady and gentleman,' the MC says in English, tapping the mic. 'Welcome to the Congreso Internacional del Tango Argentino 2001. We are so happy to see many of you here, come for the world's biggest . . .'

The greasy speech goes on for a bit, and ends with the announce-

ment of the exhibiting maestro couples who will perform during the night.

And now, to the sounds of Piazzolla and under our star-struck gazes, Fabian Salas and Gustavo Naveira and their glammed-up women dance technically immaculate numbers and execute breathtaking steps with vicious precision. Jumpsuits are in vogue this year, and the bodies of these feline goddesses pirouette and leap. This is tango art of the highest order.

I sit among the bejewelled and coiffed audience, I watch these outer-space performers and I feel like an outsider again. I'm losing my footing fast. I've been dancing non-stop for the last ten days, but this is nothing like the intimate, chatty world of the neighbourhood milongas I've been enjoying. This is a spectacle where you have come to watch and be watched. It's a catwalk of egos with a tango sound-track. It's a world of glamour, predators and fame, and inside my tasselled dress, I am a bundle of confusion.

'Dancing?'

Thank God, a familiar soul – it's Guillermo and his amiable grin. He is wearing a painterly felt hat and clownish striped trousers in an attempt to strike a milonguero look.

'Guillermo! What are you doing here?' I say. 'There are no other locals.'

'They can't afford it, that's why. But I have to come, you know, to network. This is not a milonga. This is tango for export.' Guillermo raises his tragicomic brows. 'But we don't care. We are dancing, and we are enjoying.'

And we are. Because, although Guillermo's dancing is only about 50 per cent there, *he* is 100 per cent here with me. Because I'm having

57

fun. Because our execution might be flawed, but our intention is sincere.

I don't care about how I look, because to those who form a dance couple, the external world is not an audience – it's a rumour, a murmur, a backdrop to the main event of whatever happens between two people who are dancing together.

This is the most important lesson I've learnt. The authentic tango experience is an exclusive space that only includes you and your dance partner, whoever it is, and for however long. In this sense, partner dancing is like lovemaking.

But, be warned: only in this sense. If, God forbid, you get things mixed up, if your brain gets scrambled by this exclusivity – as it inevitably will – well, then you're doomed. As doomed as I was.

CORTINA

KK: So, why do you tango?

American woman, thirty-seven: Because I have secrets.

German man, thirty-five: Because I want to know myself.

Russian woman, thirty-two: Because my body is lonely.

Italian man, forty-eight: Because I play like a child and it makes me happy.

Swiss-French woman, twenty-seven: Because I want to say things with my body.

Dutch man, sixty: Because each woman tells me a story with her body.

TANDA TWO

THE HEART

In Search of Intimacy

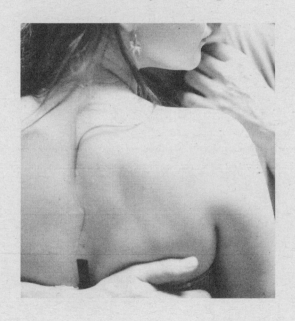

Just One Time

TANGO LESSON: TEMPTATION

Flying via New York on the way back to Auckland *is* a detour, but I can more or less justify it to myself. I've heard that the tango scene here is big. And not just big, but metropolitan, glamorous and intimidating. Or it would have been intimidating, had I not just been to the Mecca of tango.

This is what I tell myself as I arrive at a large studio with polished floors and colossal mirrors, called Dance Manhattan, on the fifth floor of a skyscraper. I change my shoes, my hands clumsy with nerves. I'm not intimidated, I repeat to myself, I'm not intimidated. So what if I don't know anyone here, and they all step out of the elevators with such breezy confidence, such matter-of-fact shoe-bags in hand, such perfect teeth, that I have a spasm of envy? Among the chatter, I catch the strain of foreign accents beneath the American English, which reassures me for a moment. But wherever they come from, they are all New Yorkers now. They greet each other with a kiss-kiss on the cheek.

(*Pausa*: In any milonga anywhere in the world, you give every-body you greet a double kiss on the cheeks. The farewell is identical – kiss-kiss. An awful lot of time goes into these hellos and goodbyes, but it's time well used because it creates the pleasant illusion of belonging.)

But I'm a stranger here and I have no-one to kiss-kiss. And just as I begin to panic that I may have no-one to dance with as well, I receive an invitation from an olive-skinned man who is drenched in sweat but scented with a citrusy perfume.

He's a dynamic, musical dancer with a very open embrace. After him, I have a few decent dances and a few mediocre ones, which is both a relief and a disappointment: they are not tango gods here, after all, and they're friendly to strangers. And most of them dance in an open embrace: New Yorkers are too cool for close embrace. They are also too cool to sit down. Everyone is either standing or dancing. Everyone is in brisk business. The turnover of couples is quick, the music is unrelenting. There are no tables, no free chairs, no refresh-ments except the water bottles everyone has brought with them. It's tango-to-go. It's as if we're dancing by numbers, in a hurry to get somewhere – but where?

To the next milonga, that's where. There is another milonga or two that night, and some people are leaving already, their shoe-bags flicked urgently over their shoulders. The tango tempo of New York is unique – it is perhaps the only city in the world that could come up with the idea of a 'Practilonga Marathon'. This sounds like a handy combo of practica, milonga and heart attack: get three for the price of one. The reason why it only runs for six hours, until midnight, is to allow the survivors to move on to another venue –

which is the 'After-Longa', free from 3 a.m. and strictly a no-shoes event.

The first ever 'dance marathon' was also an American invention. It took place in Hollywood, in 1910, the first decade of worldwide tangomania. The first victim was a woman from New Jersey who developed a serious case of dance fever and danced for fifty days without stopping. Here in New York, I can believe that.

'Dancing?'

'Yes,' I say, before I even look up to see the face at the end of a totemic body. We dance, or rather I dance with his chest. His name is Rupert Newton, which is a perfect match for his unlikely face, that of a stamp-collecting Victorian gentleman of leisure.

'I'm often in BA,' Rupert tells me casually – everything here is casual. 'I just bought a flat there.'

'That's nice.' I smile at his chest, glad that he can't see my envy. He is a good dancer, but he exudes boredom. I've been there, done that, his body says to me, what's next.

Later, I find out that he *is* a gentleman of leisure, except that he collects rare bicycles and tango records.

Over the next few days, I meet tangueros of all stripes, colours and pre-American nationalities, and there is one thing that unites them: they are chuffed to bits to be New Yorkers. One of them is a young Bulgarian guy who graduated from the same French College in Sofia as me, and who now works for a bank. He is also an accomplished dancer, and he takes me on a mini-milonga tour. His dancing is driven by an exuberance verging on mania. He's almost *too happy to dance*. He fizzles with the dynamite of his own success in the New World.

'Nu Zealand! Man, how did you wash up there? Just watch you

don't end up with a farmer, that'd be a waste of talent. You've gotta come here, man, this is where it's happening.'

I tell him, boisterously, that I've just been to Buenos Aires. He rolls his eyes.

'*Everyone* here's been to Buenos Aires. It's like our backyard, you know. Even though, to tell you the truth' – yes, tell me the truth, I think, my heart already sinking – 'we don't even need to go, 'cause we have maestros visiting every week. And resident Argie teachers. They all come here. It's the place to be.' He looks at his watch. 'Come on, time for the next milonga.'

My week in New York is a blur of milongas and dances, one after the other. I forget the names of people and venues in my rush to run up as much tango mileage as possible while I'm here. The New York scene requires superhuman stamina, and after six nights of dancing I am beginning to flag.

The last milonga on our tour is at a colonnaded, open-air market in Greenwich Village. It's a busy dance floor, circled by a crowd of onlookers. My successful compatriot is dancing like a man possessed, with a Sicilian woman he has just met. A few years from now, he will marry her, and they will live in a sunlit penthouse with a direct view of the Statue of Liberty and ten milongas within walking distance. Their children will be tango dancers with American passports and the laughter of winners.

And me? I'm standing on the fringes, looking in. I want to be one of them, one of these Shiny Happy Tango People, but I know I can't be, not if I'm only passing through. But what I *can* do is see the reason why New York tango is a success: because it gives everyone a chance on the dance floor – the kid from Sofia, the kid from Sicily – and if

they're good, they run with it. This twenty-four-hour milonga of opportunity charms them all into wanting to dance on, to belong. This is not Buenos Aires, but it is something just as monumental – it's Tango Babylon. It is what Buenos Aires used to be, a hundred years ago, when tango first flourished. Here it flourishes still, with new hybrids. It just can't help itself under these hothouse conditions.

But for me, it's time to go back and regroup in the comfort of my own tango backwater. I say goodbye to the happy Bulgarian banker and to my cousin, with whom I've been staying. She is a six-foot-tall ex-model and just recovering from a date with her worst nightmare – a midget who turned up at her flat with a huge bouquet that blocked him from view. I beg her to give tango a try. Lots of *tall* men there, I tell her.

'Sounds interesting . . .' she says, and I sense that she thinks my tango obsession is a little pointless. It lacks *purpose*. She is, after all, a New Yorker, and she also works in finance.

'Have you met anyone yet through dancing?' she asks.

'Sure. Hundreds of people,' I say breezily. I think of all the interesting men I've danced with, of Carlos Rivarola, Guillermo d'Alio . . . but I have to admit: no, I haven't 'met anyone' yet.

And now it's back to postcard town.

WELCOME TO THE CITY OF SAILS! The airport banner flaps in the ocean breeze and the sky is a blank. As soon as we land, I want to fly back to Buenos Aires. More than ever, I'm aware that I don't belong in a city of the future where the men are healthy and outward-bound. I belong in the city of all-night milongas where the men smoke and the music of yesterday plays, where the streets teem with drama and

dereliction, melancholy and memories. Is this perverse? Probably – but it's the way I'm made.

My spirit feels dislocated, but my posture has improved, along with my fitness, and I can now walk and dance in heels. I've only been away a month, but the Auckland tango scene has also been transformed.

The studios of Tim Sharp and Dan Green are still going strong. But they have fresh competition in the form of the lush Argentinian Cecilia and good old Geoff, both of whom have opened studios. There is also a new waterfront milonga every Wednesday. In short, the stage is set for public tango wars and private dramas.

That year, I experienced a series of watershed tango events: my first tangasm, my first Tango Teacher Infatuation, and my first Tango Relationship. They were with different men, of course – because this is tango, with its inevitable cortinas and 'change partners'.

(*Pausa*: Unless you are a saint or a Buddhist monk, in which case tango probably isn't for you anyway, each of these events is guaranteed to occur within your first two years of dancing. Especially, but not only, if you are single, and regardless of your age or sex. You have been warned.)

As we enter this new phase of the tango experience, it's no longer just about what your feet are doing, but about what's going on in your head and your heart. We need some new terms here, and one that crops up with alarming regularity is 'neurosis'.

Tango is a magnet for those with psychoanalytical leanings, partly because Buenos Aires is the world's capital of psychoanalysis. So it isn't surprising that an Argentine Freudian psychoanalyst has carried out in-

depth research into the dynamic of tango lyrics. He has identified a classic cycle of 'hysterical' behaviour in many of the lyrics – and, of course, this applies with even greater precision to the way a couple act out the dance:

1. seduction (he invites, she accepts);
2. engagement (they dance, they are together);
3. rejection (they separate after a couple of tandas, thank you for the dance);
4. fall (we were so close, and now we're strangers, I can't stand it);
5. longing (please, I want to do it again).

Observe how the pattern ends with longing, which means that it also begins with longing, and so the cycle continues: longing, seduction, engagement, rejection, fall, longing. Longing is what gets us into trouble time after time; we just can't help ourselves.

When you start dancing, you are concentrating mainly on what your feet are doing, so you are out of danger. Life is simple for the tango barbarian. But the moment you move on to the next level, and your head and heart are involved, the Freudians get you.

This is how I find myself, one sun-struck afternoon, in a suburban Auckland studio. It's a practica run by Geoff, and I've just noticed the new guy in the corner. He is of average height, with shorn hair, and packed with an entire rugby team's worth of muscle. He is practising quietly on his own by the wall railing, ballet-style. I think I've seen him before, and he's always in the corner, on his own. His posture and movements are immaculate. Solo dancing is one of the hardest things in tango, because you have nothing to lean on. All you have is your axis and your balance.

'That's Silvester,' Geoff says. 'He's one of mine, and he'll be a very good dancer in a couple of years.'

Geoff's classes reflect his style of dancing, which is milonguero, or traditional close-embrace style, like Cecilia's. You'd think that conditions are perfect for him and Cecilia to join forces and form a teacher couple, but no – they don't connect enough, and besides, they each want to run their own show. Meanwhile, Silvester, who in real life specializes in microchips, is taking his tango very seriously indeed. He is combining the best of what each teacher has to offer, and constructing, step by tiny step, the algorithm of his dance style.

Here is one curious fact about tango dancers in the English-speaking world: there is a disproportionate presence among them of engineers, physicists, IT specialists (with artificial intelligence leanings), mathematicians, surgeons and other scientific brains. I once sat with a physicist who explained to me, through a complex computational system involving diagrams and equations of musical beats and steps, how tango and quantum mechanics (or was it thermodynamics?) were more or less the same thing.

'But I just want to dance and enjoy it!' I protested feebly.

'Ah, you say that because you're a follower,' he said, and he had a point. 'You can close your eyes and go with the flow. But I'm a leader. For you to enjoy it, I need to figure it out bit by bit. I need a system.'

And, yes, dancing with him was like dancing with a system: operational and impersonal. I don't know whether Silvester had a system, because he was a man of few words, but he certainly had the near-inhuman patience to practise on his own for months before dancing with a woman.

And when he does, that woman is me. We take the first, most basic, dead-easy step, the

salida

which means 'exit', but is really an entrance. It's one of the few times when the couple do identical things. Both step sideways, entering the dance. I say it's dead easy, but until I dance with Silvester, I realize that nobody in Auckland can lead the salida properly. With Silvester, you just know exactly what he is doing, or rather your *body* knows. There is no force, no hand-manoeuvring, no twisted torsos, no tortured hips. Everything he leads feels effortless and intimate. Disturbingly intimate.

And so, to the appropriate sound of 'Just One Time', a 1940s Pugliese song, something strange happens that hasn't happened to me before. I feel like we are one: one body dancing, one mind tuning into the music, one heart beating.

All I catch of the lyrics is *una vez* ('once'), *amor* ('love') and *esperanza* ('hope'). It's enough. I feel as if nothing bad could happen while we are like this. He envelops me like a duvet, shelters me like a house and holds me like a lover. I have never felt so protected, so appreciated, so understood by a man. We are the same height, factoring in my heels, and his neck smells of Pacific citrus trees and fulfilment.

This is the tangasm. Do I then see the years of blue happiness stretching ahead of us, our children running across uncut grass, and us growing old under apple blossoms? No. The tangasm is not like that. It is out of time. I don't see any future or past. There is no place for it, because the present is perfect and complete. It is all here, in these twelve minutes we have together, which become twenty-five, then

71

sixty, then three hours. I merge with him, and together we merge with the music.

I'm only human, and I'm also twenty-seven years old and single — so I want it to go on. How can you *not* want it to go on? You'd have to be a pervert. But at midnight, the music is turned off and we're saying goodbye, see you next week, and I'm driving home through empty suburbia.

On my stereo is playing an instrumental version of 'El día que me quieras'. It's the conditional tense — the day that you *would* love me. I'm now teaching myself Spanish, but I'm not paying attention to subtleties of language or symbolism. I'm not thinking at all. I'm feeling, and what I feel is an aching need to dance with him as soon as possible, and that until then, I will be incomplete.

We dance again. We start practising together in the big suburban studio. And then, when the studio closes and the midnight milonga closes, we continue practising — to Di Sarli and Pugliese, romantic orchestras from the 1940s — in his bedroom. We'll just practise this giro and that ocho in the bedroom, we tell ourselves and each other. Next to the bed, the singer of 'Just One Time' warns us again in his tragic voice about his

love that turned out to be nothing.

It's *just tango*, we tell ourselves, as we shuffle closer to the edge of the bed, and over it. In an ideal world, this should be the beginning of a beautiful Tango Relationship. But it isn't.

As soon as we let go of the tango embrace and start talking, something resembling the Tasman Sea opens up between us. We are no

longer tuned in to the same music. I'm unsporty, and I live among books and films, pining for Europe. Silvester is an athlete interested in microchips and Asia. It's not going to work. Outside the dance floor, we are not actually in love. After a couple of weeks, it's over. But Silvester is as honourable as he is gifted, and we keep dancing together even after it ends.

Meanwhile, a growing number of us are flocking to Cecilia's classes in an inner-city studio above McDonald's, where we go back to basics, which is to say we are not learning sequences, but relearning technique.

'Feet pointing in the same direction, like skiing!' Cecilia conducts the pack with a metronomic snap of the fingers and a radiant smile, her breasts showing the way like friendly grenades.

'You are moving smooth. You are not bobbing like cork! You are not sinking like the *Titanic*!'

We are all bobbing and sinking, of course; all except Silvester, who will never sink and who is soon partnering Cecilia in the classes. Cecilia wears her open-toe shoes with Silvester now – a mark of the trust she places in him. Together, they make a couple so solid and well-fitting, they are a live monument to the perfect close embrace. I am not allowing myself even a twinge of tango jealousy, because Cecilia lights up my world with her smile, and Silvester and I are still dancing, our tangasm blissfully – and a bit painfully – intact.

And so the time comes for Carlos Rivarola and his mate gourd's annual visit.

'Is very nice to be here again,' he smiles at the gathered congregation of admiring tangueros, and we want to believe him.

This time I am a tango-year wiser, and I understand why dancing with him is like dancing with the angels. Because he can slip you in and out of a close embrace without you even noticing, and he never allows you to feel as if you've fluffed your steps. He absorbs your moments of ugliness, and makes your moments of grace stand out. He is not just a maestro; he is a gentleman.

I am smitten with him all over again, naturally, and when James and I take a private lesson with him, and he tells me that my legs must be more 'like elastic' and less 'like wood', I'm so desperate to get it right and earn his approval that I stiffen up even more. I'm turning into Pinocchio, but Carlos smiles forgivingly.

'*Muy bien!* Just relax, enjoy. Is tango, is to enjoy!'

This is what I've forgotten to do. It's impossible to get the best out of tango – or yourself – if you are not relaxed. This is why Tim Sharp looks like he is still ice-skating for New Zealand – because he can't relax. It's not in his nature. And yet, Tim Sharp, like Silvester, is a brilliant leader, and I still haven't figured out why.

I find out in Carlos's last class.

'He has the correct posture,' Carlos says. '*Estampa.*'

Silvester and Cecilia are demonstrating something called *ocho cortado*, an interrupted ocho. It is a space-saving staple of social dancing, and one of tango's oldest moves.

'For tango, the man needs estampa,' Carlos says again.

'Attitude. Poise,' Cecilia translates. My translation is 'tango-stamp', and I can see only three men in the studio who are tango-stamped: Carlos, who looks like what he is – a professional dancer; Silvester, who has the physique of Rambo; and Tim Sharp, who is thin and sharp. They share nothing except the tango stamp.

74

'And is leading with the chest, sí?' Carlos goes on as Silvester and Cecilia dance. 'No with feet, no with hands, but with breast and inside the breast is the heart. Sí?'

He smiles at us. We blink and gulp. Sí, the heart.

Even though I'm a tango-year wiser, I am not much wiser in any other way, which is why I find myself sharing a lunch table with Carlos and spluttering into my sparkling water, while he patiently corrects my Spanish ('you are here', not 'you is here').

In my ungrammatical Spanish, I want to speak to him of loneliness and desire, but instead I gaze out to Waitemata Harbour, which in Maori means 'glittering'. The whole thing does glitter, gulls float in the lazy air; it's lovely. And yet my spirit is back in Buenos Aires, in the darkened salons with their faded plush and cigarette burns. And Carlos is an embodiment of that tango world for which I yearn. Psychologists might call my attraction to him transference: a displaced emotion. I might call it misplaced emotion if I'm kind, and good old lust if I'm not.

Carlos continues to be a gentleman off the dance floor, and nothing *too* untoward happens between us. But what happens is enough to give me pangs in the 'breast' region later, when he is gracefully gone and the city seems empty again.

Tango is meant to be a perfect balance between desire and control, hello and goodbye, intimacy and distance.

It's meant to be, but it isn't. Not for me. Desire always unbalances me – and that's exactly why I've taken to tango so readily. Tango was *invented* by people with too much desire. It was invented by those dispossessed, woman-starved early migrants and no-gooders in the porteño slums, to express their homesickness and their woman-sickness,

75

so they wouldn't blow up. And the women they eventually danced with were also residents of the urban twilight – brothels, factories, bars, streets. In short, tango has always been for people who are hungry for something.

And Auckland seems to be full of them. Our burgeoning community is buzzing with people who sooner or later fall into the tango honey-trap like starving bees. The dramas are played out most visibly in a Viaduct Harbour café called Limon and owned by Turks. Here, Auckland tango society gathers once a week. When he isn't observing the dancers with the face of a well-groomed alligator, Limon's owner eats spaghetti and reads Dostoevsky in Turkish paperback.

On the wall is a giant painting of a tango couple. They look either about to have sex or kill each other. The Lebanese artist who painted it – a moody heart-throb – pops in from time to time, to have a few smouldering dances in his flip-flops, and leave a trail of stricken wait-resses all along the waterfront as he walks past.

We tangueros are a hotchpotch of oddballs, cultural hybrids and shipwreck survivors. The odd 'normal' person dilutes this exotic brew, like Geoff and his girlfriend, though she is no longer his girlfriend, because there are *complications*.

There are always complications in tango. Even when you're not married to someone else. Then it's even worse, because the compli-cations are invisible. There is just no way around it: tango attracts complicated people.

Here, for instance, is baby-faced Gerry from Ireland. He is a psychologist and he is dancing with a beauty of Dutch-Portuguese origins. He is here because he got married to a local who produced a

child just in the nick of time before the marriage collapsed. This seems to be a familiar scenario for foreign men in Auckland. Gerry used to say he'd rather be somewhere else. He stopped saying this when he married the Dutch-Portuguese, who would turn up to tango events wearing different wigs, in order to feel 'like someone else', she said. They divorced a few years later.

And then there's Anoush, an Armenian New Yorker with a lived-in face and heart. She is a dance clothes designer and advertises her own merchandise with panache. Her low-cut necklines and belly-revealing openings leave little to the imagination. Her nails are always brightly painted, and her dance style authentically milonguero. She is the best and most experienced social dancer here.

'You've been to New York, Kapka. You know what it's like to dance there. You can understand how I feel here. But don't let's get me started on that. I'm here for him and he's worth it.'

'He' is her husband, Tam, a cheerful Englishman and long-time Auckland resident who went to New York on holiday and came back with Anoush and a radical image makeover. From a fumbling home-body, Tam was transformed into a sleek, black-T-shirt-wearing tanguero.

In no time, Anoush is crowned queen of Auckland tango. She is running her own tango classes and milongas, vying for turf in the tiny local scene already busy with self-anointed gurus who have suddenly popped out of the woodwork and are running their own close circles of students. This includes a small Argentine with a Napoleonic personality who reigns over the desperate housewives of the North Shore. They arrive at Limon like extras from a David Lynch film – the diminutive teacher with a gaucho-like goatee and tilted bowler hat,

and his retinue of feather-boaed middle-aged women in thick make-up and pinched designer dresses. They are having a great time, even if Geoff mutters through wine-stained teeth: 'With every step they take, they murder tango.'

Anoush observes them under her hooded eyes and raises a brow at me. In her lacy dominatrix shoes, with all her best intentions, she runs her milongas not unlike community hall projects, with birthday cakes, pizzas, balloons and regimented swapping of pairs. I don't enjoy these events; they make me feel like the Lonely Heart I am. But she is passionate about it, her students dance well and, above all, she has a sense of humour.

'You know, Kapka,' Anoush says, 'today I had this new guy in my class. He's real well turned-out, smart like a dandy. And he says to me, "What animal shall I be?" I said, "Just be yourself." He said, "No, I need to be something. What should it be, possessing the woman like a tiger? Or seducing her like a snake?" I tell you, there are some crazies out there. Boy, I have such fun.'

Not everyone here does fun. Rachel, for instance, is only in her mid-thirties, but you'd think her life was over, and she is now biding her time in some draughty waiting room of the afterlife. She drifted here from Germany on a freak El Niño current years ago. Rachel's clothes come out of a melancholy valise from a previous century: she likes to put a paper flower in her hair, or wrap a fringed Gypsy shawl around her waist, but no amount of decoration can dispel the accusatory sadness of her face. Unhappiness has become her signature style. On the rare occasions when she loses her composure and laughs a brittle laugh, you fear it's the beginning of a nervous breakdown, but she quickly checks herself.

78

She gives me the uneasy feeling that I've done something wrong. It's a certain female look I came to recognize later, in other tango villages; a look that says, 'I'm unhappy, and it's your fault.'

Still, you can't help warming to Rachel. She's an Austrian Jew and exile is in her blood. She likes to mention the 'best times of my life', all of them firmly lodged in the past. Dancing at brilliant milongas in Germany, working with 'experimental' theatre troupes in Berlin . . . those were the times. At one point, she disappeared. She had gone back to Vienna, and everybody assumed she wouldn't return. But she did.

'Rachel, we didn't think you'd come back,' we said.

'But I live here!' she protested. 'I was just visiting Europe.'

'No, you don't live here,' we corrected her. 'You exist here.'

She actually *laughed*. She'd had a marriage proposal from a wealthy guy in Italy. She was visibly cheered up by this.

'But I did not love him. I tried, but I couldn't. I stayed in his villa in Tuscany. You cannot imagine. But I cannot marry without love, I am too romantic.' She laughed, pleased to be a romantic, then she lapsed into memories again. 'Oh, the house was amazing. Europe was amazing.'

I wondered if she reminisced like this about New Zealand while she drank Chianti on a Tuscan terrace. 'Oh, the west coast of Auckland! The black sand. You cannot imagine.'

The thing is, I could, and only too well, because Rachel was me taken to a dangerous extreme. She was Chronic Longing gone nuts. She was a warning to all of us Antipodean tangueros locked in some fantasy of elsewhere. Tango was the voice of a siren. It drifted across the empty Pacific and the empty city streets from some mythical,

eternal tango capital of all-night dancing and sensual inebriation. If you listened to that voice long enough, it pulled you down and drowned you, so we clutched at each other like driftwood.

Class, practica, milonga. Milonga, practica, class. As with all addictions, it was hard to say whether my need was physical or psychological. I had Silvester and the Limon crowd and the constant soundtrack of Pugliese, Di Sarli and Piazzolla, but life outside my dance routine was a blur. My past was locked away for safety. My future was unknowable. My life was a collection of fragments. The only thing I liked about my present was tango. The only thing I liked about *myself* was tango. I was overflowing with all sorts of yearnings, but I didn't know where to put them — except in tango.

Haunted places are the only ones people can live in, someone said. Auckland wasn't haunted enough, but tango was. So we made it *our* place and inhabited it as much as possible.

Then, one night, in shuffles a familiar balding figure with an extinguished cigarette.

'It's Clive James!' someone gasps. And so it is.

'Tango in Auckland!' he drawls. 'It's my lucky night.'

He's mocking us, but that's what Clive James does. He was mocking himself, too, in that 'Postcard from Buenos Aires' episode, where he's learning a few basic steps with Gustavo Naveira and fudging it.

But wait, he is asking me to dance. It's Pugliese time, which means high drama. His lead is good, and he has nice musicality, but . . .

'Something tells me you've had a few drinks,' I say after the first tune. I'm being rude, but every tanguero knows that drunk dancing is like drunk driving.

'And something tells me, young lady, that you have a nose like a paper cutter,' he shoots back. 'And the tongue to match it.'

It's the beginning of a beautiful friendship. It will feature cigar-smoking, eating, reading, writing, poking fun at people and ourselves, and occasionally tangoing. The kind of friendship that outlasts many other beautiful things in life – as it will turn out.

Another night, a new man stumbles into Limon. He is shy-smiled and blurry-faced. He sports an equally blurry tattoo on his bicep. We dance to Gardel's most famous song, 'The Day that You Would Love Me'.

His name is Jason and he fits straight in because, like all of us, he seems to be looking for something. We talk, something clicks, and I experience a blinding pain akin to a stroke: love at first sight. And, naturally, I imagine that the thing he is looking for is me.

The Day that You Would Love Me

TANGO LESSON: DISCONNECTION

By the time I meet Jason, I've been dancing for a year and I am pretty certain that tango is not really about what goes on with your feet. In fact, it is beginning to dawn on me that tango is not really about anything that can be seen or touched. The bandoneon, the shoes, the trodden dance floors, the bodies of those we dance with, our own bodies – all this is merely the surface.

Speaking of bodies, let me say now that I didn't experience anything resembling a tangasm when I had that first dance with Jason. We didn't even have a good fit. He was too tall for me and he danced open embrace, which could have worked, but didn't, because his lead was half-hearted, as if he was unsure about the whole thing. As if he was only half there and could change his mind at any moment and drop it. Or drop *me*, which amounted to the same.

Despite this, something about Jason struck a perfect note in me. If

someone had asked me what I'd been looking for in tango and in life, I would have said: *this*. To feel *this*, with someone.

To share tanguidad. Tanguidad, it turns out, is not the same as tango estampa, which is about posture, musicality and the way you move. Otherwise I would have had *this* with Silvester and with other great dancers, like Carlos Rivarola. No, tanguidad is not of the body. It is of the spirit.

Jason had tanguidad in spades. He was always smiling, but sad. He was here, but wanted to be there. He was a data analyst by profession, but he left little notes for me, quoting Borges, Neruda, T. S. Eliot and tango lyrics. On his bedroom wall, he had a portrait of a bespectacled Pugliese. On my bedroom wall, I had a photo of Piazzolla with his bandoneon. We were both exiles from our own lives.

The symptoms of our shared condition were apparent from the start.

KK: 'So, why did you quit London?'
JASON: ''Cause I was a hamster on a wheel. The only thing I enjoyed was going to tango. And I kept thinking of good old NZ. I was missing my surfing.'
KK: 'Well, the lifestyle here is great.'
JASON: 'Yeah, I'm not so sure now. London tango is amazing. The Dome, the Zero Hour milonga. With real Argie teachers, like Gavito. And here . . . in the land of the passionless people . . .'
KK: 'You can make your own passions. You have old friends here . . .'
JASON: 'Yeah, they've all vanished into mortgages. I'm listening to tango, and they're listening to the humming of fridges. We don't share much any more.'

KK: 'You can make new friends. There are good people at tango.'

JASON: 'You shouldn't get too comfy here. You should have your sights on Europe. You're cosmopolitan. You'll wither and die in suburbia.'

KK: 'I know. I miss Europe horribly. Do you miss Buenos Aires?'

JASON: 'I had the best two years of my life there.'

KK: 'Shall we dance? It's Gardel!'

JASON, sings with an ironic smile: '*El día que me quieras . . .*'

If every Tango Relationship has a soundtrack, then ours was 'Vuelvo al sur' by the fusion band Gotan Project. Someone in London sent Jason their album *La Revancha del Tango* (best translated as *Tango Gets Its Own Back*), which started a new global tango craze. It was electrifying electronic stuff based on original music, featuring Evita's and Che Guevara's voices, and lyrics that attractively mangled politics and poetry. By now my Spanish was just about good enough to make sense of them. The song 'Vuelvo al sur' struck me especially. It was about the South – about returning to the South, 'Like I return to love / With all my fear and desire'. We played it over and over.

'Vuelvo al sur' – in the psychedelic light of Pacific summer.

'Vuelvo al sur' – along the black-sand beaches of the west coast, where *The Piano* had been filmed.

'Vuelvo al sur' – as Jason decided to practise a giro in the outgoing ocean tide.

The South would release us from this terrible business of longing. The trouble was that we were already as far south as you could go without falling off the map.

'I *have* fallen off the map,' Jason declared one weekend, when ocean

and sky were a carefree blue dotted with the specks of sails and clouds, and we were sipping cappuccinos. 'Maybe that's all that's left once you turn thirty. Give up your dreams. Surrender to suburban mediocrity. Or run off to Buenos Aires.'

'Then let's go,' I said. A friend of his was getting married in Uruguay in a few weeks' time. 'Let's go to Buenos Aires. Make it a month. We have the time, and we'll find the cash.'

'Oh Time, Strength, Cash and Patience!' Jason quoted. He was good with quotes, and this one was from Herman Melville.

(*Pausa*: Poor Melville didn't suspect that he was writing about the tango condition. But tanguidad predates tango itself. *Moby-Dick*, with the ship out at sea like a soul on a quest for the unattainable, is essentially a tango story. Trust me.)

'Do you know what's happening to the Argentine economy right now?' Jason said, and this wasn't a quote. I did − it was on its last legs − but I wasn't going to let small details like this get in the way of my happiness. So we went.

Two things were taking place in Buenos Aires when we arrived: one, the catastrophic collapse of the economy; two, the Annual Metropolitan Tango Championships. Soon, a third thing was happening, which concerned only Jason and me, but first things first.

The economic meltdown was evident from the moment we arrived. The giant graffito sprayed across the Town Hall − IF POVERTY IS LAW, VIOLENCE IS JUSTICE − was hard to miss. Night and day, crowds of *cacerolazos* − pot-and-pan bangers − spilled into the streets and banged their anger against, yes, empty pots and pans. Their life's savings had suddenly disappeared into the phantom pockets

of an elapsed state. They smashed the exquisitely reliefed façades, the shop windows, even street lamp posts. The empty banks were boarded up with metal sheets that shone in the midday sun with an accusatory glare. The homeless, zipped up in sleeping bags, slept in the underpasses beneath Avenida 9 de Julio, where a dank underground city teemed with kiosks, souvenir shops, shoe repairers and fast-food joints. At nightfall, scavengers came out to sift through the rubbish bins.

Police in bulletproof jackets stood at every corner, looking close to tears – because, like everyone else, they were stuck in the hated bank *corralito*, penniless. The peso, divorced from its union with the US currency, plummeted further every day. The change bureaux in town were besieged by desperate citizens trying to salvage their dollars. Cash machines ran out of cash. No other currencies could be changed because the peso had no official exchange rate against the dollar. Nobody knew the real cost of things.

This was the year of *bronca*. Bronca is a special porteño phenomenon – a cocktail of urban rage and bad faith. Bronca and bankruptcy – this is what greeted us on arrival.

And what did Jason and I do? We checked into a cheap belle-époque hotel called Astoria, on Avenida de Mayo. We were the only guests. Our little balcony looked out onto the grand avenue. At the tops of buildings, the fantasy cupolas crumbled like meringues from some long-ago party, and pigeons flew out of their broken windows. Leaning over the wrought-iron railing, we watched the city's collapse with a mix of morbid fascination and disbelief. It was the end of an era, the end of Buenos Aires as we knew it.

In our hotel room we flicked the TV channels for hours on end,

from the news station, to the Modelling and Plastic Surgery channel, to the non-stop tango channel, where it was business as usual.

'*Queridos amigos del tango* . . .' The programme host showed us his plastic smile that revealed artificial teeth. *Dear friends of tango* . . .

That was us. Friends of tango. Wedding guests. Graham Greene characters in a troubled foreign country: decent but ineffectual, well-meaning but screwing up already, with a creaking fan overhead and failure just around the corner.

In the evenings, we walked for miles to go dancing, because traffic was blocked by demonstrators. And it was in the milongas that things between us began to fall apart. Night after night, Jason sat in the tango clubs looking like the Argentine economy.

'We're in crisis,' he kept saying with his apologetic half-smile, quoting the Argentines' favourite phrase of the day, '*Estamos en crisis*.'

He gazed at the dancing couples, and it seemed that even here, at the heart of Tangopolis, the present simply couldn't deliver. He was stuck listening to the broken melodies of the past – his own, the city's – and he was seized by some incurable heartsickness.

Jason wouldn't dance with me because his dancing was 'in crisis' and he didn't want to subject me to it. But because we were sitting together, no other men were asking me, either. It is against the etiquette to snatch women from their table escorts.

Now, there is something I must explain about the passing of time at a milonga. It's a little-understood anomaly of astrophysics. When you (the woman) really want to dance and are waiting to be asked, and nothing is happening, time slows down to an arctic chill of the soul. It slows down to about the rate at which glaciers form. It's the tango equivalent of hypothermia. You feel your pulse and respiration

rate slow down, eventually resulting in death by tango neglect. Meanwhile, everybody else is literally having a ball.

Somehow, Jason's dancing crisis didn't completely prevent him from dancing with other women. He would get up slowly, apathetically, and dance with another woman for a few tandas. I could only pretend for so long that this didn't affect me before I went into fits of jealousy, which I stifled like sobs against the smoothly shaved cheeks of the men who finally asked me to dance. But I couldn't enjoy them either, because Jason was on my mind, and worse – on my heart.

I was caught up in the Freudian cycle of hysterical tango behaviour. I was somewhere between stage 3 (rejection) and stage 4 (fall), painfully fuelled by 5 (longing). And, I hate to admit it, but the psychoanalysts were right. At least, that night they were.

'*Odio este amor . . .*' I hummed to myself alone at my table ('I hate this love') while the song 'Humiliation' played and two hundred people enjoyed dancing to it in La Viruta which suddenly sounded to me like some kind of dermatological condition. This was the exact opposite of the tangasm. This was Tango Hell.

'This is making me unhappy,' I said in the taxi. It was 1 a.m. and the demonstrators had gone home, while tangueros were dancing the night away.

'I resent being responsible for your happiness,' he snapped.

'You should be worried about *your* happiness,' I snapped back.

'If that's the way it is . . .' he said.

'Where are you from?' the taxi driver interrupted in Spanish and turned down the song that was playing on the twenty-four-hour tango station. It just *happened* to be 'Rencor'.

'New Zealand,' I said rancorously.

'Is it easy to emigrate to New Zealand?' the poor man asked.

We had no idea, we were trying to get *away* from it, for God's sake. But this reminder of someone else's real – as opposed to self-inflicted – desperation shut both of us up.

Jason went back to the hotel room, and I stormed off into the darkness of the backstreets, hoping that he wouldn't let me wander by myself. But he did – why wouldn't he, if he'd let me sit for hours at the milongas?

(*Pausa*: To be fair, he'd let me sit on my own so that I could get dances with other men, since his own dancing was in crisis. But I wasn't thinking rationally. I was in love with him, and I wanted to dance with him, end of story.)

The *cartoneros* were working their way through the garbage, and shouted half-friendly obscenities at me. It'll serve him right if I get sexually assaulted now, I thought. I sat on a window ledge among the broken pavement stones and the rubbish, and indulged in self-pity.

Buenos Aires was no longer what it had been, and neither were we. Our Tango Relationship was born of this dance, and yet the relationship was now taking the magic and the beauty out of the tango. Just as bronca was knocking the Good Air out of Buenos Aires.

While I sat there feeling sorry for Argentina and for myself, and secretly hoping that Jason would appear and single-handedly save both, or at least one, a man appeared out of the doorway. A red light shone on the inside. I looked at the sign above the door. It was a pornographic video joint.

'You OK, *bella*?' the man said. He was clutching some videos. He wore battered cowboy boots and his face sagged. 'Are you waiting for someone?'

'No,' I said bitterly. 'Because he's not coming.'

'So he's not worth waiting for, is he?' He turned to go, then stopped and turned to me again. 'Nothing's worth waiting for, if you ask me. Nothing and nobody. I used to fall in love, but after I got my heart broken a few times, I learnt my lesson. Ciao bella, go home.'

Somewhere in the night, sirens were wailing. I took the man's advice and went home to Jason. He put a desultory arm around me, and we watched some more TV feet doing embellishments. *Dear friends of tango . . .*

Things improved when Jason went to Uruguay. I stayed behind – weddings have never been my thing, even other people's. Besides, I couldn't possibly miss seeing the Metropolitan Tango Championships for the Province of Buenos Aires. This was close-embrace, social tango, in which amateur couples showed off subtleties of technique instead of their inner thighs as they did in show tango. The initial selection happened at the regular milongas.

I went to a central city club called Porteño y Bailarin (best night: Thursday). And there, by a stroke of luck, because I was the only foreigner, I was introduced to Mercedes and her friend Mario. Mario was a car dealer in his forties with a sharp cream suit and a matinee-idol face, and his eyes were full of something I'd never seen in a car dealer before: irony. It was an urban, porteño irony, the kind that comes after twenty years of frequenting milongas. I already liked him, and I instantly adored Mercedes, who was a diminutive, septuagenarian milonga institution. She was a former ballerina and she had seen it all, which didn't stop her from wanting to see it all over again.

She invited me to sit at her table, always at the front, in the centre of the action, always with a bottle of champagne cooling in a bucket,

her thin lips immaculately lipsticked. She danced a tanda or two per night, but mostly she sat by her champagne bucket and provided a running commentary on the dancers' styles for the benefit of those sitting beside her.

'Oh my God, here comes the hunchback of Notre Dame! Look at that posture. Staring at the floor the whole time – is he looking for coins? Now, see that human ruin with a rat's tail for hair?'

She pointed towards an infamous milonguero known as el Tano, the Italian. He wasn't Italian, though, he was from here, and the tango grapevine had it that he'd been a carpenter and a family man in Milwaukee, but his thirty years of respectability were well and truly over now, and he was back in the city of sin as a single man and drug dealer. He paraded his pregnant paunch through the milongas seven nights a week, his shirt spotted by sweat-stains. He chewed drugs, grimaced at invisible rivals and ceaselessly lip-synched to the songs, which he knew by heart, every single one.

'He's a crackhead, el Tano,' Mercedes continued. 'But he always plucks the young birds. And they dance with him! Really, women are idiots.'

'Oh, Mercedes,' Mario objected, but it was impossible to object to Mercedes. She was always right. Even so, when el Tano lurched my way to invite me later that night, I endured Mercedes's withering gaze and joined the ranks of idiot women. I was curious.

The truth is, it was hard to look at el Tano when he was dancing with some long-limbed nymph, and not to believe in . . . well, something good. He had a blissed-out, faraway look on his grey face, and a careful arm around the nymph's bare back, while lip-synching to, say, a waltz called 'My Soul'. Even in his own words, he was *un viejo de*

mierda – a shitty old man – but he embodied the tango principle: that you could be a bloated frog out in the street, but inside the magical milonga, where you knew every song, every square inch of the floor, and every beat of the *compás*, you could be redeemed, for twelve minutes at a time.

After a vivid couple of milongas, during which he marked every single beat and made *me* sweat for a change, I asked him, 'Why did you come back to Buenos Aires?'

The next milonga was beginning. He glanced at me with glazed eyes before he picked up my hand again.

'*Con el lungo Pantaleón / Pepino y el Loco Juan* . . .' he said, and went on in the same spirit.

I didn't get any of it, but I got two things. One, it was *lunfardo*, the urban jargon of Buenos Aires, which nobody understands except old porteños like him. Two, it was the first lyric of the cheeky milonga playing now, which was called 'Un baile a beneficio' ('A Beneficial Dance'). He lip-synched the entire song in my ear, which was a tour de force, but it was also a coup de grâce that released me from my fascination with him, because I lost all desire to dance with him again.

(*Pausa*: Men who lip-synch, hum, moan or make other disturbing sounds while they dance with you are a special category that knows no national borders. This unsolicited musical accompaniment delivered in your ear is always, without exception, a turn-off.)

Back at Mercedes's table, I felt chastened, and she pointedly made no comment. Mario lifted his eyebrows at me in his ironic way. You'll know better next time, they were both saying.

'Mercedes,' I asked breezily, trying to restore peace in the wake of the el Tano fiasco, 'what are the dance rules of the championship?'

'There's two categories, social and performance. In the social, you're not allowed any moves *above* the knee. No ganchos, no funny business.'

'In the performance, though, you don't see any moves *below* the knee,' Mario sneered. Like Mercedes, he was a passionate exponent of the close-embrace milonguero style.

'Oh, and who do I see, hounding for fresh blood, now that he's single?' Mercedes's eyes were on a glamorous dancing couple.

The man, a famous dancer called Ricardo, had a long ponytail, and in his shiny black jacket he looked like a successful pimp. The woman was a French air hostess with smoky make-up and the cold fire of the tango addict in her eye. She had approached me earlier, after I'd danced with Ricardo.

'How was it with him?' she asked.

'Nice,' I'd said casually, as if I danced with Ricardo every night of my life.

'He rarely comes out to the milongas,' she said. 'But I guess now he's single, he'll come out more.'

I thought she would introduce herself, but she wasn't interested in me at all. She didn't look at me once – her made-up eye was on Ricardo the entire time, trying to catch *his* eye.

(*Pausa*: This is why we've met so few women so far. A woman dances with men, and therefore meets the men. Women compete for the best dancers. Same-sex friendships are only made over time, in stable tango communities.)

'Ah, and now we've got a kangaroo!' Mercedes observed. She was looking at a bespectacled dancer with a ponytail and a slight bounce to his step.

'Australian tango!' Mario sniggered.

'I can't decide if he is leaping or bouncing,' Mercedes mused. 'Either way, kangaroo tango is bad news.'

But the guy was having fun, and when he asked me to dance later, I was pleased. He had a strange way of tugging at my waist with his right hand, as if my body was a double bass or a harp – which made sense later when I found out that he was, in fact, a professional contra-bass player. Anyway, he danced with great panache. He also looked foreign.

'No, I'm not foreign,' Darío said. 'I'm one hundred per cent Argentine. Which means one hundred per cent mongrel. I live in Brazil at the moment.'

His Brazilian psychoanalyst wife was here, too, looking miserable when he danced with other women – which he kept to a minimum 'to keep the peace' – and just as miserable when he danced with her. I thought, guiltily, that she and Jason would hit it off straight away.

'It's impossible to have a good time when you're with your partner,' Darío said between tandas. 'You *have* to go dancing alone. It's the nature of the tango beast.'

Next time I saw Darío at the famous Salon Canning (best nights: Tuesday, Friday, Saturday), his wife had gone back to Brazil.

'I'm relieved, frankly, 'cause I can't relax when she's around. But, Kapka, why this face? Let me guess: your man hasn't called from Uruguay, and it's been a week.'

I nodded. I was smoking the last of my cigarillos and teetering on the verge of tears and on the edge of my new sandals, which had 7.5 centimetre heels *and* open toes; a watershed moment in a woman's dancing life. The sandals had a mesh front made from strips of black velvet. That evening, I was being a melodramatic caricature of a

tanguera, straight out of a song. 'Malena', perhaps, because that's the song they were playing just then — Malena who 'sings like no-one else', Malena who has 'the bandoneon blues'.

Malena is the classic tragic tango heroine. In typical tango-grapevine style, her story is subject to endless speculation. One of the legends is that poet Homero Manzi saw a singer called Malena de Toledo doing a tango on stage, and was so smitten with her, he imagined a story for her and wrote one of tango's most poignant songs. Years later, when the 'real' Malena heard the song, she was so stunned by it, she gave up singing. Malena killed her own prototype, you might say.

'I'll have your cigarillo box, if it's empty,' Darío tried to distract me. 'My wife collects them and I want to keep the peace. But anyway, you know this won't last for ever, don't you? You won't always be in love. The good times will come back. I know about these things. My wife has analysed me.' He winked. 'I kid you not. Meanwhile, we have tango, thank God, or rather, thanks to Pugliese. God has never done anything for me, but just *listen* to Pugliese! Come on.'

As we set off around the room, I realized that Darío was right. Even though his tugging on my waist was bothering me a little, dancing made me happy. Being in love made me decidedly unhappy. Conclusion: dancing and being in love didn't go together, against all instinct, and despite all appearances.

Tango *looks* like the dance of love. It *feels* like the dance of love. It *sings* of love. Love is tango's ultimate carrot. But try to take the song outside the dance hall and you end up with the stick. This was my momentous and melancholy discovery of the night.

But Darío was ahead of me with his tango philosophy.

'Tango is a product of crisis,' he said in between dances at our table. He was mopping up his myopic face with a large hanky.

'Crisis of identity,' he continued. 'In the old days, it was the identity of the nation. Now it's masculine and feminine identity that's in crisis. You know, how the sexes relate. That's why it's still a dance of the margins, because it's subversive. The lawyers, doctors and bankers who come here often hide it from their colleagues. It's their dirty little secret.'

'But what about couples? Couples dance, too,' I said. We looked at each other and laughed mirthlessly.

'Exactly,' he said. 'Couples dance, too. And tango *amplifies* the couple. That's subversive, too. If one or both people are happy, the tango couple is fantastic. If one or both are unhappy, it's a nightmare. And I don't need to give you examples. Do you know the Spanish word *desencuentro*?'

I didn't, but I should have, because it described perfectly what was taking place between me and Jason. Desencuentro is the opposite of an encounter: a mis-encounter, a disconnection.

'Dancing?'

It was an attractive man in a tweed jacket. He had a sun-toasted face and an ascetic's peppery beard, and before dancing, he removed his glasses, folded them and put them in his top pocket. He danced tightly and intimately, the way I imagined he made love, and our fit was made to measure. He told me he was a landscape painter specializing in the Pampas, and that was the end of the conversation. He was twice my age, but this didn't stop me from noticing that he was the embodiment of the classic, old-school milonguero porteño that

96

you simply don't find in any other country: subtly sexy, serious, silent.

(*Pausa*: Conversation ruins an exceptional dance, because an exceptional dance already contains all the conversation you need. And here's something curious on the origin of tango's trademark silence and seriousness. The origin, some say, is the Kongo, a region in west-central Africa. Kongo dancing favoured silence and frozen expressions, to preserve the body's energy. It also favoured blatant sexual moves, like the *quebrada*, a twist of the hips and bending of the knees. But how did the sexy quebrada, along with other Afro-moves, and along with silence and seriousness, make it into habanera and tango? Through Creole dancers in the black suburbs of Buenos Aires and Montevideo.)

But conversation or not, serious or smiling, sexy or subtle or both, here is the truth, *dear friends of tango*. Social tango makes us happy because it is a flattering distillation of our selves and the selves of others. We never have to show or see the dingy details. Social tango is the promise without the flawed delivery. The night of passion without the morning after. The *encuentro* without the desencuentro.

We should always leave it at that. But we are weak. *I* am weak. Even milonga-smart Darío, with all his theories, had met his wife at tango, and in a moment of weakness had married her and moved to Brazil. We stayed in touch, and the following year he wrote to tell me they'd split up and he had moved back to Argentina.

Meanwhile, whether I wanted them or not, desplazamientos were the theme of the tango season in Buenos Aires, or in any case, they were for me. And I learned them from no less than the famous 'king of the gancho': el Pulpo. This means 'octopus', and fortunately it wasn't his real name, just his nom-de-tango.

(*Pausa*: Hardcore milongueros traditionally have nicknames in the old macho *compadrito* style – el Indio, el Tano, el Chino, el Turco, el Flaco (the Thin One), el Pulpo. The same goes for milongueras. In the early days when tango belonged to the underworld, it was danced in 'establishments' that carried the names of female personalities-around-town, with nicknames like la Turca, China Rosa, Maria the Basque.)

Pulpo and his partner, Luiza, had a predilection for tentacular leg entanglements. At first, to my still crude gaze, this peculiar style looked like one continuous gancho followed by one endless sacada, as if his legs had somehow become stuck to Luiza's via some gluey secretion.

On closer inspection, they were doing a series of fluid displacement moves, which did feature ganchos and sacadas, plus an innumerable array of other displacements and semi-displacements, like *enganches*, *suspenciones* and God knows what else. It turned out Pulpo was making it all up as he went along.

Pulpo belonged to the experimental tango Nuevo generation of dancers, but he also went two generations back. His father and grandfather were bandoneon players, which means a century of tango in the family. Still, he managed to look as if he was just fooling around while tango DNA floated in his blood. In other words, he was a rare thing in this tango world of imitators, monomaniacs and elephant-ine egos: a down-to-earth original. He was the best of the new wave.

This is what made his teaching style so refreshing, and why I kept coming back for more. He and Luiza had young apprentice couples in the class, affectionately known as the Pulpitos. Pulpo and Luiza's

creative coupling was producing little octopi who were already doing 'exhibitions' in the regular milongas.

The classes were in La Catedral, the grungiest alternative tango club. Its rickety floorboards were a health and safety hazard, its toilets were bursting with graffiti and more, its bar was trippy and hugely popular with the young crowd. Soon, in search of oblivion, I was taking up permanent residence in La Catedral. I was there for Pulpo's late-afternoon class, then the evening practica and on to the milonga, which went into the small hours.

Outside: bronca and bankruptcy. Inside: hugs and music. In the milonga, it is party time all year round.

Pulpo liked to play non-tango music in his practicas, just for the hell of it.

'If you can dance to Gotan Project and U2, you can dance to anything, and then you're free,' Pulpo said. 'Off you go.'

This is how I found myself wrapping my legs around the shins of an enormously tall American to the sound of 'Where the Streets Have No Name'. Hang on – he looked familiar.

'Rupert from New York!' I said. 'What are you doing here?'

'Hello, cupcake,' he said. 'I'm doing the same thing as you. Nice shoes.'

I was strangely pleased to see him, as if he were a long-lost friend. We had a drink (of sparkling water) later on at the bar.

'You know, I have an apartment here,' Rupert said. 'In Avenida de Mayo.'

'That's next door to our hotel!'

'I'm not surprised,' he said.

'But that's such a coincidence!' I insisted.

99

'There are always coincidences in tango. When you've danced long enough, you'll see. You keep crossing paths with people in weird places. It becomes a small world.'

He was right. That same night, I bumped into Nathan from Wellington and got 'Nathaned'. He'd been here for several months, haunting the milongas seven nights a week. He didn't miss a beat. He was an old hand now.

'Anyway,' Rupert said, 'come and see my apartment. My plan is to be here a few months of the year. Other than that, no idea.'

Perhaps this is what drifting tangueros with too much money ought to do: buy a flat in devalued Buenos Aires while the crisis was on. Before he'd left for Uruguay, Jason had been looking at flats, too.

'What I need is a base here, so if all else fails, I have somewhere to come,' he'd mused, as desperate estate agents rushed ahead of us with the keys to flats that were on offer at ten times less than their normal price. We'd seen a few apartments, mostly in San Telmo where all his memories were, but he hadn't been able to make up his mind. He couldn't even decide what to have for breakfast with his coffee – one medialuna croissant, or two.

The milongas were running, but little else was. Wherever you looked, there was 'pain and oblivion', just like in the song 'My Beloved Buenos Aires'. One afternoon, I walked over to San Telmo, my favourite neighbourhood, home to early tango, corny street tango for tourists and the gentlemen barber brothers, of course.

San Telmo was ailing, like the rest of the city. The *conventillo* tenement houses, once mansions for the rich, were peeling like wallpaper,

and their crumbling balconies looked like they could fall on top of you and end your troubles any moment.

Large signs had appeared in the streets:

INTERESTED IN EMIGRATING TO CANADA?

HOW TO OBTAIN AN ITALIAN PASSPORT

The long queues outside foreign embassies were made up of the grandchildren and great-grandchildren of immigrants from the same countries to which these queuing new immigrants-to-be wanted to escape. The pity of it.

It was siesta time in San Telmo. On a lino floor in Plaza Dorrego, a couple was dancing: a man with a ponytail and a girl in black and red. I recognized the man – he was el Indio, the chunkily handsome dancer with native Indian features who had been here last year with the same black-and-red girl, or perhaps this was a different one. The girls of tango always seemed to change.

The barber brothers were stiffly reclining in their leather chairs. One of them was in exactly the same place where I'd last seen him. A creaky fan revolved overhead. They looked not so much alive as fossilized. One of them opened his eyes, looked at me and perhaps recognized me. In any case, he rose, trudged to the door and kissed my hand.

'Are you well?' I said, proud of my improved Spanish. I gave him the box of chocolates I had brought for them and he accepted it with shaky hands.

'We are fine, doll,' he said. 'Nothing much changes. San Telmo is still here. The dancers are still here.' He glanced towards el Indio and his girl. 'But we're getting old. My brother especially.'

The brother remained inert in the back of the shop, like an iguana.

They looked like twins, but I guess time passes differently for each of us.

'We've seen it all before, and worse,' Andrew Graham-Yooll said over coffee that afternoon, and scratched his ungroomed beard. 'Argentina is *always* in crisis.'

Andrew is a prominent Anglo-Argentine journalist and writer who remembers Argentina's last 'crisis'. He had left the country in the 1970s with his family, just in the nick of time before being 'disappeared' by the military junta like many of his colleagues and friends. 'Disappeared' was an Orwellian obscenity that the dictatorship invented in order to avoid the more obscene truth, which featured Nazi torture methods, Latin American-style: being hung by the ankles and wrists with wire, thrown out of planes, raped with cattle prods. Andrew had visited Buenos Aires from exile in London while the murderous generals were still in power. His friends were still disappearing, or reappearing, damaged, after months of torture. Even with his British passport, he was in danger.

'What was the mood in the streets back then?' I asked.

'Well, the mood was quiet, wasn't it!' Andrew said. 'The walls of buildings blank, you know. Not surprising, since anyone posting slogans was shot.'

At the time, Andrew had described Buenos Aires as 'a clean, yet filthy city . . . white walls are the sign of a silent people'.

And, of course, there was no tango. During the 1970s and early 1980s, milongas fell into the category of suspect gatherings of *more than three* people. Besides, when people from the age of fifteen upwards were kidnapped from bars, homes, offices and street corners in un-

marked sedans, never to be seen again, you can appreciate that porteños didn't much feel like dancing.

'At least the people aren't quiet now!' I said. 'And tango is still going.' Andrew smiled. He had hard eyes and a soft voice. His face was grey with fatigue.

'I do approve of your optimism,' he said. 'You know, Kapka, this country is a mess, but it's my mess. It's my home. My love and my anger are here.'

'You know what we say about ourselves,' Mario the car dealer said to me one Tuesday night at Porteño y Bailarin. Mercedes, Mario, a psychoanalyst and I were on to our second bottle of bubbly, and it was giving me a headache. 'Mexicans are descended from the Aztecs, Peruvians from the Incas and Argentines from the boats.'

I laughed, but the others had heard this one before. The psychoanalyst had a resigned, bearded face and narrow hands like a colonial carving of a saint.

'I have a patient,' he said. 'The child of Italian immigrants. He has chronic depression. He tells me that his depression comes from the Pampa. Looking at the empty Pampa, I become lost, he says, I don't know why I'm here. This isn't my landscape. It's hard to explain to Europeans like you . . .' He looked at me.

'No,' I said, dizzy with bubbly and insight, 'I understand perfectly. I live in New Zealand, the most beautiful country in the world, but . . .'

'But you don't belong there,' the psychoanalyst said.

'Yes. I mean, no.'

'You feel like your life is elsewhere.'

'How do you know?'

'From the way you dance.' He smiled gnomically, and I didn't dare probe further. 'But imagine a whole nation that feels like this. We don't have strong indigenous roots, and that's why we have held on to European culture. Something pushes us to search beyond ourselves, to always want to be different. Special. Nothing unites us except that longing. This is at the heart of the Argentine malaise . . .'

'That's why there are so many songs in tango with the title "Adiós",' Mario winked at me. 'You know, "Adiós muchachos", "Adiós marinero", "Adiós mujer" . . .'

'"Adiós lo niño",' I said, showing off a bit. 'I love that one.'

'I don't.' Mercedes took an angry sip from her glass. 'Piazzolla is too funereal. You listen to him and you think, what's the point, I may as well end it now! But listen to D'Arienzo. Listen to this compás that begs your feet to caress the floor . . . Mario, for God's sake, we're wasting the best tanda of the night.'

Mario stood up sharply in his cream suit, and off they went.

(*Pausa*: D'Arienzo is known as 'the king of compás' because of the rhythmic punch he put into tango in the 1930s and 1940s. This made it compulsively danceable and got it back into the dance halls, until then hogged by foxtrot. One third of tango music is compás. The other two parts are the melody and the lyrics.)

The psychoanalyst, however, was more interested in talking.

'The thing is,' he continued, 'when you say adiós to one thing, you must then welcome something else. Otherwise . . .'

'Otherwise?'

'Otherwise you end up living in the past . . .'

'But what about tango?'

'No, tango is about being *in touch* with the past. That's not a neurotic thing. Tango is a *healthy* dance.'

I was relieved to hear this. It was an antidote to the pathology of the Freudian tango cycle. But I still wanted to know something. It's not every day you run into a tango-dancing psychoanalyst, I thought, so I may as well get my milonga money's worth while I had the chance.

(*Pausa*: I was dead wrong – there are so many psychoanalysts in Buenos Aires that, sooner or later, you *will* run into them on the dance floor. Or at least on the edge of the dance floor, watching. They *have* to be on the edge, in order to come up with the voyeuristic Freudian gem of 'phallic pleasure' in tango. But relax: the Freudians are balanced by the presence in milongas of the more soft-core Jungians and Lacanians. Why is tango a magnet for psychoanalysts? It's simple – tango is about sex and death. And yet it's not simple at all – people are never simple, especially in tango. Tango and psychoanalysis: a match made in purgatory, in the sense that purgatory is the soul's purging place before heaven.)

'Why do people become so addicted to tango, then?' I asked. 'Is that a *healthy* addiction?'

'Ah!' The psychoanalyst smiled. He was a Lacanian. 'Put it this way: there are two broad types of person in the milonga. The therapists, and those in need of therapy.'

And before I could ask more questions or worry about my own diagnosis, he was off – he was one of those few dancers in the tango world here who apparently have to get up before midday and therefore leave 'early', at 1 a.m.

★

Carlos Rivarola was already at Café Tortoni for our midday coffee. Even unshaven and in jeans, he cut a dashing figure.

'Sorry I'm late!' I said, and we kiss-kissed like old friends. We *were* old friends – we had a history, of sorts. 'It's these milongas, they go so late, they're messing with my body clock.'

He smiled forgivingly with mate-stained teeth and held my hands.

'I see you've been bitten by the tango bug, Kapkita. Here you are, what is it – a year later? – speaking Spanish and looking for tango.'

'I don't know, Carlos,' I said. 'I'm looking for *something*. But I don't know what it is exactly.'

He nodded, as if *he* knew.

'Don't give up. You'll find it. Tango gives you what you're looking for, eventually.'

'Has it given *you* that?' I asked dubiously. He shrugged.

'I've never known anything other than tango. Tango was with me from the beginning. But – watch out! – it's not just the dance. It's the *people* who give you that. The other tangueros. When I go to a milonga, I'm happy, because I'm among other souls who live and breathe this same culture. Doesn't matter where they're from. And it's the women – my wife, of course, and then all the women I've danced with. The great Maria Nieves says that the woman is eighty per cent of the dance. She's right. Without the woman, tango is nothing.'

He looked at me with an attentiveness that made me both happy and sad. Happy that I was sitting here with Carlos, and he was telling me that without the woman (me), tango is nothing. Sad because I was still a little besotted with him, but nothing more was possible between us. Sad because I couldn't be here for much longer, in the all-night milongas where he danced, among my fellow tangueros. Sad because

I didn't know when I would next come back. Sad because I was *just another woman*, and tango, for Carlos and for everybody else here, would go on without me. Sad because neither Buenos Aires nor tango was going to fix the desencuentro between me and Jason.

And so, a few days later, I stood in Puerto Madero in the pink-skied evening, and watched the ferry from Uruguay glide towards the shore. Jason was on it, and I was jittery with anticipation and anxiety after two weeks apart.

The port had been redeveloped in recent years, and with its designer stores and expensive restaurants along the water it bore a suspicious resemblance to the Thames Walk in London. Naturally, Puerto Madero features in various tunes, but the best tango song about it had just come out. The song is by Kevin Johansen, and it isn't about the Puerto, of course, it's about something else.

Puerto Madero, Madero Puerto, we're going to Puerto Madero . . .
And all the people that aren't from here would like to come and stay,
And all the people that are from here just want to get away.

This was what it meant to be in a *state of tango*: wanting to be else-where. Not feeling at home in your home. Perhaps, like Andrew, I had to work out where my love and my anger were. In other words, where my *heart* was.

And here is Jason, coming out of the ferry with his backpack, sporting a blond traveller's beard. He is walking across the terminal in a tango T-shirt on which the daddy of tango-song, Gardel, smiles his dazzling gardelian smile.

My heart jumps, I call out 'Jason!', but he doesn't hear me. He is walking the wrong way, away from me, towards another black-haired woman in a cream skirt with too-bright lipstick. She too is waiting for someone.

But she isn't me, unless we are inside a Borges story, and there is a parallel universe where I am Argentine and I *want to get away*. Now I can see Jason's back instead of his face, and suddenly this is a farewell instead of a greeting, and I feel sick in my heart.

In the next moment, Jason sees the other woman closer up and realizes his mistake, and turns around to look for the real Kapka. But I don't have the heart to call out any more. He keeps turning in the middle of the terminal with a vague, embarrassed smile, and he looks exactly the way I feel. Alone and lost.

SIX

The Melody of the Heart

TANGO LESSON: CONNECTION

It takes two to tango, and it also takes two to screw up. After our month of disconnection in Buenos Aires, Jason and I spent a month of discontent in Berlin, where I'd moved for a year-long writer's residency.

Part of me already knew that our Tango Relationship was *ganz kaputt*. Yes, he was looking for the same things as me. Yes, we both had tanguidad. And that was the trouble: we had too much tanguidad. We were experts at serenading each other with lyrics about the South, about our beloved Buenos Aires, but we just weren't very good at handling life. Jason was a romantic, but now he declared that he didn't 'believe in relationships'. He had been adamant that I should move to Europe, but now he didn't feel at home in Europe and decided to go back to 'the South' alone. It seemed that he didn't just want to be *somewhere* else – he wanted to be *someone* else.

It was autumn and golden leaves carpeted Auguststrasse. Buildings

riddled with the bullets of another time watched us with windows like empty sockets. We waved to each other ciao, although we knew this was a case of adiós. Adiós to 'The Day that You Would Love Me'.

In the bare apartment where an empty futon bed and some empty bookshelves awaited me, I masochistically put on 'El día que me quieras'. It was our song. Carlos Gardel's voice reminded me how Jason sang with a semi-ironic, shy smile about 'moonshine in your hair', 'crazy fountains speaking of your love'. Gardel had died in his prime, in a plane crash over Colombia in 1935. No-one else in Argentina was mourned more hysterically than him – except Evita, of course. I had a year in Berlin ahead of me: for mourning Jason and our illusions, and for my writing project, which was a novel set in Paraguay. Don't ask why.

The song came to an end and I put it on again. As night fell, I flicked through a copy of Christopher Isherwood's *Goodbye to Berlin*. The young Englishman had arrived in Berlin at exactly this time of the year, in 1930. The worst times for him were the evenings, when he felt how much he was 'in a foreign city, alone, far from home'. I knew how he felt.

But wait! I am in Europe's most exciting city. And hasn't Berlin always tangoed, or at the very least waltzed? And, as we know, the waltz and the tango are old cousins.

Tango in Berlin: it just sounds right.

I walk under the linden trees of Unter den Linden, past the cafés serving fluffy strudels dusted with sugar like angel wings, past the souvenir shops selling kitsch and past the Russian Embassy, which still has an entire wing stuffed with secret files. All the way to the Brandenburg Gate. This is my first step across the Wall.

My previous visit to Berlin was in the mid-1980s, as a child. My parents, my sister and I stood by the Brandenburg Gate. Barricades and armed soldiers separated us from the rest of the world. This is how the Iron Curtain looked from the east side: a bunch of bored soldiers in brown uniforms, picking their pimples for about forty years.

Now, all that is left of the Wall are plaques with the names of those who tried to cross and were shot by the bored soldiers. The last unsuccessful escapee died on the spot just months before the Wall fell. Berlin is like that – a linden-tree walk over invisible scars.

The Trödelmarkt in Tiergarten offers for sale nothing less than the detritus of the past: smudged hand-mirrors, chairs without bottoms, silver teapots without tops. And photos – boxes of anonymous photos.

In one such box, among the images of babies now long dead, fur-collared Frauen with thick bodies and thin lips, men with Hitler moustaches, Art Deco damsels in lace, I find a strange photo of a couple dancing tango. They're both looking at the camera, with stiff raised arms and those trademark frozen faces of tango *duro*, or hard tango. The term for these set expressions in early tango was *cara fea*, ugly face, which makes sense with these two. But their eyes are looking right at me, across the twentieth century and now past it, as if they know something about me that I'm yet to find out. Something is scribbled in ink, and there is no date.

'1930s?' I show the photo to the Turkish stallholder.

'*Drei Euro.*' He grins with black teeth.

'Rip-off,' I mutter, but hand over the money anyway.

So what if it's autumn and the sky over Berlin is darkening, and today is the day after the day that he would never love me, and I don't

know a single soul here? I'm going to be all right. I have no right *not* to be all right. My 'August Street' has seen many goodbyes, infinitely worse than any of mine would ever be, because I'm lucky enough to be living now, and not then. In fact, the Germans have an expression for this, just as they have a word – a *single* word – for coming to terms with the past: *Vergangenheitsbewältigung*.

Auguststrasse is in Mitte, the Jewish neighbourhood. My white-washed apartment belonged to a Jewish family. A small tomb-like memorial around the corner from my flat reminds passers-by that the 55,000 inhabitants of this district were all murdered. The local supermarket is on Invalidenstrasse, which is the continuation of Veteranstrasse. Who am I, with my nice Kiwi passport and safe Bulgarian name, to be miserable?

I stick the photo of the dancing couple on the bare wall of my living room. Perhaps they'll guide me in this ghost city.

And, sure enough, on Wednesday night, I stumble across my first milonga, right in my own Auguststrasse. A string of garden lights leads up to the entrance of an old stone building. 'Malena sings the tango, like no-one else ...'

I walk in, my heart pounding. They knew I was coming, surely, otherwise they wouldn't be playing my favourite song! But who are they?

'*Was ist das?*' I ask the gum-chewing woman collecting money in a little lobby.

'Clärchens Ballhaus,' she says with Teutonic bluntness, and tears off a little ticket for me. Then she softens up and adds, 'Milonga de los Angelitos.'

The little angels' milonga. Clärchens Ballhaus is in fact one of Berlin's oldest dance halls – the walls a golden brown in the candle-light, with retro posters of Berliners drinking beer. The little angels are dancing on the polished floor, others are sitting at tables sipping beers, and everybody is smoking and wearing tango shoes. My year of tango in Berlin has officially begun.

Berliners started couple dancing right here in 1913. When the salon's owner was killed in the Great War, his widow Clara took over. In Berlin's golden age of decadence and cabarets, Clärchens was the place to be if you were artistic, liberal, dissolute, or a philosophizing one-armed pimp, like the anti-hero of *Berlin Alexanderplatz*, a classic pre-war novel. Franz 'Beverhead' had lost an arm in the war, which didn't stop him from putting the other one around the Fräuleins who moved right here to the sound of popular ballads.

I edge around the side of the dance floor to get my bearings. A happy waltz is playing, called 'Desde el alma' ('From the Soul'). It was written in 1947 – two years after Berlin was ground to rubble, including the front of this building where we are right now. I slip on my black velvet heels before I miss too many tandas. The floor is busy. Clothes vary from slacker jeans to soft dresses and sharp trousers, and ages range from twenties to sixties. Good. I can already spot several Terminator-style dancers (the ones to avoid), and a few younger men in trainers and baggy trousers doing well with the open embrace (the ones to aim for).

But the dancer who grabs my attention is a slender man in his thir-ties with shiny, straight indigo hair, impeccably turned out in a stripy shirt. He dances close-embrace, milonguero-style, and his face has a sharp-cut Asiatic beauty to it. I see him light a cigar at his table

afterwards, and look at people through the slits of his eyes. It's obvious that he is a regular from the way everyone greets him, but he keeps himself apart. I'm itching to dance with him, but he looks like the type who only dances with *proven* women. I'd better go and prove myself then. Luckily, a guy with black-and-white shoes is already standing by my chair.

'Hallo,' he says. 'Would you like to dance with me?' Clearly, Berlin tango is foreigner-friendly. I won't be a wallflower.

'You don't have to dance with me if you don't want to', he adds. 'I will not be offended.'

Actually, he was one of the *bad* ones I'd spotted earlier, but when you're new in town, you can't be too picky.

'Oh, but I do want to dance with you.' I smile radiantly.

'Thank you. I hope that you do not regret it.' It's a waltz tanda, and he leads me into laborious sacadas not suited to the tempo of the waltz. He's also twisting my wrist with his hand.

'The Germans love waltzes.' He has an intense stare and stiff hair like a helmet. 'You can take the German out of the waltz, but you cannot take . . . how do you say . . .'

'The waltz out of the German.'

'Correct.'

'And you're not German?'

'No, I am Hungarian, in fact. My mother is Hungarian. My name is Tomas.'

We dance a couple more tracks, and I like Tomas, but he is hurting my back, and he executes figures as if they are his enemies, so I have to end it with a bright 'Thank you.'

He accompanies me back to my table.

'I told you, I am not very good. Actually, I'm terrible. But at least I know it.'

'That's not true,' I lie, all the while thinking, there's no way indigo-hair is going to dance with me now. Damn, damn. And Tomas is still standing here!

'How old are you?' he asks suddenly.

'Twenty-eight. And you?'

'Twenty-eight also. We have two more years to get it right, then it's over.' He stands by my table. I laugh, slightly alarmed.

'I'm about to turn twenty-nine, so that leaves me one year.'

'Yes,' he says, dead serious. 'But your dancing is perfect already. That is the difference. Now, excuse me, I must leave.'

And he does – he disappears just as suddenly as he appeared, first his helmet-like head, then his black-and-white shoes. Later, I found out that he didn't speak a word of Hungarian. His Hungarian mother was a way of *not* being German. For a generation who grew up with Vergangenheitsbewältigung, being German is still painful by proxy.

'Dancing?'

Hans, on the other hand, looks excessively German. And I am ashamed to say that my first instinct is to say no. He has a solid jaw and small blue eyes sunk beneath a cruel forehead. But I swallow my prejudices and accept his offered hand. And, surprise – he dances like a Romantic poet (possibly Schiller) composing one of his great love poems, and that poem is me. In real life, he is an entrepreneur. He dances seven nights a week. He is built like the Minotaur, but laughs a high-pitched, eunuch's laughter.

'You are a lovely dancer,' he says. 'And if you'd like to marry me at any point, please let me know.'

'I'm not the marrying type,' I laugh.

'OK, we don't *have* to marry. I'm just saying it so you know it's an option. But don't destroy my night. I'm trying to enjoy it. Listen, "Melodia del corazón", I love this song. I love Donato. Do you know Donato played in an orchestra for silent movies in Buenos Aires? Come, let us dance ...'

Who knew Germans were so romantic? Tango, like nothing else, dislodges lazy cultural assumptions by putting you straight into an embrace with real people.

'Be careful, though,' says Lara. 'The Nazis were into art, too. The land of poets and romantics was also the land of book-burning and people-burning.'

Lara is a thirty-something theatre actress from Tel Aviv, and a regular at Clärchens Ballhaus. She is in Berlin playing in an English production of *Hamlet*.

'Which part?' I ask.

'Ophelia, obviously.' She rolls her smoky eyes. 'God, I hate *Hamlet*. I can't wait till the evenings so I can come to the milonga and have a break from madness.'

Lara is a beginner and still taking intensive tango classes, which means that she isn't dancing much yet in the busy milongas. Instead, she smokes, observes and looks formidable with her mane of curly black hair and face like a Babylonian princess. I nod towards the man with indigo hair.

'Who's he?'

His name – or at least his nom-de-tango – is Mr Che, and he is Malaysian, or is it Indonesian? He is an artist, or perhaps restaurant owner, or is it a bar ... (*Pausa*: The tango grapevine always yields rich

information, but quantity prevails over quality. It favours impressions and distortions over hard facts.) Anyway, the general impression is that Mr Che has a bit of a tough reputation — he is admired by many women but attached to none. He always turns up alone and leaves alone, with a cigar.

Lara puts out her cigarette. Hans has invited her for a dance and they walk to the floor together. She moves like a cat and I can hear Hans's heart crack under the strain of so much beauty. After just one dance, she drops him unceremoniously and comes back to our table.

'Did you speak to him?' I ask. 'He's a lovely guy. And a lovely dancer.'

'I know. But it's difficult,' Lara sighs. 'Berlin is much nicer than Tel Aviv. Israeli men are a nightmare. But . . . no. It's impossible. My grand-mother escaped the Holocaust because she happened to be away on some sports trips. And the rest of her family? Murdered. They lived here. My grandfather left Mitte in the early 1930s as a young man. The rest of his family? Murdered. The Germans are very nice to me now, and I've learnt a bit of German, but how could I ever make love to a German? I can dance with them, but no more. No more.'

She shakes her curls and lights up another cigarette. She has me thinking there. The thought of making love to a German would have been uncomfortable to me, too, and not just because I'm busy getting over not doing it with Jason. Now, just a few German tangos later, things have shifted in my mind — or perhaps just in my body.

Anyway, there isn't much I can say to Lara without putting my foot in it, so I put my feet on the dance floor instead, and this time I dance with a tall, handsome dentist from Potsdam. He has frizzy hair and Slavic cheekbones. He is an experienced dancer, although his open embrace is a bit slack and he runs ahead of the music. But his intelli-

gent grey eyes are fastened on my face the entire time. French is the language we have in common, and at the end of the dance he says:

'*C'est le pays de nos desirs, c'est le bonheur, c'est le plaisir.*'

'*Pardon?*'

'It's a song,' he says. 'One of my favourites. I'll get it for you. It's called "Youkali", written by Kurt Weill in the 1930s.'

I've never heard of it. I've never heard of any other European tangos in Klaus's vast collection, and I'd never had a tango CD made especially for me. I had also never had a red rose deposited on my doorstep, wrapped in tango lyrics. Not just once, but every Wednesday evening – the Clärchens Ballhaus night – when Klaus drove in from Potsdam.

Ours was an Osties' courtship – old-fashioned and frustrated. The Osties, as opposed to the Westies, are the former East Berliners and, by extension, all the former kids of the Eastern bloc. We sipped *Kirsch-Bananensaft* smoothies and got tipsy on mojitos on Oranien-burgerstrasse, in the hunched shadow of Tacheles, a Bauhaus ruin full of graffiti, spontaneous *Kunst* and squatting artists. It had been a Jewish-owned department store until the Nazis moved in to torture French prisoners of war. It sat there, unloved and unlovely, until the fall of the Wall.

Klaus danced only with me the entire night, every time, and he was the brightest, warmest man I'd ever danced obsessively with. This was the stuff of high romance. But I couldn't tell whether I was enchanted or suffocated, seduced or resentful. Why didn't it end in a beautiful Tango Affair? Because he was from here, and I was passing through. He was a dentist. I was a drifter.

'I want your life,' he said one night in my flat after Clärchens Ballhaus and a bottle of cheap Gewürztraminer. 'The bohemian life. I

want to dance with you from the heart, *desde el alma*.' He picked up my dance shoes and buried his face in them.

'You can have my life any time,' I said, feeling pity for him and for myself, but also worried that my shoes were whiffy after a night of dancing. 'It's not that great. I don't even know where I'm going to be next year.'

'I know exactly where I'm going to be and what I'm going to be doing,' he said, and stroked my legs. 'That's my problem. And where will these legs be dancing, in eight months' time, in eight years?'

'God knows,' I said. All the cities, all the people, all the journeys ahead. I felt tired and lonely just thinking about it.

'Everything will fall into place for you, and your life will be like a tango poem.'

'Which one?' I scoffed. '"Malena"?'

'No, not "Malena". Maybe "Melodia del corazón".'

'And you?' I said. 'Which tango song will be yours?'

He shook his head. His hair was going grey at the temples.

'I don't know if tango has a song about my life . . . how many tangos are there about dentists?'

We had to laugh. We looked at the tango couple on my wall. They knew – they knew everything – about the past, and about the future, too. I asked Klaus about the writing on the back of the photo, but we couldn't even decipher the words. It was old German, Klaus said, I'd need to get an expert.

One day, the roses stopped coming, and although I liked Klaus, I was relieved. I didn't want *complications*. I just wanted to dance.

So I did – at milongas, practicas and classes every night of the week.

★

Sonntag: classes with a cheerful Argentinian DJ called Diego el Pajaro ('the Bird') because at the end of the night he always plays a happy instrumental tango called 'El Amanecer' ('The Dawn'). It features sounds of plucked strings and chirping birds – or perhaps vice versa.

Diego el Pajaro is pure bohemia in velvet flares, and one of a handful of expat Argentinians scraping together a living from teaching tango and running milongas in Berlin. I am hungry for better technique and new steps, so I am partnering Hans in Diego's classes. It's here that I learn for the first time about *disassociation* – something that occurs in tango Nuevo, where the embrace opens up scope for ampler bodily happenings and leg extensions.

'So, what is disassociation?' Diego says, and demonstrates a series of sacadas with his borrowed dance partner, a girl from Paris so tiny she has to wear special platform shoes.

'Disassociation is a conversation between upstairs and downstairs,' he tells us. 'Your upstairs body and your downstairs body are doing different things.'

Sacada – and he twists his hips to extend his leg between his partner's. Sacada – again. Sacada. He is a human corkscrew.

'Your legs are very long. Your legs are always long when you step back. Extend. Extend.'

'Look at her legs,' Hans says. The tiny girl is twisting and extending, twisting and extending.

'*Mein Gott*, Hans,' I say, because he's looking at the girl's legs, but I'm looking at the elegant *disassociation* that allows those tiny legs to look so long. 'Nobody taught me this before. It's so obvious!'

'Come on, *chicos*,' Diego calls out. 'Turn. Extend. Turn.

Extend. What is this? A leg? Why is so short? Extend. Extend. Muy bien!'

Disassociation: clearly, this is what we must do: 1. physically, to improve our open-embrace style; and 2. emotionally, to ease our suffering. I'm determined to practise this new lesson, to disassociate every night of the week. Turn, extend, turn, extend. Away, away from the chest. Muy bien!

Montag: B-flat, in a small bar in Mitte, where the gawky DJ Gustav had unorthodox taste in music. Who knew there were so many cabaret-style tango songs in Russian, Hebrew, German, French and – do I hear Czech? Gustav alternated these with modern Greek ballads like Haris Alexiou's 'To tango tis nefelis' ('Tango of the Angels'), which became a hit in Europe. Then he would play some Balkan tune that tugged at your gypsy heart strings – like 'Underground Tango' by Goran Bregović.

How did we dance to these things? Badly, or not at all. Which is why I mostly propped up the bar at B-flat, and talked to Lara and Hans. One night, around 1 a.m., Gustav put on 'Youkali', sung by the cabaret artist Ute Lemper, who is Berlin's modern Marlene Dietrich. A few couples rocked about to this tango habanero's irregular beat, like shipwrecked vessels. Hans sat between me and Lara at the bar.

'I have a big problem,' he said.

'Yes, you do,' Lara said. I was glad I wasn't one of her admirers.

'There are many women who want to stay with me,' Hans continued. 'But I don't want them. Then there are the women I want. But they don't want me.' He looked at me and Lara with a face that

made us laugh, a little cruelly. 'How can I live like this? I don't want to *dis-asso-ciate* all the time.'

He took a look around the room. He took a sip of his wine. 'I'm serious,' Hans said. 'What is your type?' he turned to me.

'My type? I don't have a type,' I said. 'And you?'

'You are my type,' Hans said.

'She's not a type,' Lara said. 'She's a person.'

'OK then,' Hans conceded, now looking at her. 'You are my type of person, Lara.'

'Rubbish.' Lara blew smoke through her exquisite nostrils. 'I don't fall in love any more. What's the point?'

'Oh!' Hans looked crushed. 'But what is the point of *not* falling in love?'

'We all have the same problem, Hans,' I said. 'We all want someone who doesn't want us. Or not enough, anyway.'

'Youkaaaali,' Hans bellowed in his ropey throat, and nobody in the bar batted an eyelid. He wasn't drunk – he was just a Berliner. '*Mais c'est un rêve, une folie / Il n'y a pas de Youkali!*'

It's just a dream, a folly / There is no Youkali.

For once, Lara didn't snort cynically. This song was doing all our heads in. Youkali was what the South had been for me and Jason. Youkali was the day that you would love me. Youkali was what Klaus had wanted to find with me, and what I had wanted to find with Jason. Youkali was dancing with Silvester. Fairy-tale snow fell outside the glass walls of B-flat. It was almost Christmas.

'This is our Youkali, guys,' Lara said, suddenly. 'This bar. This night in Berlin.'

And she smiled at me and Hans in a way that left us speechless and

revealed everything worth knowing about her. Now I knew why she was learning tango.

Dienstag: the glitzy Bebop in the Turkish district of Kreuzberg. Here, I shared a table with Giselle and the Catastrophist. Giselle was a fifty-year-old psychologist who wore silk dresses. The Catastrophist was a retired East German Egyptologist. He liked to have conversations in as many languages as possible, so we spoke a muddle of English, French, Spanish and Russian, then he would sometimes continue – on his own – in Arabic. I could never remember his name, but he always talked about World War IV and 'the new Nazis' (America), without explaining how these two were connected. There was something about him that was utterly . . . Berlin. Not the new, cool Berlin, but the old East Berlin of overeducated polyglots who couldn't go anywhere, so their brains atrophied with fantasies of distant lands.

Giselle was always waiting to be asked for a dance.

And here is Mr Che looking more inscrutable than ever, in a sharp charcoal suit.

'Why doesn't he dance with you?' I ask Giselle.

'I'm the wrong age for him.' She smiles ruefully.

'Darling, a beautiful woman is never the wrong age,' says the Catastrophist, and asks her for a dance.

(*Pausa*: A note about age and tango. Age is not a problem in itself, for a woman. If men know you, and you are not a club-foot, you will get dances. But the older you are, the more you are likely to get dances with certain *regular* partners *only*. Let's say it now: men go for fresh meat. Unpleasant but true. The only thing that stops the milonga from being an overt meat market is social grace. But brutal biology is never

too far away, and seeing Giselle sitting by herself while younger – and less proficient – women are dancing is a reminder. Older men, like the Catastrophist, can also be rejected by younger women, especially if they have BO or aren't good on the floor.

A second note about age and tango. There is an Argentine expression: *tango knows how to wait*. Emotionally and psychologically, tango is not for the very young. You may be a technically brilliant dancer at nineteen, but unless you have been through a hell of a lot, you won't connect with tango's soul – only with tango's feet. At twenty-six, thirty-five, forty, fifty and sixty, however, life has already smacked you a few times. You've lost a few illusions. Now you are ready. Tango has been waiting for you all this time.)

And tonight is my lucky night! Mr Che nods at me from his table, and we find out what I had suspected all along: that we are a close-embrace match made in heaven. Factoring in my eight-centimetre heels, we're the same height and a similar body-build, too. But that's not the reason. The reason is tango chemistry. We move to the same music, and this feels amazing after my dances tonight with gangly men who move to something playing in their heads, possibly a military march.

Mr Che hears and feels the music in his compact and fragrant body. And we are waltzing like dervishes (can dervishes waltz?), and at the end of the first tanda we are laughing with dizziness and exhilaration. (*Pausa*: You are not dancing a waltz if 70 per cent of your steps do not include giros. After a good waltz tanda, you *must* feel dizzy and exhilarated.)

With each tanda, we get dangerously closer to a tangasm, and then it ends. To end it is the decent thing; we both know it. This is only our first dance together, and an excess of pleasure would be inappropriate.

'Thank you.' He smiles his clipped smile.

The next night, we dance again. And – tangasm!

'Thank you,' Mr Che says afterwards. The tangasm has lasted a few tandas *only* – it's never enough, but the pain of ending it is soothed by the knowledge of dancing with him at tomorrow's milonga, and next week's, and next.

'I must stop now, Kafka, or I get Chinese obsession,' Mr Che says. He is Chinese, it turns out, not Malay or Indonesian. At least tonight he is.

We perch at the bar.

'Would you like a fortune cookie?' Mr Che produces one from his charcoal-coloured jacket. I unwrap the little message inside, which says: 'If you start flirting, it will get quite hot.'

I laugh, embarrassed. It's impossible to tell whether he, too, is embarrassed, because his eyes are black. Actual black – no pupils.

'What's your real name?' I ask him.

'Mr Che.'

'That's not your real name.'

'Kafka is not your real name either,' he says.

'No, but I never said my name was Kafka.'

'I call you Kafka anyway. The metamorphosis. Because you are different woman every time I see you.' He laughs a little awkwardly, then composes himself. 'You like fado? You like flamenco? I'll take you to a flamenco bar.'

He does, later that week, and we drink sangria in a bar called El Sur, and gaze into the nicotine-blackened mouth of the flamenco singer.

No tengo lugar,

no tengo paysage,

y menos tengo patria . . .

'Means I haven't got no place, no homeland,' Mr Che translates. 'That's Gypsy life. Are you Gypsy? I don't want to be Gypsy.'

'I don't want to be Gypsy either,' I agree.

'I want to have home.'

'Me too.'

'But at home, I listen to tango and flamenco and I have too much *duende*.' Mr Che bites on a fat cigar. 'Chinese duende. Do you feel duende?'

'I don't know, what is duende?'

'Duende is how you feel when you listen to sad and beautiful music. Like this flamenco. Like tango. You know Lorca? Lorca say duende is power, but not work. Struggle, but not thought. Like falling in love. You don't have no head. It makes you happy and sad at same time.'

'Do you ever fall in love?'

His Asian eyes look at me sharply.

'As long as I have cigar, I don't fall in love.' He laughs cynically. 'But if you like, we can have short story.'

Now it's my turn to laugh cynically.

'I'm leaving in a few months, Che.' It's weird to call this glabrous, dandyish man by the hairy Che Guevara's name, and even weirder when you think that *che* is a slang interjection in Argentina – like 'hey'. Hey you!

'I know,' he says. 'That's why I don't say novel, I say short story. But

anyway, sex is not important. You can have sex with anybody. It's having a *relationship* with someone . . .' He trails off and looks away.

'What are you doing in Berlin, Che?'

'I'm living here twenty years. *Ich bin ein Berliner.*'

'But why did you leave Asia?' By now, I've found out that Mr Che is in fact from Singapore. He is also recently divorced.

'Have you been to Asia? Too many people there already, who needs me? I want to open new restaurant here. Small but good. Like me.'

He takes out a fortune cookie and unwraps it.

'What does it say?' I want to know.

'Don't trust Bulgarians, they are always making up things. Come on, I take you home.'

Mr Che always walked me home, past the enormously tall platform-heeled prostitutes along Oranienburgerstrasse who wore painted-on jeans and fluorescent jackets in winter. One of them took a shine to Mr Che, and every time we passed she would lean from the height of her platform shoes, produce a red-wrapped condom and say to him in a thick bass, 'Hallo, sexy.'

'Good night and sweet dreams,' Mr Che would say courteously, wave a cigar, and we'd walk on.

Mr Che always travelled on foot now. At one point, he had a car, but then his licence was taken away for drink driving.

'Chinese always find way home,' he reassured me, and disappeared into the black night in his film-noir coat.

Mr Che was a Renaissance man of the new Berlin, a gentleman and a tough fortune cookie. I liked him very much – no, I liked him too much – but I couldn't cope with *complications*.

Remember: disassociate! Turn and extend. Your legs are doing their thing, and your chest is not getting involved.

Mittwoch: our old friend Clärchens Ballhaus. El Pajaro was the DJ here, and I sat close to his lit-up platform, along with the tango 'elite' of Berlin. We were all self-appointed, of course. Some were amateurs who overtly or covertly wanted to be professionals. Others just wanted to be recognized as the best. We wanted *something*, anyway. I wanted to dance with the best. It had become terribly important. My Paraguay novel was very slowly and diligently going nowhere, so tango was once again *the only* important thing in my life. You see, I may have been making progress in my romantic disassociation, but I was finding the practice of social disassociation harder.

In the eye of the milonga, its centrifugal passions suck you in, and they are not always noble ones. In fact, the milonga is exactly the kind of competitive social space that can bring out the very worst in you, if you let it. For example:

Naked ambition: to dance with the best dancers of the opposite sex, at any cost.

Jealousy: of that shameless careerist who's always clawing at him to dance with her – some women would do anything!

Aggression: I want to strangle her, quietly, in the toilets.

Pride: I'm going to sit here until he asks me, because I'm too good to make eye contact or, God forbid, get up and circulate.

Self-doubt: maybe I'm just not good enough.

Self-loathing: I'll never be good enough, there's something fundamentally wrong with me; why did I even come tonight, this is the pits!

Shoe envy: if only I had sandals like those – they'd look better on me, anyway, than on her sausage feet.

Revenge: he took months to ask me to dance, now I'm going to ignore him.

Tribalism and righteousness: that lot over there never dance with our lot, so I'm going to make a point of ignoring them – who do they think they are, Al Pacino? Not that *he* could tango, either.

Snobbery: no, I'm not dancing with him, he's a nice guy but not prestigious enough.

Cruelty: 'Having a good time?' – to the woman who's been sitting all night.

Self-importance: all eyes are on me tonight.

Narcissistic delusion: God, I'm so gorgeous, I could weep.

It's the same for the men. The only gender difference at the dark end of the milonga spectrum is this: women are castratingly cruel, men are stupidly macho. Women suffer dejection, men suffer rejection, which comes to the same.

(*Pausa*: Tango can bring out emotions at the happy, noble end of the spectrum, too. Coming up soon, I promise.)

One of the regulars at the 'elite' tables was Olga from Montenegro. She cut an elegant figure, but had the permanently disappointed face of a baroness fallen on hard times. She did little apart from complain and wait for Diego el Pajaro and a couple of his Argentinian friends to dance with her – because the other men were simply not good enough.

'Germans! How can Germans ever get tango?' She furrowed her handsome nose. 'Germans and tango: it's an oxymoron.'

'That's not true.' At least I was *trying* to resist my tango snobbery.

'There are some very nice dancers here,' I said, but she shook her head.

'Yes, and they are all foreign. Germans just don't have . . . soul.'

'They do, Olga,' I said. 'It's just a different soul.'

'When I dance with Diego, I feel . . .' She waved it all away. 'Kapka, how old are you?'

'Twenty-nine.' Everyone here seemed obsessed with age.

'You'll see. When you get to my age, you'll see what I mean.'

I guessed she was in her late thirties, though she kept her age a secret.

'I want to dance close embrace,' she said. 'I want to *feel* a man's chest. I don't want to do this prancy Nuevo stuff. It has no heart. Look at them, just look at them.'

The open-embrace, Nuevo style was favoured in Berlin, especially by younger dancers. The best of the Nuevo dancers was Christophe. Dancing with Christophe, each time I felt on the verge of permanently converting to the open embrace. When you dance it with someone sensitive and musical, tango Nuevo is more fluid, more liberating and more creative than the traditional salon style of close embrace. And, most glorious of all, in Nuevo you must always keep your own axis, which means that you don't lean on each other. You are together, yet separate. You are close, but not intimate. It's pure emotional disassociation. It's tango for the emancipated, egalitarian couple. Of course, many traditionalists argue that this isn't a tango couple any more, because there is no *embrace*.

'Yes, there are some exceptions, but most of the Nuevo lot here look like they're operating heavy machinery,' Clive James says.

He is in Berlin for a week, to sit 'alone in a café' and write his big book, which he describes as 'either my masterpiece, or a suicide note a quarter of a million words long'.

'Mind you,' he adds, 'some of the German women *feel* like heavy machinery. Oh boy.'

Clive has joined the Clärchens 'elite' tonight, and Olga is paying special attention to him because she loves celebrity. She's now on the dance floor, showing off for his benefit. Clive is sceptical.

'Her behind is almost as beautiful as her face.' He puffs on a Café Crème cigar, which he inhales as if it's a cigarette.

'Clive, why are you inhaling?'

'Are you kidding? What's the point of *not* inhaling?' He takes another drag. 'Unfortunately, her behind is also more *intelligent* than her face.'

Olga is a great dancer so they dance a few tandas anyway, and Clive comes running back afterwards. 'Quick, get me out of here before she becomes part of my life for ever!'

But we're not going yet. We're enjoying Clärchens too much, and the crowd are now doing what they love best – waltzing.

'Think about it, kid,' Clive says. 'Waltz, good old waltz, is responsible for all this. Who would've thought?'

Popular couple dancing in Europe started in the late eighteenth century with the waltz, and once men and women were *touching* while facing each other, there was no turning back. Before the waltz, couples were always facing off from a distance, in *ancien régime* dances like the gavotte and minuet. At first, waltz was new and scandalous because – let's face it – there *is* something sexual about the man putting his arm around the woman's waist, and the woman opening up her chest by

placing a hand on his shoulder. As dance historian Sergio Pujol writes, waltz succeeded where Napoleon failed: in conquering Europe. Alas, he adds, European waltz ended up like the French Revolution: it became terminally bourgeois. By 1815, the 'satanic dance' had become establishment. Even the Catholic Church blessed the waltz eventually, and when the Catholic Church blesses something, you know it's time to move on.

And the waltz did – as early as 1805, it travelled across the Atlantic to Buenos Aires and Montevideo, where it was lapped up by the local high society as well as the farmers in the provinces, who did it their own way, according to region, and along with the polka and mazurka imported by Ukrainian, Polish and Russian migrants. So, long before tango was even a squeak in the first imported German bandoneon, the waltz was turning and turning across the Rioplatense dance floors of the nineteenth century, picking up new turns and 'staggered' double-time steps, until it was transmogrified into what is known today as 'tango waltz'.

All these strange bedfellows! Strauss and Carlos Gardel. The peasants who invented the bandoneon a few hundred miles from here in the village of Carlsfeld because they couldn't afford an organ for their church and . . . Piazzolla's jazziness.

Strange, except in tango, where such mongrel couplings *had* to take place, otherwise it wouldn't be tango. Otherwise we wouldn't be here: me puffing on Café Crèmes with Clive, Mr Che dancing the birdsong tango with Olga, Hans waltzing with Lara who doesn't want to make love to a German, while Diego el Pajaro whistles through his beard.

Here, at the dark heart of Berlin, in the Milonga de los Angelitos, we are all Berliners, and I'm immensely happy.

'This is the life, kiddo.' Clive muses, 'If I was your age and starting up, I'd do it in Berlin. As Kennedy said, I am a doughnut.'

Freitag: the Walzerlinksgestrickt milonga, which to me sounded alarmingly similar to Vergangenheitsbewältigung. Coming to terms with the past and coming to terms with waltz – well, there was something in that. Walzerlinks was a grand Art Deco dance hall inside a brick warehouse-like building from the 1860s. It heaved with sparkling lights and dolled-up dancers. A giant chandelier watched over us. This was Berlin's most glamorous tango venue.

'Che, why do we dance so much?' I asked Mr Che one night at the bar, over minty mojitos.

'Because . . . T*angotanzen macht schön*,' he grinned and bit down on a cigar.

Dancing tango makes you beautiful.

'And also because when I dance, I feel,' Mr Che added.

'But what about technique?' This was Tomas, who had appeared beside us suddenly – first his black-and-white shoes, then his earnest face. 'First, you must master technique.'

'No difference,' Mr Che said. 'Feeling and technique is the same.'

'But I don't want to feel!' Tomas said. 'If I feel when I dance, then I might fall in love. And my heart has broken twice. That is why I am concentrated on my feet.'

Mr Che looked at him with undisguised contempt.

'Why looking at your feet? Your feet always there. Woman is not always there. Woman is here tonight, not here tomorrow.'

Tomas looked stricken.

'Oh,' he said. 'I must think about this carefully.'

'How is your writing going?' I asked. He'd told me that he was a writer of short stories, as well as a musician in a band. This is what young Berliners did: they were either eternal students, or authors of works-in-eternal-progress. Everyone in Berlin tango was about to do something, become someone, make their mark.

'I have written a story,' Tomas said. 'It is about a man without a name and without a face also. He has forgotten who is he.'

'It sounds like my autobiography,' Mr Che sneered.

'It is *my* autobiography,' Tomas said, very serious. 'Now excuse me, I must leave.' And he vanished – first his face, then his shoes.

'Poor Tomas,' I said. 'He's had a bad experience with love.'

'Do you know someone who *didn't* have a bad experience with love?' Mr Che said. 'That is why we dance tango. No bad experience, no tango music. No tango music, no tango dance. No tango dance, no happiness.' He tucked his glossy hair behind his ear.

'You're right,' I said.

'I know,' he grinned. 'And you know something more? I have special expression: *Ich bin tanzerisch verliebt.*'

I blushed, because I felt the same. *I'm in dancing love* with him, too. It's not the same as being in love, because it doesn't go beyond the dance hall. And therefore it doesn't make you unhappy. Lots of hot dances, no *complications*: this is what I had wanted. This is what I was getting.

'Better to be tanzerisch verliebt than not be verliebt at all,' Mr Che said.

'Yes,' I said. 'And better to be tanzerisch verliebt than to be verliebt.'

Christophe the DJ was playing one of Mr Che's favourite songs,

'Trasnochando' ('Staying Up All Night'), so off we went to join the anticlockwise human whirlwind on the dance floor.

(*Pausa*: Tango traffic is always anticlockwise. Why? There are several theories. One, it's metaphysical – an attempt to stop the clock. Two, it's historical – a way of connecting with the music of the past and all the dancers who went before us. Three – it's just for the hell of it, because tango always went against the grain. Four – old milongueros insist that it just *doesn't work* clockwise. And the old milongueros are right – it doesn't. Try it.)

Samstag: Ballhaus Rixdorf, which is an echoey, balconied dance hall with a polished floor and a sleepless DJ booth lit up like a lighthouse. It's been going since 1998, and it's run by an aged hippie of a DJ with bloodshot eyes and what is rumoured to be the largest collection of tango music in Germany.

This was where the fashionable people came to dance all night (Hans), dance just a few tandas (Mr Che) or make a point of *not* dancing (Olga). Here, the latest tango fashions were paraded: the increasingly erotic tango sandal, the tango sneaker, the unfortunate transparent unisex trousers worn with a G-string underneath (women) and a visible panty line (men).

Rixdorf is where I had my last tango in Berlin. It was autumn again, and my visa was about to expire. The stone buildings of Mitte began to cast longer shadows. Soon, the open-air milonga by the River Spree would close, and it would be back to the regular milongas. And I wouldn't be here, and no-one would notice that I was gone, because that's the nature of the milonga. Those who are here keep dancing, and those who are not are forgotten, until next time they turn up and

everybody says, 'Oh, you've been away for ages! How long has it been, five months?'

'No, two years,' you say, hurt that your absence has meant so little. Time passes differently for those who dance in the same place and those who move around. Your tango *friends* do notice, of course.

'I hate winter,' Mr Che said at our table. It was about 3 a.m. and the Rixdorf was winding down. 'People are like plant. They need light. Chinese need light.'

'Che, I want to stay in Berlin,' I said. 'I've been so happy here.'

'But you are gypsy. Gypsy always leave.'

'I don't want to be gypsy. I want to be part of something.'

'Me, I want to leave. Go Spain. Learn flamenco. Tango make me sad now. I'm throw out my things: disc, gramophone machine, cassettes, books, clothes. I want to be new man.'

Then he perked up, for both our sakes.

'I take you noodle-sucking at Monsieur Vuong tomorrow.'

At Monsieur Vuong's, the waiters were gay Asians, and one wall displayed a poster of the original Vietnamese Monsieur Vuong, a karate master with muscles like ropes.

'Noodle addict is best addict,' Mr Che said as we sucked our noodles. 'Better than tango addict.'

'Or short-story addict,' I said.

'I don't want short story. One fucking short story after another. I want to marry. Come back to same person every night. You want to marry me, Kafka?'

I laughed, but there was a lump in my throat, and it wasn't Monsieur Vuong's noodles.

'Che, I thought you never fall in love,' I said.

136

'I *want* to fall in love. But I can't. Or woman is leaving. So I make joke. Like tango. You dance so you not cry.'

'I don't want to leave.' I squeezed his hot hand. I felt sudden panic. What was I returning to in New Zealand? Nothing, *nada*. He squeezed my hand back and looked away.

'You know Plato?' he said. 'Plato say, there are three souls in human. Mental soul, emotional soul and soul of desire. When there is too much one soul, we are off balance.'

'Are we?' I said. 'Are we off balance?'

'That is why we dance. Tango is balance of soul.' He reached out and wiped my cheek. 'Don't cry for me, Kafka.'

'And you, Che? What are you going to do?'

He smiled.

'I am Chinese. I have cigar. Come on, I walk you home.'

I packed my books, my tango CDs, my four pairs of battered dance shoes and the photographs I'd collected at flea markets. But no matter how much I packed and repacked my stuff, I felt that I was leaving something behind.

Hans came with me to the airport. His farewell gift was a cassette with Russian and German tangos. He was seeing an actress from Russia now.

'I really hope it works out,' I said.

'*Ja*,' he said. 'Me too. I really, really hope. I want to asso-ci-ate. Anyway, when are you coming back?'

'I don't know,' I said. 'The trick is not to leave in the first place.'

'Everyone leaves Berlin,' Hans said, serious for a moment. Lara had already gone back to Tel Aviv, but not before having a turbulent affair

with a fellow dancer. He was not Hans, but he was German through and through. 'But Berlin is always here for everyone.'

Berlin tango had taught me that you can have a connection while practising disassociation. You can connect with your dance partners deeply, even have tangasms, without trying to torture them and yourself into a Tango Relationship or Tango Affair, or anything else with capital letters.

Saying goodbye now – to Berlin seasons and to my tango beloveds, my *tanzerisch Verlieben* – was hard, harder even than that adiós, a year ago, in Auguststrasse.

The taxi drove us past Clärchens Ballhaus, past the hunched ruin of Tacheles, under the blossoming linden trees, over the bridge of the River Spree, past the Kunst und Nostalgie market where fake pieces of the wall were for sale (stamped for authenticity), past the stains and scars of the old Berlin and the glass and glitz of the new Berlin, and Hans reached into his pocket and produced something. It was my forgotten tango-couple photo.

'I have resolved your big problem,' he said. 'The Catastrophist told me the meaning of the writing. You know what is it saying? Tangotanzen macht schön.'

The couple seemed to wink at me with their hard faces: see, we told you.

CORTINA

KK: So, why do you tango?

Spanish woman, twenty-six: Because I want to find out who I am.

Uruguayan man, fifty-three: Because I remember who I am.

Australian woman, thirty-six: Because I am more myself.

Englishman, thirty-eight: Because I can forget who I am.

American woman, twenty-nine: Because I can be someone else.

Greek man, forty: Because I don't want to die.

TANDA THREE

THE MIND

In Search of Home

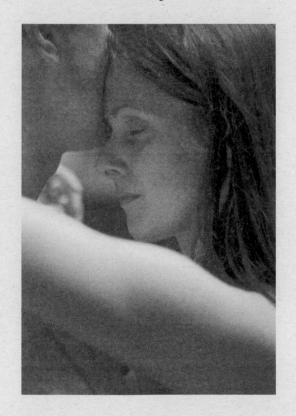

SEVEN

To Dream, and Nothing More

TANGO LESSON: TOURISM

'KK, you're back!'

Wednesday night, Limon, Viaduct Harbour. The Turks behind the bar are playing a selection of Silvester's beloved Pugliese, and my Auckland tango friends are shocked to see me.

'We didn't think we'd see you again.'

'But I live here, remember?' I said. I checked myself before I launched into a nostalgic monologue like Rachel. Oh, the milongas in Berlin, you cannot imagine!

'No, you *exist* here,' they said.

'Gad,' Anoush said, 'I would have stayed in Berlin if I were you!'

'But tango mania has arrived in the Antipodes, KK,' James said. 'It's all happening here. You don't have to run away any more.'

'Don't worry,' I said. 'I'm staying put.'

'For at least a few months, you mean,' James laughed. 'I know you too well.'

I ignored this remark, because back in Limon, life was sweet. Tangueros old and new, from here and there, danced lazily, drank flat white coffees and Chardonnay and caught up on tango happenings. New milongas were running, new teachers had materialized, new good dancers had emerged from the various studios, and new relationships had blossomed in the wreckage of previous ones. Beach parties, 'barbies' and even a monthly milonga in the Auckland Yacht Club with the thousand sails around us, were on the tango menu. There was an NZ Tango Championship now, and my old friend Gavin with the hobbit's smile won the title for best performance by executing perfect ganchos and sacadas in his sharp black suit, with his younger dance partner who wore shiny red stilettos. Fency thet, ladies!

And then there was Silvester.

'I think we owe ourselves a few tandas. What do you say?' Silvester held out his hand, and I didn't say anything because I was grateful beyond words to be in his arms again.

'Your style has a changed a bit,' he said. 'You're disassociating.'

'Sorry,' I said. Silvester and I danced a strictly close-embrace style, which is all about association.

'No,' he said. 'Sorry is only when you hurt me. I've been trying to alternate open embrace and close embrace anyway, so it's all good. It's good to have you back.'

'It's good to be back.'

Our next dance was 'our' song from two years ago, 'Una vez'. It felt strange to be dancing it again with him. It made me realize that Silvester was my ultimate 'dance beloved'. In his arms, I still found the kind of bliss that I hadn't found anywhere else. Not even with Mr Che or Carlos Rivarola.

Only once in a lifetime, only once . . .

'Your axis is spot on,' Silvester said afterwards. 'Your balance has improved, too.'

The truth is that, after my year of emotional equilibrium in Berlin, balance was something I was desperately trying to hold on to. The other truth is that my life, like tango itself, was now moving anti-clockwise again. I was thirty and living in my parents' house by the beach. I was taking walks along the beach with the bittersweet 'Melody of the Heart' playing in my head, collecting shells and missing Berlin's ugly beauty. I missed the bullet holes in the buildings of Auguststrasse. I missed Mr Che and our banter full of innuendo. I missed Lara and her clever, gorgeous head.

'Una vez' came to an end, and then a famous waltz came on.

'"Soñar y nada más",' Silvester said. To dream and nothing more. 'The world's most beautiful waltz. I love it.'

It was an hour before midnight. We danced tight, perfect giros, and the aroma of sizzling lamb drifted over us. I closed my eyes and tried to think of nothing but this, *to dream and nothing more . . .*

But I did want something more. I didn't know what it was, but I knew that here in the Antipodes I felt as anguished as ever. *Don't wake up if you're dreaming of love, girl*, the singer was crooning, *for love is a dream.*

Before the dance was over, with the corner of my eye, I glimpsed something strange. It was a man's face pressed against the glass wall of Limon, and it was looking at me. I knew instantly who it was, although we hadn't seen each other for years.

Terry and I had been friends in a small university town in the South Island, and for the last eight years, he'd been writing to me from various troubled parts of the world where he was having one troubled

145

experience after another – slumming it in the streets of Damascus, being chased by a drug gang in Colombia and shadowed by the Syrian secret police as an Israeli agent . . . none of it surprised me, because he'd always been a fabulist and an opportunist. The latest I knew was that he was doing something mysterious in the British Army.

Now, he walked into Limon and it was as if the sun came out. A brutal crew-cut had replaced the curls. His face was worn and aged, though he wasn't even twenty-six yet. But the green eyes were still the same – happy and curious. He was carrying a guitar, which in his clumsiness he banged against a table, and it rang out loudly while a waltz called 'Neighbourhood Romance' was playing in the background.

'Yeah, gidday Kapka,' he said. 'You've cut your hair.'

I shrugged, feeling ridiculously happy to see him. 'Well, it's been . . . what, eight years? I had to have a haircut.'

He gave me a big, cheesy grin and I found myself grinning back. He looked absurd among our *dolce vita* crew with his shorn head and military rucksack.

'But, Terry, what are you doing here?'

'My grandfather died. I'm on leave, home for the funeral.'

'Sorry to hear that. But . . . what are you doing *here*?' I said.

'I dunno. I thought I'd go for a gander. See the new Viaduct Harbour, let my hair down, you know. Plus, I saw a photo of you dancing somewhere, so I thought I'd look you up.'

Despite his exaggerated Kiwi swagger and choice of words, the years of 'officer class' training had given him an incongruous English accent.

'But . . . how did you know I'd be here?'

'I didn't. I just thought I'd rock up. And here you are.'

He gave me the longest, warmest hug I could take without breaking into a waltz. He sat down with the rest of the tango crew at our long table, and met everyone. 'Yeah, gidday Jim. How do I pick up this tango thing?'

'Tango is not a disease to be picked up, mate,' James said, and everybody laughed. James was protective of me against this intruder, but by the end of the night, Terry had charmed them all. And especially me.

A week later, he left for Britain, and what followed was ten months of highly romantic correspondence that featured crackpot plans of how to get together in the same place permanently. Clearly, fate had always wanted us to be together, since we first met as teenagers at university, when he was pimply and I was anorexic.

We finally agreed I'd move to Britain until his commission came to an end. So under the worried eyes of my parents and the knowing eyes of Piazzolla, who was still playing his bandoneon on the wall, I packed a few boxes with my tango shoes, CDs and books. I had a visa, a one-way ticket to Europe and what looked like the love of my life. What more does a romantic need? Nothing more. Nada más.

Once again, I said goodbye to my tango friends in Auckland.

'KK, if it doesn't work out with the commando, you always have tango in Limon.' James chuckled into his Chardonnay, but it was a sad chuckle.

'I look forward to your army dispatches,' Geoff said.

'Long live the Queen!' Murat winked at me. He was the handsome new Turkish owner of Limon.

'Go, tengow!' Anoush waved me away with blood-red nails.

*

Terry and I were strangers who shared nothing except a dream. But it was a big dream. When Terry met me at Heathrow Airport, we hadn't seen each other for ten months. I was shocked to see an overgrown boy in khaki shorts and Jesus sandals. My God, what have I done, I thought for one insane second. But there was no turning back. I had a two-year visa and my previous life was sealed in boxes in my parents' basement. Besides, I loved this man who now, in the middle of the booming airport crowd, was strumming a little tune on his guitar by way of a greeting. What was it? It was the opening chords of 'Malena' – my favourite song.

'Malena sings the tango, like no-one else . . .'

I was grinning through my tears, and so was he. Grinning and crying, both of us, with relief, after years of criss-crossing the earth looking for something, for someone. No more bandoneon blues for Malena.

Terry had warned me that he was living in an army barracks in the middle of nowhere. Inside his room in the military compound, I arranged my dance shoes, CDs and books along the window sill while Terry polished his parade shoes interminably, because they had to shine at all times – for the Queen. The trees dripped with blossoms, and the evenings were balmy and full of the future. And the present?

Presently, we were the happiest couple in the world. We were on the Georgian rooftop of the Officers' Mess building overlooking the parade square. The crickets screeched, and the moon looked painted against the indigo sky, like in that corny scene from the film *The Day that You Would Love Me* where Carlos Gardel is serenading his future wife, their faces caked in make-up and their 1920s hair shiny with brilliantine.

Terry put on 'Soñar y nada más'.

'Care for a dance?' he said, beaming. He was always beaming, and around him, so was I.

'But . . .' I smiled, puzzled. Surely he didn't know how to waltz?

But he did, in his own military style. He knew to lead the waltz giro – one–two–three, one–two–three – even if he couldn't keep up with the music yet. Every weekend for the past few months, while his mates hit the pub or went 'whoring', he had been driving to Cambridge to take tango lessons, in an old Presbyterian church hall. He'd then stay for the milonga, and spend the night somewhere in the fields nearby in his camouflage sleeping bag.

'I know I'm no good,' he said. 'But I wanted to surprise you. I don't really get this music and why it's so bloody sad, but I want to dance with you. You've got to teach me now.'

Unfortunately, I was a hopeless teacher. I had only ever followed, never led, and imagining the man's part was like trying to step through to the other side of the looking glass.

Everything is in reverse on the other side. The man lifts his *left* arm. He walks forward a lot while the woman retreats with backward *caminata* or backward ochos – a nod to the macho origins of the dance – and he has always to keep an eye on the terrain, even if the terrain consists of a bed rather than other couples. I had no clue how any of this worked. All I could say to Terry were things like lead from the chest, listen to the music, connect with me, no, don't put your foot there, your hand is hurting my back, that's lovely, do it again – what do you mean, you can't?

'Holy mother of Jesus! How am I supposed to do all of that at once

without my brain having a short-circuit?' he said, and I hadn't the faintest idea, except to say, 'Don't think, just feel,' which didn't help at all, because for the leader thinking is essential. Alas, the boring computer geeks had been right! You do need a system if you are going to lead, and you need a good, tidy brain.

True, tango is the ultimate dance of improvisation, but we're not talking about disco here. We're talking about improvisation based on a pattern of steps – remember Oscar with his four coins on the floor – which, after more than a century of competitive social dancing, has expanded, like the universe, into a cosmic system of incalculable beauty and complexity. Each one of us who dares to enter the celestial gateway of tango must discover this for himself. From the four coins on the floor to the Milky Way, each of us travels the road alone – even when surrounded by others, even when taught by a lover.

I try to explain all this to Terry, but between his military brain and my mixed metaphors, something gets lost in translation. I try to lead him, to illustrate the points I can't make otherwise, but fail miserably.

(*Pausa*: These days, it is very common for women to learn the man's part. The trend began in Europe and North America in the 1990s, and travelled back to Argentina, in a typical instance of reverse cultural tango traffic. There are now woman-only practicas all over the world, and seeing two women dancing is commonplace at milongas everywhere. Many women learn to lead simply because they don't get enough dances, or because they don't want to feel at the mercy of men.

What's the point of same-sex tango, you ask. Is it still tango? Yes, technically. But in every other way, unless you're gay, it's mind-numbingly dull. In my experience, dancing with a woman, no matter

how good a leader she is, feels like *rehearsing for the real thing*. OK, but didn't someone say earlier that tango shouldn't be about sex? Correct. Entire books have been written on gender in tango, some of which are even readable, so all I can say is this: now you see what a tangled web we weave when first we practise tango.)

The fact is, I didn't *want* to know how the man's part worked. It would have taken the enchantment away, and I want to feel enchanted when I dance. I want the man to *just do it*, I don't care how he gets there.

Besides, unless you have the activist gene in you, you will find that there is something fundamentally unsexy about teaching your man how to tango. It's different if you're Jennifer Lopez, and Richard Gere rocks up to your studio. You're teacher and pupil, and the steamy stuff happens later, climaxing in that late-night studio scene where they are both sweaty and you don't even notice that she is *leading* while pretending to follow – a neat trick indeed, something only a pro can pull off. But when the steamy stuff comes first, and the tango second, the lessons are an anticlimax. So I found myself saying astonishing untruths to Terry that I almost believed myself.

'Why bother with tango anyway? I don't really care about dancing any more. Maybe tango was just a chapter in my life and now it's over. How are those cupcakes?'

'But I can tell that you miss dancing.' He saw right through my earnest attempts at homemaking. 'You looked so happy when you were dancing in Auckland with that guy. I want you to feel like that when you dance with me. I want to be good enough to do that.'

So, whenever Terry wasn't away training, we went looking for tango classes and milongas in nearby towns. Tango in Canterbury? Oh,

yes. Tango in Gravesend? You bet. He applied himself to the business of tango as if it were a military exercise, and made steady progress. And when he went off on actual training missions, and the military brass band struck up 'We are the Champions' in the parade square outside, I would turn to my old friend Piazzolla to muffle the loneliness, the worry and the growing sense that I was stuck in a not very funny sitcom about someone else's life.

Once again, tango was the perfect soundtrack for my mood. Give me 'Oblivion' any time. Give me 'Years of Loneliness'. Give me 'Winter in Buenos Aires'. Carlos Gardel, Pugliese, Di Sarli, Gotan Project, Daniel Melingo – they were my surrogate family. They understood me wherever I went. They understood me especially well here, in the army barracks, where I was the only 'civvie' and also the only woman. And I quickly realized that if I didn't go somewhere – anywhere – other than the barracks, I'd start climbing the walls to the sound of a song called 'My Delirium'. I started coming up with ideas for travel articles. And – sure enough – all the cities I went to were places where I knew I could dance.

This is how I discovered that tango mania was sweeping across Europe like the Spanish influenza. Of course, it hadn't always been this way. Although tango travelled from the backstreets of Buenos Aires to the ballrooms of Europe in the early years of the twentieth century, later it spent several decades underground, thanks to war, dirty politics and pop music.

Who killed tango in the late 1950s? The generals who deposed Perón and introduced a 'state of siege' where public meetings of groups larger than three were banned. Who killed tango in the 1960s? Jazz

and rock. Who killed tango in the 1970s? The Beatles. Who killed tango in the early 1980s? The generals again, who also killed thirty thousand souls. The dark ages of tango lasted a long time.

The turning point came in the 1980s when Astor Piazzolla's strange new music revolutionized the genre. In 1982, an international show called 'Tango Argentino' made tango look sexy and modern all over again, and for this we must thank the first great couple of show tango – Maria Nieves and Juan Carlos Copes.

In the 1990s, Argentine tango began to go global. Tango schools, milongas, events and concerts started popping up in the big cities of Europe, North America, South America, Asia and the Antipodes. And by the first decade of the twenty-first century, there was no city, town or backwater in Europe that didn't have a tango community. In just twenty years, Argentine tango went from being a down-at-heel dancer in an unswept corner of the map to a diva in stilettos on the glittery centre stage. This is how tango power passed from those few pioneers who had kept the tango fires burning – like Nieves and Copes, Miguel Angel Zotto, los Dinzel (more on whom later), Carlos Gavito (more on whom shortly) – to a giant industry of professional dancers who now compete over tango's gold pot.

In every European city where tango is danced – and there are very few where it isn't – a distinctive tango personality has emerged. I discovered that just as each of us dances *as we are* in our deepest selves – sensuously, tensely, dreamily, desperately, egotistically, generously, fussily, vainly, frigidly, angrily – in the same way, cities dance as they are.

And how was I? I was schizophrenic, that's how, because in my first year in England, I tried to stitch up a life from two half-lives that had

exactly nothing in common. In fact, they negated each other – from the shoes, to the ideology. I'm talking about the British Army and tango, of course.

One moment, I was living in a military compound, with a patrolled gate and shorn men with clipped accents, all identical in camouflage uniforms as they came and went to and from Iraq and Afghanistan. At the interminable silverware dinners of roast and three veggies in the Mess dining hall, everybody had to wear a suit. On special occasions, like 'ladies' nights', when every officer could invite a 'lady' and the gentlemen moved chairs after each course, we all stood up at the long tables – long and stretching into the distance like a dream of Empire, and covered with the silver loot of the former colonies – we stood and raised crystal port glasses to the giant portrait of a young Queen Elizabeth II with a corgie.

The next moment, I was slipping through the patrol gates in my guise as a tango butterfly, flitting from one airport to another. In my hand luggage, my tango travel essentials were packed as small as possible, like a dirty secret: a pair of tango shoes, a dress, a silk fan, a city map with tango venues marked on it, and an eye mask – so that I could sleep through the days and dance through the nights.

So, let me take you on a milonga crawl around Europe, moving from east to west.

Milonga 1: Before and After in Sofia

Before and After takes place in a decadent Secession house-restaurant. The *before* was the end of the nineteenth and beginning of the twentieth centuries, before the Red Army arrived and it all went to hell in a tank. This was the bourgeois-bohemian house of a poet and high-

society lady who entertained her friends right here, around the marble fountain. They tangoed and smoked long-handled cigarillos, had affairs, became tubercular and wrote lyrical verse.

The *after* is now, Sunday evening, with leather seats, photos of tangueros on the white-and-blue Art Deco walls and dapper men and women changing shoes on the Viennese chairs. I have just missed a class with the teacher couple, Danie and Charlie, whose technique is as sharp as their dress sense. She has a designer skirt and fishnet stockings, and he wears a paisley cravat tucked into a crisp white shirt, which gives him a warm compadrito touch.

He needs it, because the tango grapevine has it that back in the Cold War – which we may call the *in between* – he was a cop or a secret agent. (*Pausa*: There was no tango under Communism. Tango and Communism: it just doesn't gel.) Charlie's fish-cold eyes are in tune with this rumour, but, as we've seen before, the tango grapevine is often out of tune with reality. What is certain, though, is that Charlie is nuts about tango. He started up the tango scene here some years ago from nothing, and his whole life revolves around classes, performances and even a tango radio station, Sofia Tango Radio.

It's now milonga time, and Charlie asks the newbie (me) for a dance to a grand-sounding track by the De Angelis orchestra. Charlie is a good dancer, even if he is a transcontinental cousin of Tim Sharp. His technique is faultless, but it feels like we're ice-skating across some frozen tundra of the soul.

'Come and visit us more often.' He kisses my hand at the end. Close up, it looks as though his face has seen a few things, not all of them pretty. 'Don't be a stranger.'

Sofia is where I spent the first sixteen years of my life, and the only

place in the world where they can spell *and* pronounce my name without screwing up. But like all émigrés, I'm trapped in some outdated version of the homeland, and out of touch with everything new here – except tango.

'Hola!' An older guy is proffering a hand. 'Does the *señorita* dance?' She does, and just one ocho with this cravat-wearing, tanned old fox tells me that he has a salsa heart in an alpinist's body. In short, he is a terrible tango dancer. But he's delightful in every other way, and I'm trying not to be a tango snob. He is an antiques dealer. At his stall at the city's flea market, with the golden domes of Alexander Nevsky Cathedral behind, I find the junk-heap of history: old gramophones and gold-plated watches, Nazi insignia, Ottoman filigree rings, furs from extinct animals, a matryoshka doll set where Putin goes inside Stalin, and Stalin goes inside Lenin.

'I think they forgot Brezhnev,' my new friend grins with a gold tooth.

It's almost like being back in Berlin.

Back in Before and After, I meet the other top tango couples in town. Ivo and Nadia are dashing Oxford graduates.

'I'm an economist, but I live for tango,' Ivo smiles. His black hair is threaded with silver. Nadia is in pharmaceuticals, and looks like she just stepped out of the pages of *Vogue*.

They are the best of the *after* generation, which is my generation. Except they returned here to create something beautiful, like their dance studio, Tanguerin. What have I, the expat, created? A massive carbon footprint across the globe. A dream, and nothing more.

'Do you feel at home in Britain?' Ivo asks after a tanda. He is a playful, fluid dancer as well as a mind reader.

'No,' I say. 'But maybe that's because I'm living in military barracks.'

He laughs. 'I lived in Oxford for a while, so I know how you feel.'

'Just enjoy being a visitor and not having to live here,' Nadia advises at their table.

'That's right. If I could dance non-stop, I would,' a gaunt-faced woman at the table says. She's a former gymnast, and wears long red silk gloves. 'It takes *a lot* of dancing to be able to live in this country.'

'You don't have to see it that way.' A man smiles with dimples. His name is Ivailo, and he has the heavy-lidded face of a Russian count and the body of a wrestler.

'Whether you live here or in Casablanca is just an accident of geography,' he continues. 'You make your own world.'

D'Arienzo's 'Pensalo bien' ('Think About It Well)' is playing, and when Ivailo dances with his ballerina-faced partner a tanda glittering with flights of fancy, I see three things: they are fantastic dancers, they are in love and they have indeed created their own world here in the post-Communist *after*. Ivailo has degrees in maths, psychiatry, drama and semiotics, and for him, tango isn't just a dance, it's a statement of political and moral intent. We get a taste of Ivailo's complex vision from his Tango Manifesto. It states (in English) that tango is:

1. a radical resistance against the banality and madness of an empty mind, a moral protection against contemporary kitsch;

2. a challenge to unite with the dangerous other, a preserved oasis of the expression 'I can', the freedom to touch the entire world;

3. the unbridled ecstasy of our own identity which is evoked to liberate us from the feudalism of our own history;

4. a deep penetration into the strata of the human soul, where the native vortex of Duende oscillates, shattering the horrors of civilization.

If we deconstruct this garble of semiotese, we get – I think – a belief that tango offers the possibility of escape, connection, freedom and ecstasy. This sounds pretty good to me. When I think about it, so far in my quest, I've known at least two of these things: escape and connection. Freedom and ecstasy, however, remain strangers to me.

'Does the señorita dance?' The antiques dealer is proferring a hand and a smile so sincere, so hopeful, that to say no would be like a slap. So I grit my teeth and push through the tanda with him and an aching back.

At the end of the milonga, everyone kiss-kisses and says things like See you at the practica next week, Call me about the shoes, I've got the Istanbul workshops on film, See you tomorrow. I kiss-kiss, too, but I won't be here tomorrow. In spite of the warm welcome and the charming people, Sofia is not my home any more. I have a wealth of memories here, but they are from too long ago, and don't connect with the fact that I am just a tango tourist now.

Milonga 2: The Old Port in Marseilles

I'm upstairs in a seedy bar, one of many in the Old Port, where Europe ends and Africa begins. Outside: boat masts in the pink dusk and an eaten sandstone fortress, like the remains of a film set. Inside: maritime maps, cigar smoke and salt in the air. To the sound of a chipper milonga, thirty people dance or watch. It's a casual weekday event, and everyone looks casually smart in light cottons. I am trying to enjoy

rocking to a milonga with a man possessed of white shoes (always a bad sign) and poor rhythm.

(*Pausa*: Tango, because of the pauses it allows, can conceal faults in your musicality and technique. But milonga is pitiless. Dancing a milonga tanda with an unknown partner straight away is rare because experienced dancers prefer to warm up with something more forgiving, such as tango or waltz. But my partner doesn't seem to care.)

'I'm Rolland. Do you have many *amores*?' he asks when we sit down at his table, which his younger girlfriend has just vacated to dance with someone.

'Excuse me?'

'We just danced to "Milonga de mis amores" by Aníbal Troilo, *n'est-ce pas*?'

Rolland has a ponytail, a crumpled Indian-style shirt and dodgy teeth, but behind the round John Lennon glasses, his eyes are comical, so I relax.

'Just one,' I say. 'It's enough.'

'How old are you?'

'Thirty-one.'

'You have another ten years to enjoy.'

'Enjoy what?'

'Your prime. Make the most of it.'

The cheeky old goat. 'And how old are you?'

'Fifty. Men have an extra ten years. Still, I'm past it now.'

'But you have a young girlfriend . . .' I point out.

'Yes. And she's leaving. The story of my life. And the story of Marseilles. See, Hamadi here has just arrived.'

Hamadi is a stocky Algerian with dreadlocks and a crisp white shirt,

and he has come over to ask me for a dance. In more conservative tango settings, a woman is never approached when sitting with a man. But they're not fussed about etiquette here, and that's good news for the stranger in town.

'*Eh, oui.*' Hamadi's face blooms into a dark smile. 'I've been arriving for ten years now.'

Hamadi is here illegally, doing odd jobs. His Levantine good looks are eaten away by rough living and too many magic mushrooms, and there is a fever in his eyes that already haunts me, just as this city has haunted me since I lived here for a while in my early twenties as a fresh French graduate. Hamadi holds me in a tight, close embrace as if there is no tomorrow. True, he is one of those self-taught dancers who took a few classes years ago and made up the rest, but he *feels* Di Sarli's romantic tune 'Motivo sentimental' in his body, and I feel it with him. I feel it so much that after three tandas there is a lump in my throat, and possibly in his trousers, though I might be wrong. In any case, I decide it would be disloyal to Terry to keep feeling this sort of connection with another man, so I say thank you, and regret it instantly, because now I see that the lump is Hamadi's wallet, which he extracts from his trouser pocket to buy a Coke.

(*Pausa*: Is it OK for a man to be 'glad to see you' while he dances with you? Well, these things can't be helped. But it is not OK to want the woman to know about it. In fact, men who do that are surprisingly rare, and they are instantly ostracized. Bodily intrusions outside the remit of the dance are a major no-no in tango, which prides itself on its civilized code of honour. In any case, your pelvises are not in contact so it's easy to avoid finding out, but sometimes a brush of the leg or hip against his crotch raises a question.

This is where the traditional baggy trousers of the compadrito are handy in more ways than one. In fact, you won't find a true tanguero wearing skinny or fitted jeans. For women, stretchy fabrics, loose skirts and baggy, harem-style trousers are favoured. Ease of bottom movement is the bottom line, so to speak.)

At the bar, I chat with Hamadi. His brother, a cop, was killed in Algiers in a terrorist attack. Hamadi left soon after.

'*Et oui*, people ask me if I'll go back,' he shrugs. 'Who was it that said, my country's past is sad, its present is catastrophic, but fortunately it has no future whatsoever?' His throaty chuckle gives me permission to smile, too.

'People here get into *magouilles*, shady deals. Me, I try to stay out of trouble. What I'm saying is, going to Algeria is tricky. Ships leave the port every night . . . but I can't board a plane or ship 'cause I don't have papers. So to go home, I have to drive to Gibraltar, then catch a ferry.'

'Must be hard for your mother,' I say.

'Et oui, it kills her . . . but then I found tango. I love it. I can dance seven nights a week if I want. What I'm saying is, it gives me everything I need. And who knows, maybe one day I'll marry a French woman and become respectable!'

'There are lots of attractive women here,' I say. We look at the women gliding past with their slim hips and high heels.

'There's a problem,' Hamadi sighs. 'They're too skinny. They make me feel sad inside. Hey, bro!'

A young Arab has just arrived, hair-gelled and dapper in a charcoal suit.

'Yussef, the other *maghrebin* of tango,' Hamadi grins. Maghrebin means North African.

161

'Yeah, two of us, and already it's a crowd!' Yussef grins back.

Yussef is cocky and dances an excellent milonguero style with lots of pauses and leans.

'So, Yussef, you in town to see your folks?' Hamadi says, and adds for my benefit, 'He lives in London.'

'Yep.' Yussef turns to me. 'In London, I'm taking classes with Gavito.' This explains the pauses and leans: they are Carlos Gavito's trademark style, most dramatically seen in his stage performance with Marcela Duran in the show 'Forever Tango'.

'Next time you're in London, Kapka, you should check out The Dome,' Yussef adds. He is obviously chuffed to bits to be living in London.

We share a joint that Hamadi produces from his magic pocket.

(*Pausa*: Although drunk dancing is a no-no, tango is partial to drugs of all kinds, soft and hard, but especially those you can inhale or snort, and there is an entire subcategory of tango songs about bars and intoxication. Examples: 'Tonight I'm Getting Wasted', 'The Last Drink', 'Whisky', 'Cocaine Blossoms'. The refrain of a 1940s song called 'Tango and Drinking' goes like this: 'Nostalgia drives me to drinking / Drinking drives me to tango'. Old-school milongueros will have had an addiction problem at some point in their lives. A famous dancer of the 1940s was dubbed el Petróleo because of the volume of wine he imbibed. Later in life, he turned to non-alcoholic drinks, but he reported that it was worse – they 'oxidized' him.)

While the two men catch up, I gaze out over the harbour. How fitting it is that Marseilles was tango's first European port of call. From here, it spread across Europe and all the way to St Petersburg.

Who brought it? Argentinian sailors on board the *Sarmiento* ship. What were the first songs they brought? 'La Morocha' ('The Brunette') by Uruguayan musician Saborido, and 'El Choclo' ('The Corn Cob'). Despite its agricultural name, it is one of tango's most famous tunes, up there with 'La Cumparsita'. Its composer and lyricist, Angel Villoldo, was the first man to write tango lyrics in a literary language, as opposed to suburban slang, so he can be credited with creating the genre of tango poetry. 'The Corn Cob' became so popular that it flourished in three different poetic crops, and my favourite is the one that Discépolo wrote half a century later, especially for the tango diva Libertad Lamarque, who performed it in Buñuel's film *Gran Casino*. 'With this jokey friendly song / Tango was born,' it goes. 'It shot like a cry / From the sordid 'burbs to the sky.'

So who did the Argentinian sailors dance with here? The poor local girls – Italians, Corsicans, French, Armenians, Greeks – who were game, unlike respectable ladies who didn't set foot in the port. They danced right where this bar is, and in the seedy lanes behind. This is where it all happened – the crime, the trade, the sex, the dreams, the nighmares, the tango.

It was the dance of the twentieth century. Tango was also the first couple dance to relish improvisation. All couple dance until then had a rigid pattern, and all couples executed the same figures. Waltz didn't, but its variations were extremely limited. Dancing a tango, on the other hand, with a known or unknown partner, is always creative, fun, intimate – and therefore unpredictable. Two tangos are never the same, even for the same couple.

Tango was history's first individualist dance. Tango was the first urban dance to leave the ballroom. Tango was the first couple dance

to transcend society, age and race. Tango was never *safe*. This is why it has excited people for so long.

'*Ça va*, la Kapka?' Hamadi looks at me.

'You know, Hamadi,' I say, 'I dream of Marseilles a lot. And now that I'm back here, it feels surreal, like . . .' I don't know how to finish. I'm high on skunk and fuzzy happiness. Hamadi looks at me with blood-shot eyes.

'Et oui,' he says, 'there are streets here called Guadeloupe, Martinique, Montevideo, Israel, Palestine, Alexandria, Casablanca . . . what I'm saying is, you're not the only one, la Kapka.'

'That's it.' Rolland has joined us again. 'And in Buenos Aires, it's the same. There's a district called Palermo. A square called Plaza Francia. That's why tango came about in port cities.'

'It's not always about place.' His girlfriend Margot has joined us. 'Tango deals with time, above all.' Her black hair falls over wide yoga shoulders. 'Tango is about man's struggle with time. Tango just can't accept that everything goes. It's like a stuck record.'

'She's got it all figured out,' Rolland says. 'She's gonna be humming "Omm" instead of dancing.' Behind the sarcasm, I hear his hurt. She smiles a forgiving Zen smile.

'Are you?' I ask her.

'Yes, I'm going to a Buddhist monastery,' she says. 'For a while. I don't make long-term plans because I've learnt that it's pointless. Real life is where you are, here and now.'

'That's it, Margot.' Hamadi smiles darkly. 'Me, I've only just arrived.'

'*Maaaar, ya no tengo a nadie . . .*' Rolland suddenly breaks into song. The tune 'Tristeza marina' ('Mariner's Blues') is playing. He's been smoking a joint, too.

'My dear sea, I have nobody . . . I have no love no more,' Rolland explains the lyrics to us. 'But he did have a woman, called Margot.'

He looks at the Buddhist Margot, who presently leaves the table. It's too much sentiment for her.

'But he loved the sea too much, and lost Margot,' Rolland carries on. Behind the little glasses, his eyes look tired. 'That's the curse of the port city. That's why they put that massive golden Notre Dame on top of the hill, to protect the sailors. But no fucking virgin can save us. Tango, that's the only thing that can save a man's soul.'

With impeccable timing, Hamadi nods at me with an invitation. Hamadi is no French intellectual. He speaks with his body.

And although I never saw him again, *what I'm saying is*, during our twelve minutes I knew for sure where real life was.

Milonga 3: Zero Hour in London

When Astor Piazzolla was playing the clubs of Buenos Aires in the 1950s, he and his fellow musicians would take a break to have a stretch outside. In the emptiness of the midnight streets, he would hear the eerie, lonely, dangerous 'zero hour', which he later played on his bandoneon. Zero Hour is the name of London's most famous milonga, and it happens inside a place called The Dome. I've come on Yussef's recommendation.

Here at The Dome, you are greeted by a tall, dark-haired Bosnian woman called Biljana who founded the milonga, and who moves like a queen. On the raised podium is wiry, olive-skinned Os: one of Europe's first – and finest – specialist tango DJs. Together (though no longer *actually* together), they create a heady mix of old and new

tangos, Canaro and Gotan Project, Pugliese and Piazzolla, mellow and upbeat moods, bright salsa cortinas and dim lights.

And, goodness, is that . . .

'Look, Gavito is dancing,' says a woman behind an open silk fan.

There on the floor is one of tango's living legends: Carlos Gavito. The old devil's arm is around some young slip of a thing. His black-clad frame, bald pate, white beard, gold ring and that glint in the eye spell out *milonguero*.

If you want to know what sort of a creature the true milonguero is, you must see Gavito dancing. You must see his 'pyramid' signature style, where he and his partner are sharply inclined against each other at the kind of angle that would give an osteopath nightmares. And you must see – if you don't mind watching her simulate an orgasm facially, that is – Gavito and his red-hot ex-partner Marcela Duran dance their piece in the show 'Forever Tango'. If seeing them dance doesn't make you shudder, you may consider yourself officially dead. In fact, the aging Gavito and the statuesque Marcela met right here some years ago, while she was touring with the show. After starring with her in 'Forever Tango' worldwide, Gavito became forever famous – including, finally, in his home country, where he had been unknown after a life-time in Europe and the Middle East.

'Gavito is the best teacher you could have,' Os the DJ tells me. Os is a longtime Argentinian expat, and I've just met him because I caught my stiletto on some cables and nearly fell on my face. 'Tango has blinded you,' Os said, and helped me get untangled. 'It happens to people.'

'I've taken some classes with him,' he says. 'Gavito is pure tango. Melody, poetry and movement, as someone said.'

'And ladies . . .' I say. Gavito has enjoyed a string of stunning dance and life partners.

(*Pausa*: What you see in Gavito and Marcela's shattering perform-ance is not a *prelude* to what went on between them in private – it's the *pinnacle*. This is what Gavito has said on the subject: 'Our rela-tionship represented that rare thing we search for in life, and sometimes find – but without the need for it to go any further than the dance, because it was always about the dance. The dance was much more powerful than the personal relationship.'

In short, they turned the tangasm into art, then parted ways. This tells me something about the nature of: 1. the perfect tango connec-tion; 2. the Tango Relationship; and 3. every true tanguero's life quest. What it tells me is not good news, because the message here is: make art, not love. Love will let you down. Art won't.)

'Yes, the ladies . . .' Os is saying now. I never thought DJs could be shy, but Os is just that: a shy DJ with glasses. 'Gavito has a way,' he says. 'A way with tango, a way with ladies, a way with whisky . . . he lives the way he dances.'

'And do you dance?'

'I used to. But not much these days.'

'Why not?'

'Oh, you know how it is with tango . . . it waxes and wanes.'

'Like the moon.'

'Exactly.' He humours me with a slit-eyed smile so disarming I want to hug him. 'You know this tune? "A media luz". In half-darkness. An old song, from 1925. *Corrientes, tres-quatro-ocho* . . . Have you been to Corrientes? The avenue that never sleeps . . .'

I ask DJ Os about Zero Hour.

'Tango in London started small, back in the early 1990s. A Chilean guy and an English lady gave me classes. Then I met Biljana. She asked me to DJ. I played Gotan Project here when they first started up, and nobody was dancing! Now electrotango is everywhere. So, you see, tangomania has arrived in Europe. It's good, no?' He smiles his tobaccoey smile behind his glasses.

Under DJ Os's bespectacled gaze, the Zero Hour people fill the dance floor. The impassive Asian girls with too much make-up, the East European women with angry eyes, the English roses with pallid faces dance with the Latin men with paunches, the English men with determination, the American men with abandon. They dance mostly tango Nuevo, open embrace.

London, along with Paris, was the original European capital of tangomania. In the lead-up to the First World War (which temporarily killed European tango), tangomania swept through London. The novelist H. G. Wells called 1913 'the year of the tango', and the tango ball in the Selfridges department store was *the* event to attend. *Punch* magazine wasn't impressed, and wrote: 'So, we understand that the tango is a mix of black dance and gaucho dance, but the young Englishmen and women who dance it look like spastics.'

They were happy spastics, though. Tango transformed English society, the courting ritual and even fashion. The hat feather started pointing upwards, to avoid poking out the eyes of your dance partner. Skirts started opening up and splitting, to allow leg movement. The corset was tossed aside. The tango shoe and tango stocking were an industry. Several tango instruction manuals appeared, one of which was written by the prodigal son of a rich Argentine family. He was supposed to be studying engineering in Europe. Instead, he was

performing in Shaftesbury Theatre and writing a dance manual under an English name, in case Mum and Dad back home found out.

And now? Now they dance with self-conscious embellishments and the traffic is a bit out of control, but they are happy to be here and doing this. The split, curtain-like skirt that appeared in Selfridges almost one hundred years ago is still here – but much shorter. The corset has reappeared as a soft bustier, and is on its way to becoming a strapless top and, eventually, the boob tube favoured by professional tango nymphs around the world.

Gavito dances with yet another nymph. Yussef (back from Marseilles) dances with Biljana. I dance with Clive James, who has come on a rare tango outing to accompany me across 'Jack the Ripper' territory (Tufnell Park).

'Actually,' he explains as we scurry to the milonga, 'Jack the Ripper had to leave, it was getting too dangerous for him round here.' Now he's huffing as he executes an ambitious double giro. It's good, but he's a perfectionist.

'Shit, forget that giro ever happened,' he puffs. 'I want to be born again as Osvaldo Zotto. He can uncork a giro that has chapter after chapter, like a little book.'

'Not as Gavito?'

'Are you kidding me? I've already lost my hair in this lifetime.'

Tonight, I'll sleep on Clive's leather couch, and tomorrow, I will leave for the army barracks. Clive will leave for Australia. DJ Os will leave for Argentina. Biljana will leave for the Devon countryside, where she will eventually practise Shamanic Tango (please don't ask me what that means, ask Biljana). And Gavito?

There is a song by Piazzolla called 'Ballad for my Death', whose

first line is: 'I will die in Buenos Aires'. In a few weeks, this will be Gavito's fate. The life of the true milonguero is exciting – in sixty-three years, Gavito danced in ninety-three countries – but it is also short. The price for living the tango dream is high. We mustn't blame everything on tango, but here is a fact: tango's greatest men don't live to a ripe old age. A few years after Gavito, tango's most lyrical dancer, Osvaldo Zotto, would die of a heart attack, aged forty-six.

'Come on, kid.' Clive bends down painfully to change his shoes. 'It's zero hour. Let's go before I turn into a pumpkin. Hang on, I *have* turned into a pumpkin. Just pass me that cigar and roll me down the stairs, will you.'

Milonga 4: Tango on the Seine in Paris
The floor is crowded.

'I'm not getting your rhythm,' he says after the first song.

That's because I have some and you have none, *mon ami,* I want to say, but I smile instead. He's a rough dancer with poor musicality, and I already regret compromising myself by dancing with him. But, as we've seen before, when you're new in tango town, you have to choose one of two evils: either dance with whoever asks you, or not dance at all.

He is a Uruguayan expat and his face is a handsome wreck.

'Have you been dancing long?' I ask.

'Longer than you've been alive,' he laughs with patchy teeth. 'When I first arrived here in the early eighties, I didn't speak French, so I started learning tango.'

My God, I think cruelly, how is it possible to dance for so long, and still be so bad!

'Are there lots of Argentinians and Uruguayans here?' I ask after a painful tanda. We stand by in polite conversation. The Seine moves darkly behind us.

'Too many! And too many of them are semi-legal upstarts with tango ambitions. You know, professional Argentines trying to make it.'

'Nothing wrong with that,' I say. I think fondly of el Pajaro in Berlin.

'No, of course not. Good luck to them. And you, where are you from?'

I explain.

'That explains everything,' he says.

'What do you mean?'

'I mean that's why you dance. You're exiled, my dear.'

'I'm not exiled!' I protest. 'I have two passports.'

'OK,' he smiles. 'There are many forms of exile. I was a political exile. You're an exile for the twenty-first century.'

'I prefer to think of it as global soul,' I say cockily.

He smiles. His name is Salvador and he is a novelist. We keep talking and I face a classic milonga dilemma. I'm torn between an interesting conversation with him, and a decent dance with someone else. Another cruel thought sneaks in: his dancing is no good; is there any point in wasting any more precious tandas as well as discrediting myself hanging around a low-rating dancer?

(*Pausa*: Yes, I am on the fast track to becoming a tango snob. The tango snob is the investment banker of the tango world: he invests in people according to their tango capital, nothing else. The tango snob is neurotic. He is unable to have a good night unless he is seen dancing with the best. The tango snob is not relaxed because the dance stakes

are so terribly high. The tango snob is thin-skinned when it comes to himself, but a rhino when it comes to others. The tango snob doesn't see people, he sees dancers.

The tango snob is not much fun, but he features, often in multiple numbers, in every tango community. Moreover, tango snobbery is contagious, otherwise I wouldn't have caught it myself. I blame the Berlin elite.)

I'm grateful to Salvador for saving me from tango snobbery, at least tonight, with his conversation.

'If you want to understand about the exiles here, you must see the film *El exilio de Gardel* by Solana. Piazzolla wrote the music for it.'

'I've been looking for it,' I say. 'I can't find it.'

'But you've found me. *El exilio de Gardel, c'est moi*, as Flaubert would say.'

Salvador was imprisoned by the military junta in Uruguay for two years, in a prison called, in a stroke of unintentional dictatorial humour, Penal de Libertad. But he won't say anything about his prison years, except: 'I have the scars. Let's not talk about depressing things.'

I ask him how he discovered tango here.

'A French friend played to me Carlitos Gardel singing "Mi Buenos Aires querido", and bang – the tears came. It's funny, because I'm from Montevideo. My wife said, let's take tango classes. Tango orchestras started coming to Les Trottoirs de Buenos Aires . . .'

'What's that?'

'A venue. It was where they kick-started tango in Europe again, on a shoestring budget, and it had a domino effect all over the world, including back home. Young people think that tango has always been

trendy, but I was around in the sixties, the seventies, the eighties . . . tango was for fuddy-duddies. For my uncles and aunties at family gatherings, that sort of thing. And look at it now.'

His French wife died a few years ago.

'I stopped dancing. But I felt even worse. So I threw myself back into it. I'm never sad when I dance.'

'Do you go back to Montevideo?'

'Once a year. To dance.' His laughter is open and total, a laughter he has won the right to have.

Then we kiss-kiss goodbye.

I wander back along the Seine to my hotel. As a child, my dream was to come to Paris. My exile from that dream – thanks to the Wall – made Paris a place of myth. It's a mythical place in the story of tango, too.

Paris was the city where tango first boomed at the start of the twentieth century. Low-society dancers from the clubs of Buenos Aires with nothing to lose brought the dance here – and, hey presto, overnight tangomania made them stars. They had Europe at their toe-tips and the pick of European ladies at their fingertips. Gifted upstarts quickly spotted that the louche exoticism of tango was a winner, and upped the ante by wearing gaucho gear (with spurs – try dancing with spurs!). The ladies swooned.

In the French media of 1912, those afflicted by tangomania were described as 'the possessed'. The Argentinian ambassador in Paris couldn't believe his eyes: the lowest of porteño pastimes was winning hearts and minds in France. He tried to tell Parisians it was all a terrible mistake. But nobody was listening. They were too busy dancing. The

institution of tea-tango was invented, for those ladies respectable enough to pretend they'd rather embrace the necks of men in the decency of daylight.

When tango went back to Argentina with its new Parisian label, Argentine society finally relaxed into liking it. Tango was OK, after all. Tango is what made us famous in France; there's *got* to be something classy in it.

Paris is also where Astor Piazzolla discovered who Piazzolla was. In 1954, he arrived here with his family and his bandoneon to study with the grande dame of musical pedagogy, Nadia Boulanger. He'd had a rough time with his tango compositions in Argentine musical circles. That's not tango, people cried, that's an obscenity! He even received death threats; that's how seriously the gatekeepers of tango took themselves. By the time he arrived in Paris, Astor was in a creative crisis. His bandoneon languished in a corner.

'I'm done with tango. Tango died for me,' he told Nadia Boulanger. She gave him tea, and hit him with the truth: his classical music lacked something, and that something was sincerity.

'Where is Piazzolla in all this?' she asked. 'Where are you?'

He didn't know. In their final lesson, nine months later, she asked him to play one of his tangos on the piano. He played 'Triunfal', which hadn't triumphed at all back in Buenos Aires. She took him in her arms and held him.

'*This* is Piazzolla,' she said. Astor was forty-three years old, but at that moment Piazzolla was born. He took his bandoneon out of its case, and for the next thirty years he put all of himself into his instrument. He put in the melancholy of tango, the syncopated sophistication of jazz, the polyphony of the classical orchestra and the

velvety voice of the bandoneon, and he put in his soul. What came out?

A new genre that has no name except the name he gave it when the shrill little voices of tango's gatekeepers were squawking, 'Is this tango, or isn't it?' It's *musica porteña*, he said, the music of Buenos Aires. The music that has struck a chord in the hearts of people all over the world who, just like me, are convinced that 'Oblivion', or 'Libertango', or 'The Seasons of Buenos Aires' were written especially for them.

'*Vous voulez danser?*'

It's a blond-bearded guy with vague eyes. It is the following night and I'm back at the milonga by the Seine. Leon blows hot and cold. He can't find the right temperature for our embrace.

'I can tell that you've learnt in Buenos Aires,' he says.

'Actually, I mostly learnt in New Zealand,' I admit. He smirks.

'There's tango in New Zealand?'

'Yes, and it's very good,' I say defensively.

'But you're not there any more,' he points out.

'No. I'd like to live here, one day.' I look out to the dark river. We've done a few tandas and we're sitting on the stony edge of the river bank, away from the dance fray.

'And I want to live in Buenos Aires,' he says.

'But you can dance here seven nights a week!' I say. 'This is Europe's tango capital.'

'Yes, but I'm sick of it. I want to find a stable dance partner.'

Leon has the phlegmatic manner and plump vowels of one fed with a silver spoon.

'I organize tango events and I'm starting to teach,' he declares.

'You as well?' I say, tactlessly. 'Why does everyone want to teach?'

He bites his soft beard.

'Because I've tried lots of things and nothing gives me what tango gives me. I have a law degree and a philosophy degree. I worked for a puppet theatre. But tango is something else . . . have you read Freud?'

'Yes,' I lie. Another damned dance-floor psychoanalyst.

'Freud said that the aim of psychotherapy is to replace neurotic misery with common unhappiness. I had a psychotherapist. It didn't work. But tango works.'

'So now you're just commonly unhappy.'

'No, I'm happy!' he says. 'This is me happy. Don't laugh.'

A mellow electrotango is playing and the dancers are twisting themselves into giant knots of disassociation, because electrotango is the signal for tango Nuevo, which means opening up the embrace as much as possible, fanning your legs out into wide strides and multiple desplazamientos, and making the dance floor even more dangerous. The experimental Nuevo influence of the big-name Argentine teachers here – Mariana and Sebastian, and Chicho (no longer with Lucia, but with another partner called Juana) – is in full, wild evidence tonight.

'I'm glad I'm not on the dance floor,' I say. 'What is this music?'

'Bajofondo. "En mi soledad". In my solitude.'

Bajofondo means underworld, which is a nod to where tango began. The original name of the band, Bajofondo Tango Club, was perhaps a nod to the Buena Vista Social Club. Along with Gotan Project, they have created the new genres of electro-, chill-out and lounge tango. And there's nothing like good electrotango to get you

into a trance. In moments like this, you realize, with a semi-religious awe, that . . .

'Tango is infinite, like chess!' I say to Leon. 'Infinite permutations, variations, interpretations . . . I could watch it for ever.'

Leon is staring at the dark river.

'Why don't you come and live here?' he says. 'You can teach with me. We can dance. Just . . . dance.'

Then an American woman whisks him off, and he's gone. I never see him again. My happy trance has worn off, and I suddenly miss Terry very much. I think of my musty hotel room, and I feel horribly homesick, though not for a place.

Tango tourism has saved me from my other half-life in the army barracks, and it has connected me again with Europe, which I had missed so acutely and for so long in the Antipodes. But, after a year, I'm tired of my butterfly way of life. I want a meadow of my own. I want normality. I want to have a desk again, and local shops around the corner.

I change my shoes, fold my fan and say goodbye to Paris.

A Little Piece of the Sky

TANGO LESSON: HOME

Home becomes Edinburgh. Why? Because we can't think of anywhere else in the world to go, the stony skyline of the city appeals to us and the street names remind us of the Kiwi town where we met as students. And we've heard that the tango scene here is good.

I am – *we are* – deliriously happy. We finally have a proper home with a view of Arthur's Seat – the volcanic hill smack in the middle of Edinburgh. Everything delights us: the castle on its green out-crop, the Gothic spires, the Georgian stone, even the weather. We love the lush cemeteries where body-snatching thrived, and we love the Jekyll-and-Hyde fog that creeps in from the open sea down Leith Walk.

There are some problems, of course. After his discharge from the army, Terry has no job, and as a writer I am congenitally unemploy-able. I am penniless, and he puts his savings into an apartment that turns out to be unliveable. Oh, and we don't know a single soul in the

city. But what is the most civilized way of meeting interesting people in a new city? Correct.

The truth is, I postponed it for many months. The excuses to myself were: Terry doesn't dance well enough yet; I don't need to dance any more; there are more urgent things to take care of. The *real* truth was this: I wanted to keep tango away from him – because it was mine. Conversely, I also wanted to keep him away from tango – because *he* was mine. I didn't want anything to come between us. I didn't want a Tango Relationship. I didn't want the Freudians breathing down my neck again.

But I also knew that possessiveness is one of the cardinal sins in tango, and a source of unhappiness for many couples. You can pretend to possess your partner in real life. But not in tango. You have two options on the dance floor. You either shackle him and make him suffer (you're not allowed to dance with anyone except me and two pre-approved women deemed by me ugly/married enough to be safe). Or you set him free and prepare to suffer yourself (you can dance with whomever you like, and I'm happy to see you blissed out in the arms of X, the way you never are with me. Really, I'm happy). Both sexes face the same dilemma.

You can avoid the issue altogether if one of you is not a dancer and also not possessive. Then the other one can dance the night away, once or twice a week, while the homebody keeps the bed warm. Bliss. This way you, the tango nut, get the best of both worlds. This is why, in milongas around the world, you see seemingly single people who aren't single at all.

Unfortunately, now that I was trying actively to avoid tango, it seemed that it was clinging to me like destiny. No matter how much

I showed Terry that I was happy just being with him, he wanted to seduce me specifically *with tango*. Perhaps he felt that until he could dance with me 'properly', he couldn't fully know me – because tango men knew something of me that he didn't, and that's without even taking their clothes off. Or perhaps he was simply bitten by the tango bug. Either way, Terry began weekly tango lessons at the university, in a huge ornate hall in Teviot House.

The university tango classes for beginners are enormous – up to one hundred students of all colours and nationalities – and the teacher is a noble-looking Scot with an avuncular manner and a grey moustache. His name is Toby Morris and his vision of tango is not mechanical, but philosophical, social and humanist, which makes sense in the cradle of the Scottish Englightenment.

'Forget *Strictly Come Dancing*,' he announces to his beginners. 'That's two people doing steps together. It's not the same as dancing.'

'Tango is not a fixed dance. It's a *method* of dancing.'

'Don't think about *looking* good, but about *feeling* good.'

'Leaders, if you need to force her into doing it, then you're committing rape on the dance floor.'

'Followers, engage your imagination. That's how the same step is never the same.'

'Leaders, no hands! You are leading from the chest.'

'Followers, connect with your leader from the chest.'

'Leaders, your lead is not a sudden signal, it's a continuous motion.'

'Followers, listen to your leader.'

'Use the floor. Use the floor. Use the floor.'

Well, no wonder that some of the students drop out and take up

salsa. But many stick with it, and in a few months, they turn up to the milongas as fully fledged tango addicts. The symptoms are similar to falling in love, but they last longer. I recognize them because I've been there.

1. Physical: your eyes acquire a messianic glint. Your posture and body confidence improve. You are flushed with adrenaline, dopamine, serotonin and every other hormone in your body, which gives you a sexual glow.

2. Psychological: you have a *need* to move specifically to tango music, several times a week. You crave the sound of the bandoneon like caffeine.

3. Social: you spend more and more time with the tango crowd, until you ditch your other mates, who now seem dull with their drinking and *sitting* around. When some of your pre-tango friends listen to Gardel singing 'Mi Buenos Aires querido' and snort 'What's that?', you either try to drag them along to a class, or cut them out of your life.

4. Cultural: you listen exclusively to tango music. You take Spanish lessons to prepare for that future trip to Buenos Aires. You are no longer interested in mainstream culture. Tango is the *only* culture.

5. Financial: you spend all your money on tango shoes, private lessons, tango music, tango trips. If you have to choose between dinner and tango, you'll go hungry and hope there are snacks at the milonga.

After passing through these obligatory stages, the tango addict might graduate to a tangoholic, after which it's only a hop, skip and ocho to the serious condition of Not Having a Life Outside Tango.

(*Pausa*: There's also the medical condition of Tango Fever, but we'll come to that.)

As well as initiating a new intake of tangueros, Toby runs a milonga twice a week in an old stone building called the Counting House, which sits on top of a tatty pub plastered with old movie photographs. The milonga takes place inside a wood-panelled hall with a glass dome, an old-fashioned DJ booth perched in one corner, and lots of red velvet and roses. In an adjacent room, new addicts and old hands practise steps, change shoes, swap gossip, laugh and shed a discreet tear when 'Oblivion' is playing and it all gets a bit much.

My first tango in Scotland is with Toby and, after my year of tango tourism, dancing with him is like coming home. Why? Because he startles me into feeling the dance again. He dances with small steps, on each beat and with lots of traspié or staggered double steps. 'Small is intimate', runs one of his mottos. It isn't about the steps, it's about our connection inside the music. No frills. No pretence. No showing off. It's dancing that *reveals* each to the other, but doesn't *expose* to anyone looking in. It is social tango at its best. In other words, Toby is one of tango's *organic* dancers. According to Rodolfo Dinzel, there are two kinds of tango: organic (good) and non-organic (bad). In the organic dance, all movement is curved. I dance around you, and you dance around me. I am the moon to your earth, and vice versa. Like everything in nature, our movements are rounded – like the traffic on the dance floor and the dance floor itself.

The only straight things in nature are the earth's fault lines. That, and non-organic tango dancers who scurry from one end of the dance floor to the other in a straight line, like rats from a sinking ship. The

kind of dancers who manoeuvre the woman brusquely into THIS ocho and THAT *boleo*. Their feet draw straight lines across the floor, straight like architectural draughts for the Third Reich.

(*Pausa*: The most organic dancers in the world are, of course, the Argentines, and the most organic dancers in Europe are the Italians. Think of it this way: organic tango at its best is like tantric sex. Non-organic tango at its best is two wind-up toys butting each other.)

'Welcome to Edinburgh,' Toby says afterwards. I have finally arrived, and this time I am going to *stay*.

Twice a week, Terry and I return to this enchanted space behind the velvet curtains and become part of a small tango community. Here are the expat Argentines, and among them is lanky-haired, soft-eyed Gladys; she is just divorced, and moved here for a handsome Scotsman who turns out to be emotionally unavailable. With the compassion of a saint, she waits for him 'to change'. She is into alternative therapies, and over time becomes a close friend.

Here is Al, a witty lawyer whom I met by chance in a Buenos Aires milonga, before I knew I was going to live in Scotland. Tango is a small world, as Rupert from New York said.

Here is Sean, a media and education guru, who wears outrageous shirts and puts a smile on every woman's face when he dances with her, but whose blue eyes drown in sadness. He becomes my best friend here.

Here is chubby, lisping philosophy graduate Dan, who will end up in the arms of a luscious Greek doctoral student from Thessaloniki, and will embroider his adoration for her on the floor with frantic foot-work, while she wears diaphanous belly-dancing gear. Everyone is

dismayed – but not for long, because astonishment never lasts beyond the night or the week. After all, the family milonga is a place of acceptance. You come as you are, and leave when you must. There is a place for everyone.

Here is Greg, with a milonguero paunch and endless cheer. He is the family photographer who records, milonga after festival, party after practica, the life and times of Edinburgh Tango. He teaches free beginners' classes, and female students are often found in his arms ('Let me show you this gancho') – until they find a boyfriend their age, leaving Greg to the next crop of beginners, which makes him just as happy.

Here is the Swiss girl with a face made for pleasure and closed eyelids that flutter orgasmically in the arms of men – *all* men. Her Dutch boyfriend smiles bravely, in a 'we're having an open relationship and it's cool' sort of way, but he's a sensitive soul – and, a year later, a broken heart.

Then there is the French-English student scientist couple, thin and pale like lovely young vampires. They never see the sun because they practise seven nights a week, until their Nuevo routine is flawless, like a perfectly executed chemistry experiment in some midnight tango lab.

We even have noms de tango, Buenos Aires style, for the three men who share a name: Irish Brian, Tall Brian and Handsome Brian.

We have skinny black accountant Martin from South Africa, who wears hats and gloves even in summer. Here is his preferred partner, Japanese translator Akiko, who sits at milongas drinking green tea out of a flask and looking abstract like a haiku about Mount Fujimori. Here is the stolid Sicilian Egyptologist whose secret cake recipes are kept in the family, but whose dark moods make the Godfather seem

like a sunny extrovert. Here, one day, is the intense banker from Sofia with the hard look of a woman who knows exactly what she doesn't want as she keeps you at an arm's length. But she melts in the arms of the student from Transylvania who is really a large boy with outsized feet and puppy eyes. Here is a fellow Kiwi, Rose, an exquisitely beautiful artist who looks like a Pre-Raphaelite painting herself, and paints us in tango couples that, by the time the canvases are finished, are no longer couples. And here's the dry-humoured Aussie designer Ben with the narrow face of a prophet and a determination to get very good very fast, by dancing with the best. I make the mistake of turning him down when he asks, and bitterly regret it a year later when he turns out to be rather good.

(*Pausa*: Saying 'no' is your right as a woman, but nothing is without consequences. When you snub beginners, you must bear in mind that they won't be beginners for ever. One day, when they're good and don't ask you to dance (girls), or say 'no' when you ask them (guys), you'll have learnt your lesson. Conclusion: talented beginners of both sexes must be nurtured by the old hands, in order to reap the harvest later.)

The best female dancer is a tall, sinewy Englishwoman with a chiselled face. One day, a Dutch dancer with greying hair visits, and the next, she is moving to Holland to teach tango with him. I am sad to see her go (I'm always sad to see *anybody* go, even if they aren't friends), and say so to Toby, who loves dancing with her.

'She's gone,' I say.

'Yes. But *you* are here.' He smiles philosophically. This is his mantra, and it is both heartwarmingly personal, and heartwarmingly impersonal.

'Everybody in tango is transient,' Toby says. 'People start taking

lessons. They may stick with it, or they may move on to t'ai chi. Even those who dance for years leave one day. Even those who are still here stop dancing one day.'

'Why do they stop?' I'm curious about this, because I had stopped too, for a while, in the barracks with the cupcakes.

'For emotional reasons. Because they can't cope with something. Because of jealousies. Because of babies. Because they don't get enough dances. Transience is what tango is about. But hey, girl, Donato tanda coming up, let's dance.'

Even those who don't dance are part of the family. Like the guy with dreadlocks who turns up in a kilt, drinks beer and buttonholes you with talk about his latest save-the-world project. ('I'm thinking of setting up a charity in Bulgaria . . .'). At first, he tried to dance without taking classes, but he soon realized that women would rather chew off their own feet than dance with him, so now he stays put. There is also the guy who comes all the way from Glasgow not to dance. He watches the dance floor with a stricken expression.

'He has recognized his own limitations,' Sean says to me one night. 'He feels that the way he dances expresses something of himself that others don't want.'

'How do you know?'

'Because each of us reflects something back to the others.'

Sean is spot on, as usual. Tango is a hall of mirrors. Some of them are distorting, others show us the truth.

The first thing we glance at is our own reflection, in the big mirrors that line the dance studios, as I did in those first few months in Auckland.

Then we begin to see ourselves reflected in the eyes of those who

watch us from the sides. Some dancers are so spellbound by what they see there, they never get past it and end up dancing with their own reflection.

'That's the autistic style of tango,' Sean comments. 'But if we're lucky, we reflect something back that the other person recognizes.'

What do Terry and I reflect to each other on the dance floor? After all, he is dancing very well now. I'm proud of him. But somehow, there is no reflection. Something is missing, in him, in me, or in us, when we try to come together in the embrace. This is upsetting – how can this happen with someone you love? But I'm trying not to let this worry me. It's just a tango, after all.

I'm glad to see him dancing with others, and I'm surprised at how unjealous I feel. We admire each other from a distance; we are each other's greatest fans. But my dancing has plateaued, and I've lost interest in taking it further. I've reached a place of happy complacency, as far as dancing is concerned. I can take it or leave it. I can go dancing, or I can bake cupcakes. I don't need to be a tango butterfly any more, because now I'm a domestic goddess. This feels like progress.

(*Pausa*: Tango stasis is not *always* a symptom of personal or relationship stasis. You *will* reach a plateau in your dancing after a few years. The tango plateau is like the tango crisis we saw earlier in Jason – it feels like the end of the road, but isn't. To move yourself forwards, you need actively to do something: dance with new people, take private lessons, practise more, get inspired, discover a new aspect of tango, rediscover yourself or your partner. Or you can stew in self-satisfied inertia, like me.)

And so the seasons and festivals of Edinburgh ticked over, as we flocked to the Counting House. For once in my life, I had everything

I'd ever wanted: love, home, fellowship and a feeling that I'm in the right place.

At Hogmanay, the Scottish new year, we danced tango and drank champagne with the family in the Counting House, and watched the fireworks light up this fairy-tale city that we all loved, no matter where we came from.

In the summer, we danced on a makeshift lino floor inside a court-yard in the Old Town, under the stars. Seen from above, we were at the bottom of a medieval well.

On Valentine's Day, we dressed in red, ate chocolates and danced whether we were happily in love, unhappily in love, divorced, single parents, recently single, semi-single, in non-tango couples, tango couples, pre-tango couples, and couple-aftermaths . . . ah, the couples.

They form and unform before your eyes; they reconfigure in unlikely ways. What – him with her? Surely not! They won't last. Or maybe they will – look, they *are* lasting, it's been two years now. At the same time, the couple who seemed cemented inside their coupledom suddenly come apart like a house of cards, and you see them sobbing in the bathroom, though not together. They are in each other's way here, in this small space. Do they avoid each other completely, do they dance, do they kiss-kiss hello and goodbye, do they make small talk, do they stop coming altogether? And then they see each other with someone new, or perhaps someone old, first on the dance floor, then off it. They want to scream or strangle someone, but they can't, because it's against the etiquette.

Over time, few are spared. Because even with all the civilized rules of tango etiquette, all the kiss-kisses and thank yous, all the anticlock-wise navigation and polite chat, the milonga is still a Wild West of

emotions. We still fall in love with the wrong person. We still make long-term couple plans after the Monday night practica, although we're twenty-one and leaving next year for Sweden (he) and Canada (she). We still want to sleep with someone twenty years younger or older than us. We still . . . but not me, obviously.

No. Terry and I are going to be one of the happy tango couples who *don't* break up. They aren't many, but they do exist. Carlos and Maria Rivarola. Rodolfo and Gloria Dinzel. Toby and his wife Linda. The ones who stay together for decades, on and off the dance floor, untouchable.

Untouchable, until one fine Saturday afternoon at our Milonga Atemporal, meaning 'from time to time'. This milonga happens inside a shabby church hall across from Teviot House, and we lounge about on gutted couches, eat rich cakes, drink Earl Grey out of dainty cups and talk and dance for hours to the cheerful, rhythmic tangos. 'Nothing too dark in the afternoon,' DJ Al explains to me. 'Best to have plinky-plonky tangos from the twenties and thirties. And milongas.'

'Dancing?'

This is me asking Joshua. The first time I saw him in a practica a year ago, three things occurred to me: he has the lupine face and wild air of a Steppenwolf; he will be a good dancer; here is trouble. Since then, he's been practising diligently, keeping his eyes on the floor. He never makes eye contact or conversation. In fact, he looks autistic. Hence my approach.

(*Pausa*: When are women allowed to ask men to dance? Whenever they feel brave enough to face rejection, or determined enough

to dance with someone. Where? Everywhere, except in Buenos Aires.)

And – bliss. The connection is instant. I'm melting in his close embrace. I like his smell. His musicality is wonderful. I feel as if I have no head. This is unusual. This is amazing. I haven't said a word to him in a year except hello, and he is congenitally monosyllabic, but now we speak the same language. We are saying things that nobody can hear. We are one. We are . . . this is . . . oh God. This is a tangasm in the making. I must end it immediately.

'Thank you,' I say to him.

'Thank you,' he says at the floor.

I go to get water, and I am shaking on my stilettos. I'm guiltily relieved that Terry is busy dancing with one of the Greeks.

Who is Joshua? A kite-surfer, or perhaps a gardener. The tango grapevine is vague. He has no friends here. But I know that I haven't come close to this kind of connection with anyone since Silvester. And never while happily in love with someone else.

This is the first time that I've had to ask myself the question: can you have a tangasm on the dance floor with someone other than your real-life partner without feeling guilty? Well, it depends on whether you are having any orgasms with your real-life partner off the dance floor.

One thing is certain, though: the milonga is one of the few remaining places in our Western world that favours polygamy. In fact, it *requires* it. Otherwise it wouldn't be a milonga, because the milonga is, by definition, a *social* space. If everybody danced with their life partner only, we may as well dance in our kitchens, in our pyjama bottoms. Some do, of course. In the old days, some committed

milongueros would stop dancing once they got married – like the legendary couple 'Coca' and Osvaldo 'Honey Feet', who sacrificed pleasure and career for their family, and only returned to dancing again once their children were grown up. Sweet, but sad. Others, like Rodolfo and Gloria Dinzel in Buenos Aires, rarely go to milongas. I once asked Rodolfo about this.

'Because when I go to a milonga, I want to dance with the world's finest dancer, and that's my wife. But so does everyone else, and I get sick of men saying, "Can I borrow your *señora*?" No, you fucking can't. So we dance at home. Nobody looks at us, nobody bothers us.'

But many maestros, like Carlos Rivarola, who don't exactly *need* the extra hours of dancing, and who are married to their dance partner, still *want* to go to milongas and dance with friends and strangers. When I asked him why, he told me: 'Because in show tango, you think. But in social tango, you feel. Every tanguero needs to *feel*. The milonga is where the heart of tango beats. Without social tango, there is no show tango either. There is no tango at all.'

In the atmosphere of every milonga, big or small, meat market or family lounge, New York or Marseilles, you feel a fine vibration between the private (the dance couple in an embrace) and the public (the crowd on the edge of the floor). The two are in constant flux, of course, hence the vibration. The boundaries shift all the time – you are the couple now, but three tandas later, you will be the crowd. The public is intimate, and the private is seen by all.

All this explains the curious phenomenon of the failed home tango studio, built at great expense and with great enthusiasm by the tango

nut, never to be used. Clive James in London only goes upstairs to his penthouse tango studio when he is showing it to visitors. An Auckland friend built a studio in his basement, which was used once, then converted into a children's play area. The surgeon who built a mirror-studded studio in his Tokyo house for his private lessons with Carlos Rivarola eventually cracked and started his own milonga in it.

The milonga transforms tango from aerobic exercise to a communion. In your kitchen or in your private studio, you can only be your familiar old self in your familiar smug couple. In the milonga, however, you are transformed by the volatile energies around you. Your couple dances among other couples, and this creates a mingling of personalities, moods and body heat that affects the way you feel. How many collective activities exist in the world that strike a perfect balance of familiarity and surprise, comfort and thrill, heart and mind, body and soul, public and private, real and fantastical?

I promised to tell you why the milonga can bring out the best in you, so here it is – the happy end of the milonga spectrum. Warning: being your best self is harder work than being your worst self.

Generosity: I'm not having a great time, but I'm glad she is.

Humility: my dancing is not the best tonight, but this is not a competition.

Tolerance: his ocho cortado is crap, but he's such a lovely guy, and he tries so hard, it doesn't matter. He makes me laugh and that's more important.

Friendly banter: 'DJ Al, you're playing *my* song! What do you mean, it's *your* song!'

Counselling: 'Are you OK? Yeah, I know. Just ignore him. He's being a clown. You'll feel better next week.'

Self-acceptance: I'm OK. Not perfect, but good enough. Life is too short to want perfection.

Insight into human nature: she's flirting with my man, but she flirts with everyone. The compulsion to seduce is her only way of asserting herself. She'll grow out of it.

Graciousness to women: 'Nice dress' (to the woman who's been flirting with your man and everyone else's).

Graciousness to men: 'Oops, sorry' (when it's *his* fault for leading you into a boleo that kicks someone behind you).

Shoe-sharing: I'm so glad those shoes I gave her/sold her cheaply look good on her.

Serenity: I can listen and watch the floor for hours. This is wonderful.

At its best, the milonga makes women feel wanted and held, and it makes men feel accepted and competent. It brings out the noble, nurturing side of men, the grace and creativity of women. It sensitizes us. It teaches us to notice each other – as a couple, and as a group.

So, I'm not exaggerating when I say that here, under the hothouse glass dome of the Counting House, twice a week we engage in a sort of collective prayer. Tango is the music of the urban loner, which we all are. The milonga is our secular church. The tandas are the ticking hands of our clock. The dance is our prayer. The DJ is our priest. The musicians are our saints.

And who is our god, to all of us here – the atheists, the New Age spiritualists, the Muslims, the Greek Orthodox, the Eastern Orthodox, the Jews, the Jains, the Christians, the Buddhists, the Hindus, the faithless, the confused? Tango itself, of course. Tango loves all its children

equally. All it asks in return is for us simply to *be here*. That, and to move anticlockwise without crashing into people.

And even if we belong to other clubs, this is probably our only place of *ritual*. It's better than Christmas, because the exchange of gifts happens every week. It's better than religion, because your body as well as your mind enjoys it and, best of all, there is no guilt (inappropriate tangasms excluded). It's better than sport because it doesn't hurt (most of the time). It's better than the national pastime – getting drunk in the pub – because it's never boring and you don't end the night vomiting on yourself. You end it with kiss-kisses, your shoes in a silk bag, a rose in your hand (for the girls), her perfume on your hair (for the guys), a tune on your lips and a smile on your face.

To be fair, sometimes you leave with curses between your teeth, tears on your face, resentment in your guts and a bruise on your shin. Sometimes, your tango night is a triumph of bitterness over pleasure, disappointment over hope. But, like tango happiness, tango unhappiness doesn't last. There is a special *milonga economy* at play and, over time, everything evens itself out.

Everyone is dancing with the orgasmic Swiss girl with the fluttering eyelids tonight, but next week, elegant Rose is queen of the milonga.

Sean's arch-enemy is darkening his milonga on Tuesday, but he's not here on Sunday.

Last week, Al just hated the music Toby was playing, and sulked all night, but tonight he is giro-ing in a trance.

There's just no-one to dance with tonight, Gladys complains (except the drunk guy in the kilt), but on Tuesday all her favourite dancers turn up, and she is spoilt for choice.

New male dancers progress fast and hog the best women for a while. This annoys Tall Brian – he's better than them. But the new stags eventually reach a plateau and he gets his own back. He is happy again.

I feared that Joshua had dropped out of tango because I haven't seen him for weeks, but here he is again, with dirt under his nails. He's been very busy in the garden, he says in between dances, because it's spring.

Spring, already?

NINE

Your Diagnosis

TANGO LESSON: HOMELESSNESS

I'm learning to play the bandoneon. It's an expensive instrument and hard to find, but Terry has managed to get me one for my birthday, because I've always wanted to play 'Malena'.

People live fulfilling lives without ever knowing of the existence of the bandoneon. For most people, the bandoneon is a twee irrelevance. It's a foreign man clearing phlegm in his throat in some musty corner of history. But to the tanguero, the bandoneon is all you hear. The bandoneon calls out individually and personally to you, like the bitter-est sweet voice. The bandoneon is not just an instrument. It's a being. It has a soul.

I have counted at least thirty tango songs with the bandoneon as principal character. Songs about the soul of the bandoneon. Songs about the neighbourhood woman with a broken life, laughing a brittle laughter, the bandoneon her only true companion. Songs about the

'brother bandoneon' who 'laughs when he arrives, and cries when he leaves' – like all good things.

This is all very poetic, but I have just one thing to say about learning to play the bandoneon: don't. Astor Piazzolla was right when he said that you have to be mad to do it. If you're not, it will *drive* you mad. I've come into close contact with the accordion and the piano before, but that's no help at all. The bandoneon looks like a button accordion, has the insides of a piano, boasts the melodic range of the violin in the right hand, but plays like none of the above. It plays like itself, which is to say that the sounds it makes when you open it are not the sounds it makes when you close it – and that's while pressing *the same buttons*. To feel at home with the bandoneon, you must possess mathematical genius, a personality disorder and the patience of a saint. It's no surprise that after three months I can't even play scales. 'Malena' shrinks out of reach, along with all the other 4000 tango songs, sung and instrumental, registered by Argentina's Society of Tango Authors and Composers.

But then, I'm not practising enough. I'm not practising because something strange has been happening with Terry lately. He is by turns restless and listless, manic and lethargic. When I look into his eyes, I feel a sickening vertigo, because what I see there is an emptiness.

We stop dancing. I go into a frenzy of cooking. I buy herbal tinctures and make doctors' appointments. He tells me, in a monotone voice – his voice has changed, too – that he's fine, everything is fine, and I'm just being Balkan and neurotic. It's just a busy time, I tell myself. A rough patch. We'll make it through. Stand by your man. I clutch at these clichés, because I feel suddenly alone, and because losing him is my worst nightmare.

★

Just then, an invitation for a travel-writing job crops up – in Buenos Aires, of all places. I've been wanting to return for years, but we've been too poor to travel. Now I'm torn: I don't want to go, but Terry tells me he'll be angry if I don't, and anyway, it's only for three weeks. When the time comes for me to leave, I'm so preoccupied that I do something I've never done before: I forget to pack my tango shoes.

<p style="text-align: center">★</p>

'You're Bulgarian, you moved to New Zealand, and now you live in Scotland.' The taxi driver from the airport studies me in the front mirror. 'Couldn't you come up with a more weird combination?'

'I do my best,' I say.

'I was born in Buenos Aires, lived in Buenos Aires all my life, and I will die in Buenos Aires. This is what my epitaph will say. No ambitions to go anywhere. Not because I'm happy here, but because I'll be even unhappier away from here.'

I'm too jet-lagged to respond.

'This country is colonized,' the taxi driver says. 'Nothing is ours. In the thirties and forties we wanted to be like France. Then we wanted to be like England. In the seventies came American culture. Now, we just don't know what the hell we are. Nothing we have is ours.'

'Except tango.'

'Yes, tango.'

'And mate.'

'Yes, mate.'

'Foreigners love it here,' I add.

'It's not a bad city, really. I'm personally very fond of it. No, I wouldn't change it for the world.'

I'm about to discover that some people have done the reverse –
changed the world for Buenos Aires. Or, rather, for tango.

After dumping my stuff at the hotel, I take a walk. In San Telmo, there
is new graffiti on the walls: VIAJEROS, BAJOFONDOS, LOS TOXICOS,
LOS NEUROTICOS, ANONIMOS. Some of these words are the names
of bands, but others sound like unhealthy states of mind. In Plaza
Dorrego, el Indio is still dancing. He looks more unshaven than ever,
and the black-and-red girl has changed – again.

And I've changed, too. I'm no longer the girl whose hair the
ancient barber brothers cut all those years ago. I cross the square
towards their shop, but it's not their shop any more, it's a leather
boutique. All that is left of them is an ornate plaque: PELUQUERÍA LA
MODERNA: FELIPE Y JOSÉ LAVORE, 1923–2003.

I'm stricken, as if my own grandfathers have died and nobody has
notified me. Time passes differently for all of us, but not when we're
twins. I buy two roses and place them on the pavement below the
plaque. Buenos Aires has survived the crisis, but San Telmo is not the
same without Felipe and José, whose names I never knew.

The waltz 'Tu diagnostico' ('Your Diagnosis') is washing over the
plaza, and long-haired jewellery sellers beckon to me with cavernous
eyes and grubby hands. I notice one of them in particular. He is
older, and has a baked-earth face with deeply carved native Indian
features. He sits on the ground surrounded by twisted forks and enor-
mous earrings, and beams a dreamy smile at me, as if he already knows
me.

I walk the streets in a daze, drunk on the city's brash energy.
How I've missed it, like an old friend who knows the most important

things about me. I love everything about it – the hotchpotch of lived-in faces, the footballish walk of the men, the sensuality of the women, the sing-a-song Italianate accent, the old cafés vast like beer gardens, the steaks larger than your plate, the traffic, the noise, the bronca.

Andrew Graham-Yooll once described the city as being 'filled with lust' and, for the first time, perhaps because of my own state of mind, the dark side of Buenos Aires really gets to me. At dusk, something menacing creeps down the streets, like a stench from the port, like a filthy shadow. In my light dress, I walk down Corrientes (*Corrientes, tres-quatro-ocho . . .*). Men leer at me and mutter things I'm glad I don't understand. Oops, I do. I speed up without looking back. Invisible hands are reaching out from all sides, and I'm not sure if I'm disturbed or excited. This ambiguity disturbs and excites me even more. The city bleeds its lurid colours, and tango music spills out of every doorway on Corrientes. I look at a street name and realize I've been walking in the wrong direction for ages, looking for the milonga The Kiss, in calle Riobamba. What am I doing, anyway, going to tango without shoes?

It's only my second day, and I'm already losing the plot. I tell this to Andrew over killer coffee. His beard has gone white. He looks like a prophet.

'Yes,' he grins. 'You should already know that Buenos Aires is an invitation to be unfaithful to every love declared. To break every rule made, and go back on the very few principles held . . .'

'Except tango,' I say.

'All right, except tango. So you have *something* to be loyal to.'

'Tango and love,' I add fiercely.

He looks at me and pats my hand with fatherly affection. He is twice divorced.

'All right, my dear. Let's go. Where are you staying this time?'

I'm staying in a cheap, grungy tango hotel called the Dawn of San Telmo. The rooms in the Dawn are permanently dark and filled with the smell of damp shoes and the furniture of another century. The water is off because of a burst pipe, and the place is chock-full of long-term visitors who are too busy with tango to notice anything else. Here, it begins to dawn on me just how severe and far-reaching Tango Fever has become.

The curvaceous porteño girl who runs the place is called Zoraida and, naturally, she's a tango nut. In the communal kitchen where she likes to recline moodily on a bench and snack on sweets like a concubine in some run-down harem, I ask her how often she goes out dancing.

'Five, six, seven nights a week,' she yawns. 'I'm a tango zombie. I can't live without it. Tango is the only place where I can express my personality fully.'

Zoraida moves from room to room as they get vacated by guests every few weeks or months. She gives private lessons in the dance room. Horizontal on the bench, she is a blob. Vertical on the dance floor, she is a nymph.

'I expect the man to express his personality, too,' she goes on. 'When two dancing personalities connect deeply, that's when the magic happens. And when they don't connect at all, it's crap. That's why you can never get bored with tango. Because you never know what you're gonna get. Pure gold or rubbish.'

In the kitchen, the guests from Turkey, Switzerland, Holland, Australia and Canada come and go, make cups of tea and talk tango steps and milonga schedules. They all look under-slept and over-danced, with fever in their eyes. In fact, there is a bug going around, everyone is coughing, and before I find out what the bug is, I've got it.

I spend the next week shivering under a thin blanket in my single bed. My monastic room is perched atop an iron ladder with a sheer drop into a lane below. My view consists of peeling walls and the shifting sky of an Indian summer, or is it a warm winter? Languages float past my room. I drift in and out of fever. I forget where I am. The only thing that reminds me is the muffled music that wafts out of the studio at all times of the day and night. 'Soñar y nada más' plays regularly – someone is practising their waltz – and it reminds me that

> To wake up is to break the spell,
> To tread, deep in the shadow, over bitter truth.

When I finally crawl out of my dark room, I'm weak and half blind, and inside my chest there is a torn bandoneon wheezing as it opens and closes. In the kitchen, I peer at the other inmates, all of them in various stages of tango influenza.

Wim is Swiss and a classic case of a tango bore. He is researching his PhD on tango and economics and he speaks a methodical, flat Spanish, like an electronic voice-dictionary. He has been here three months.

'How much longer will you stay?' I ask him.

'As long as it is necessary, maybe four months, maybe more.' His

English is like his Spanish. 'I want to become a good dancer. I want to connect with Argentinian dancers and dance like them. The length of my sojourn depends on whether something will happen.'

'Like what, falling in love at a milonga?' I say, a bit meanly.

'No,' the voice dictionary says, 'I do not think that this will occur.'

I do not think so either. But Wim has a temporary dance partner who also lives in our hotel. Dana is from Amsterdam and has a face like breakfast cereal and a blunt, cheerful personality.

'I don't understand,' she comments on my lack of tango shoes, 'how you come to Buenos Aires and do not bring shoes. How many pairs will you buy?'

'One,' I say, a bit embarrassed. 'I can't afford any more.'

Dana looks at me and can't decide whether to feel contempt or pity. In her room, she has accumulated two dozen pairs of tango sandals for her no-nonsense Dutch feet.

(*Pausa*: The fashion for tango sandals is in full swing, and to paraphrase Dorothy Parker on lingerie, brevity is the soul of the tango sandal. Less and less surface, thinner straps, more sparkle and maximum exposure at both ends of the foot is where it's heading. Add to that a nine-centimetre stiletto, and you see the challenge specialist shoe manufacturers face. Because the tango sandal, unlike any other common-or-garden sandal, must fulfil two crucial functions: 1. make you look like a million-dollar slut; and 2. make you dance like royalty.)

In her sandals, Dana practises from morning till night in the dance room. Sometimes she does it with Wim, sometimes alone, in sickness and in health. Then she goes out dancing, coughing all the way to the milonga. Like me and everyone else here, she's on antibiotics.

'But when I commence to dance, everything disappears,' she

explains one night in the kitchen to the other inmates. 'That is why I want to terminate my PR job in Amsterdam and come to live here. It's a very good-paid job but it doesn't make me happy like tango. But there is one problem: my boyfriend does not like tango.'

Wim smirks, but then he's always smirking. He seems perpetually pleased with himself, in a neutral, Swiss sort of way.

'And why do you have a boyfriend who doesn't dance?' Zoraida wants to know, on her bench, between mouthfuls of chocolate mousse.

'I do not know.' Dana shrugs her handsome shoulders.

'Dump him,' Zoraida advises. Dana seems to think about it. A middle-aged couple from Istanbul are holding hands and sipping mate at the kitchen table.

'We'd like to stay more than two months every year, but we can't. Is too expensive for us,' the man explains.

'Every time we return in Istanbul, we have terrible homesickness. For Buenos Aires,' the woman says, and laughs a small, embarrassed laughter. Zoraida looks delighted. She's a patriot.

'You know, I spent two years in LA and Rio,' she says. 'And I decided to come back. I can't live without tango. Plus, I was missing the cafés, the culture. Rio doesn't have that. LA is a graveyard, everybody stays in. Or jogs. I hate jogging, my thighs rub. Argentina is a lunatic asylum, but I feel at home in it.'

After all this time among the tango inmates, I'm suddenly desperate to dance. This is my second week into a three-week trip and I've finished my travel assignment already, but I still haven't danced! I haven't even bought shoes yet. Time is running out, and coughing phlegm like an

old sailor, I head to the famous Comme il Faut shoe store, where they make tango shoes *as they should be*: beautiful and unbreakable.

In a boutique full of zebra skins, three women serve the foreign customers. The customers are foreign because the prices repel the locals. The prices repel me, too, but I have no choice. No other brand of tango shoe fits my bird-bony foot. I've tried them all. At the moment, there is only one customer here, with milky skin and a woolly bun. She has the opposite problem: her feet are duck-wide and all the shoes are too tight. The three assistants have whipped up a storm of stilettos in an attempt to find a pair broad enough. Soon, they are whipping up another storm for me.

'Between the two of us, there will be the right shoe . . .' the foreign woman says. She has the expression of a countess tired of her useless servants. Her name is Anna, and she is a young Russian living in Chicago. 'The thing is, I need a shoe that doesn't exist. I want to design it and have it made. These women don't get it. I don't know why they keep bringing out more boxes.'

They keep bringing more boxes for me, too, and all three gaze at my unfortunate foot in amazement. Every time I try on a shoe, they cry out in unison, '*Inmenso! Inmenso!*'

The kind of shoe narrow enough to fit me is inevitably two sizes too short for me; defeated, the assistant-in-chief concludes: 'Darling, you'll have to have surgery on your big toe. There's no other way.'

'*Operación! Operación!*' the shoe chorus trills. I look up at them from my shoe-doldrum and laugh. Anna laughs with me. But they're not joking. Here, in the world of 'as it should be', looks are everything. If none of their shoes fits me, there is clearly something wrong with my feet. And here, in the world of posh porteños, where wrong on the

inside equals lifelong psychotherapy, wrong on the outside equals cosmetic surgery.

Just then, the magical shoe appears, and although it's brown suede, I walk out of Cinderella's cave poor but happy.

'Let's go to Canning,' Anna suggests. 'I've brought some shoes with me anyway. In BA, I carry shoes at all times. People say to me, be careful, don't carry any valuables. So I've got two bags. One with stuff like money, phone, map. And another with the tango shoes. If someone's gonna rob me, at least they won't take my shoes. Everything else, you can replace. But the shoes . . .'

Salon Canning is where I've arranged to meet up with Darío tonight. As soon as we arrive, I lose Anna from sight and never see her again.

Darío tugs at my side while we bounce and glide, kangaroo-like, on the crowded floor. He is still single after his Brazilian divorce.

'I keep a low profile at milongas. Thing is, Argentine women have a third-world mentality when it comes to relationships – you know, a breadwinner husband, kiddies, a boob job and that's it.'

'What about love?' I say. Darío nearly chokes with laughter.

'Love comes and goes, but money is for ever. That's the Argentine woman's motto. Nah, I relate to Western women better. In fact, some people become taxi-dancers so they can meet foreigners.'

'What's a taxi-dancer?' I want to know. Even the terminology of tango has changed since I was here last. Darío scoffs.

'It's the latest form of tango prostitution. See her, over there, dancing with the Tangonator? She's a taxi-dancer.'

'What's a Tangonator?'

'Honestly, Kapka, where have you been? It's a tango Terminator. Anyway, that girl . . .'

'Do you know her?'

'Nope. Never seen her before.'

'How can you tell she's a taxi–dancer then?'

'Have you seen her face?'

True: the girl dancing with a bobbing middle-aged Northern European looks as if she is having a tooth extracted without anaesthetic. But whenever a song ends and they face each other again, she forces a smile. He, of course, is beaming. His night of good dancing is guaranteed, for a modest sum. His alternative? Turn up alone and be turned down by every woman here, including the foreigners desperate for a dance. Such is the fate of the Tangonator.

'Have you seen his T-shirt?' I say to Darío. The man's T-shirt has a logo on the back: TANGO ADDICTS. WE CROSS OCEANS TO DANCE.

'I wish he didn't,' Darío mutters. 'That's why the dance floor here has become a killing field, thanks to jokers like him. I couldn't do the taxi-dancer thing, even if I was desperate for money. It would kill my *libido tanguero*. I dance for pleasure, and that's it.'

'But not everyone dances for pleasure, do they?'

'Oh, no. Some dance for money. But not in an honest way like the taxi-dancers. See that woman over there?'

The woman has lacquered nails long enough to dig somebody's grave with, and a black lace dress. She revolves in the arms of an elderly man who looks as if all his Christmases have come at once. That's because he can't see her face. And her face says: this man isn't good enough for me; no man is good enough for me. Except a very rich man.

'I've danced with her. With her, I had what I call *tango condom*.'

The tango condom is part of Darío's own classification and means a dull, soulless dance.

'The *tango random*, on the other hand, is when you have a surprisingly delightful dance with someone,' Darío continues.

'What about the men?' I ask.

'The men come in various types, too. The narcissist. The poser.'

'The poser? Like him?' I nod towards Ricardo of the long ponytail and maestro status, who is still hunting for fresh blood seven years after I last danced with him.

'Yes, like him. The poser is a glamorous dancer, sometimes but not always professional, and out of reach for plain-looking women and women beyond thirty. The poser is always, without exception, a dickhead. Women love a dickhead. Then there is the seeker. The seeker is after the perfect woman and the perfect dance. He's always moving on to the next woman because perfection doesn't exist.'

'Are there any nice men in your classification?' I ask Darío.

'Yep. The tango gentleman. A semi-extinct species.'

'That's you!'

'Yep. I often feel semi-extinct. Now excuse me, I've just spotted a victim.'

The tango gentleman can be an amateur or a professional. He dances with women of all ages. He dances with friends, acquaintances and complete strangers, and he will accompany every single one of them back to her table and thank her. He does all this as if it's the most natural thing in the world. He will never try it on with you. And he will never dance to show off – only to show *you* off, because with the

tango gentleman, the woman feels at her most feminine and desirable. But wait, is that a cabeceo from . . .

'Nathan! Nathan from Wellington! What are you doing here?'

'I'm living here, what are *you* doing here, Kapka? My God, how many years since that Congreso?'

'Eight. You know, I've counted every single year away from Buenos Aires.'

Nathan, on the other hand, spends half of each year here.

'I can't live without it, Kapka. I just can't.'

'Which – tango or BA?'

'Can you tell the difference? 'Cause I can't. If I stop dancing, my life isn't complete. If I stop coming to BA, my life isn't complete. I've *got* to dance here. Anyway, how many milongas have you got before you leave?'

Not many. It's already Thursday: Niño Bien. Here, I see another familiar face that I can't place immediately. I watch her dance, and something about the nervous way she taps with her feet suddenly reminds me who she is. The French air hostess with smoky eyes.

'That's Juliette,' Zoraida tells me. 'She moved here two years ago. She's a full-time dancer now. Giving classes and everything. And she's got a younger boyfriend who studies philosophy. It's the thing to do now, you know.'

'What, get a younger boyfriend who studies philosophy?'

'No, darling, move to Buenos Aires. You know, live the tango dream.'

A while later, Juliette sits down with us and lights up a Gauloise.

'It's like this,' she says in a matter-of-fact voice. 'Did I want to hit forty and still be going, "Tea, coffee, sir?" Nope. I found myself flying

from Paris to Boston on the weekend, on my *time off*, just for a class with this amazing tango teacher. And hanging out at milongas here several times a year. Did I want to wait until it was too late, or did I seize the day and go for broke? I went for broke. Et voilà, here I am.'

'And how is it?' I ask, almost afraid of the answer. That it's so good I might be jealous. That it's so bad I might feel sorry for her.

'The thing is, I burnt my bridges with France. My family cut me off. You'd think I'd taken up drugs,' she snorts. 'And I can't go back to the job. That's it. Make it or break it. And now I've got no money left, of course.'

'Is it possible to make a living from tango?' I say. Zoraida is shaking her head. She's fighting the same fight.

'Only seasonally,' Juliette says. 'And it's unpredictable. It all depends on foreigners coming here.'

'Hel-lo, darling.' Juliette suddenly stretches out a slender arm to a young guy with smouldering features. He doesn't wait to be introduced before he whisks her off for a dance. It's a waltz tanda, and right now the dark waltz 'Tu diagnostico' is playing:

> *The diagnosis is simple,*
> *I know there's no cure for me . . .*

They look hot together: she with her sharp profile, and he with his porteño-Neapolitan looks somewhere between student and pimp.

'Fifteen years' age difference between them,' Zoraida comments. 'And they look great. Good on her. I'm sick of seeing viejos de mierda, shitty old men, grabbing young birds.'

Juliette is doing what I've never dared do with tango: go for broke.

Some darker part of me is already wondering if I *could* do it, were my *real* life to fall apart in some ghastly way. Burn my bridges. Move here. Start from scratch and scratch out a living from tango. The lighter part of me is frightened and appalled.

But not appalled enough, so I arrange to meet up with Juliette the following day at a café near her house, to quiz her more. In the daylight, she is pale and wilted. Her beauty is not in tatters yet, but the last two years of sleepless nights tug at her face.

'I rent a tiny room with an old woman. That's all I can afford. So I have to go out every night, otherwise I'd go nuts.' She laughs tensely, and I try to laugh with her.

(*Pausa*: Tango was invented by sailors, immigrants, workers and prostitutes who needed to escape lodgings that were too small and drab. Respectable ladies and gentlemen had large houses in which to do respectable things.)

'But these days, I don't dance so much,' she says.

'How many times a week?'

'Four, five . . . and I don't practise as much. I used to practise up to eight hours every day, for the first year. I still practise every day, of course; that's the only way to stay on top of things. But I'm more relaxed about it.'

'You call that relaxed?' It's my turn to laugh, and for her not to join me. 'Anyway, what about relationships in tango?'

'I don't look for love or sex in the dance. Only for connection. Tango is a personal project for me. It's my own quest for perfection and meaning. And it's all in the embrace.'

'But you have a relationship, a *Tango Relationship*,' I insist.

'Sure. But I can't afford to take anything for granted. The tango

scene is vicious. You have to fight for survival, as a dancer and as a woman. Even now, he's surrounded by attractive younger women, they're all available, and some of them are awful. They kiss-kiss me, then they whisper in his ear, "Are you still with that Juliette?" I hate that. They can have him when he's not with me. Right now he's with me.'

Something about the way she puts this makes me uneasy. After all, I always took it for granted that true love endures.

'And what about the future?' I ask, and swallow the lump of anxiety in my throat.

She chortles. 'I don't think about the future. I know that I'll be alone at sixty. I'll have no-one. But I'll have stories to tell.'

I fear for her, painfully. I feel like I've known Juliette all my life. Perhaps because she's me. She's me seven years down the line, without the stability of a long relationship, and with the stoppers taken out. I'm desperate for her tango dream to work out. When I check her Facebook profile, I find this:

Religious views: tango

Political views: tango

Employer: tango

Relationship status: tango

This is full-blown Tango Fever. And it seems to be a global epidemic.

At Salon Canning, the bandoneonist in the live orchestra tonight is Japanese. The performing couple are Korean. I sit next to an Italian nurse who has come to work at the Italian hospital here, so she can dance.

'Sometimes, I have to rush off in my uniform to come to the

milonga, and change in the taxi. The drivers have got used to me now.'

In the Club Sunderland milonga (it must be Saturday), a Japanese woman with a face expressionless like a kabuki mask tells me that she comes once a year, for three months.

'I have one dream in life,' she says. 'To die in Buenos Aires.'

'Aren't you a bit young for dreams like that?' I tease her.

'I am forty-eight,' the mask says. 'I have thirty more years of dancing.'

I dance with a Frenchman from Nice who comes here every few months. He rushes ahead of the music, as if on speed. He just can't get enough of this stuff quickly enough. What does he do when he goes back to France? I ask him when we sit down.

'I fall into a depression within a week. You know, I dream of dying here. Recently, I was in La Viruta, and a couple fell to the floor. The woman was youngish, but the man was around eighty. A massive heart attack. What a wonderful death! Quick, painless, in the arms of a beautiful woman, doing what you most love in the world. This is how I want to go.'

At La Nacional, I meet smooth-shaven Aslan who is a Turkish antiques dealer. He's been dancing for nine years and lives here for months at a time. Why? I ask.

'*Maniaco, tango maniaco!*' he laughs. 'That's me. You understand?'

Oh yes, I understand.

As well as haunting the milongas, the new breed of tango emigrants – those, like Juliette, who've decided to make 'BA' their home – can be found in situ in the famous Dinzel studio. Here, between the narrow

walls plastered with dance photos from the past half-century, resides blue-eyed, bald-headed Rodolfo Dinzel.

At his feet – literally – sit the disciples. Here is a Moldovan-American girl of twenty-three who has dropped out of a law degree to pursue her tango. Here is a Canadian-Argentine woman of thirty who has ditched her fiancé and her career as a dietitian to find her 'tango roots'. Here is a Colombian ballet dancer with a black singlet and mesmerizing abs, who dumped Tchaikovsky for tango.

These are the world's tango ambassadors. They are not after money or fame. They are after a dream. Every day, they come here to drink mate, talk steps and milongas, and listen to Rodolfo, who speaks like a sphinx from the depths of his tobacco fog.

'Maestro . . .' someone begins.

'I'm not a maestro,' Rodolfo cuts her off. 'I'm just a dancer. I've been dancing for forty years, and I still don't know what tango is.'

(*Pausa*: Rodolfo and Gloria Dinzel are one of the great living tango couples. They are so legendary that their old shoes are exhibited in the Museum of Tango above Café Tortoni).

'OK, Rodolfo . . . tell me, what's your explanation for tango's success in Europe?'

'Well, the Europeans came here with glass beads and took the gold. Now, it's enterprising Argentinians who take the glass beads of tango to Paris and London, and take the Europeans' gold. Here, they say, we give you tango Nuevo, we give you the splits, and you give us money and fame. It's fair, isn't it?'

The sarcasm doesn't escape the disciples, and there are chuckles all around.

'But Nuevo is so popular now . . .' someone protests.

'Look. The girls dancing Nuevo these days show you their panties before they show you their face. Tango is a dance of spiritual pain, couple communication and sensual union. Not the fucking splits.'

We glimpse him briefly – shaking with passion and indignation – before a new emission of tobacco smoke swallows him again.

Through the fog, I peer at the eager faces and wonder what it is that tips people from tango addiction into full-blown Tango Fever. Tango addiction is when you're crazy about tango – that's everyone here, including me. Tango Fever, however, is when you act out your craziness to the full. When you live out the tango fantasy *as if it's real*.

Nothing wrong with that, you say. After all, Gavito himself said, 'Never give up the dream.' But he was not a forty-year-old French air hostess out of a job and with all her bridges burnt. Tango was all he ever knew. He had nothing to lose, and everything to gain from tango. These people here have put their whole lives on hold, in exchange for a dream.

Sunday night: La Viruta. I have three milongas left.

The ceiling is too low, the floor is too crowded, my feet are aching in my new shoes and I feel a crushing anxiety about my imminent return to Edinburgh and about Terry. He hasn't called once in three weeks, and every time I call, he's not there. His sparse emails sound as if they are written by someone else, someone cold, mechanical and disconnected. He's fine, he reports flatly. Everything is fine.

On my way to the toilets, I find el Tano in the hallway and out of it. He is banging his greasy head on the wall and lisping, '*Puta, puta . . .*'

Yep, life is a bitch sometimes, and he has lost all his teeth. Too scared to walk past him, I watch until he pulls himself together and washes

back to the waterline of the dance floor, where he gulps to the tide of music, like a dying carp.

Mercedes and Mario the car dealer are here, thank God, and going strong with their bottle of chilled bubbly. They greet me warmly with kiss-kisses, though I'm not sure they remember who I am from all those years ago.

'And here comes the Butt,' Mario announces to us. A short woman in a thin skirt with a G-string underneath leans against her partner and wiggles her bottom with each move.

'What does she think she's doing?' Mercedes fumes. 'This isn't tango, it's cha cha. Cha-cha-cha!' she shouts in the dancer's direction. 'Cha-cha-cha!'

But the Butt has her eyes closed. Now a woman in a very low-cut skirt appears on the dance floor. Her taut belly is exposed down to the pubic line.

'A beastly thing,' Mercedes comments. 'Tango is about elegance and estampa. What's this? Belly dancing and meat rolls. Beastly.'

'Beastly,' I agree, to keep up the good vibe.

'Very beastly,' Mario agrees, but his eyes are fastened on the belly. I ask him about his tango.

'I was married to a tango professional. We used to do tango classes and performances, and that's when I saw the life of tango dancers: forever waiting for tango to feed them. It's a terrible way to live. When we split up, that was it for me. Now I come to tango to bring something to it, not to take away from it.'

Mercedes keeps an eagle eye on the dance floor, but doesn't miss a word.

'For me it started twenty years ago,' she says. 'My parents died and

I got divorced. Life was terrible, I was crying every day. That's when I started to dance. I never looked back. When you're going out every night, putting on your lipstick and getting dressed up, there's no time to feel sorry for yourself. I get up at midday, have lunch and plan which milonga to go to. There's something missing from everybody's life, but at least we have tango. I pity those who don't. Because what do they have to console them? TV.'

'Look at him,' Mario is saying. 'He's good. Oh, he moves so well . . . pity about the potato sack he's dancing with.'

The man has a lived-in face, high-waisted trousers and slicked-back hair. He could have stepped off the boats in Puerto Madero. The year could have been 1910. I'm delighted when he asks me to dance. He is Greek and he dances like a man condemned to hang at dawn.

'I am here since two months,' he says. 'In Patra, there isn't tango. In Athens, yes, but it's four hundred kilometres to go to milonga twice a week. So I come to Buenos Aires for six months, and dance.'

'Are you enjoying it?' A silly question. He has a bad case of Tango Fever in his eyes.

'I love tango too much. Because when I dance, I can know what I feel. There is too much inside, too much, it needs out. Sorry, my English is not very good.'

'But what will you do when you return to Greece? How will you live without tango?'

'I don't know.' A sun-wrinkled smile. 'I don't want to think. Terrible. Terrible. I can't live without tango. I *need* to dance.'

Apostolos owns a bookshop. I start talking about Greek writers and ask him about Kavvadias, a poet I've just discovered, but after two minutes of no dancing he is fidgeting.

'Would you like to dance more?' he says. 'I like Kavvadias too, he was a sailor, you know. But the body speaks better. I try to tell you everything about Kavvadias in dancing.'

'I'll try to listen.' And I do – I listen for distant boat sirens. I smell the acrid breath of the Aegean sea, and hear a husky sailor's voice reading out the poems of Kavvadias in a lisping Greek. I also hear the music of 'Así se baila el tango', I smell the sweet sweat of Apostolos, and feel his soft trousers with my bare legs. It's a beautiful dance, and I feel the pang of post-tango tristesse when it's over.

When I leave with Mercedes and Mario, I don't get a chance to say goodbye to Apostolos. He is lost in an embrace on the dance floor with an older local woman. One look at his face tells me that Rodolfo Dinzel is right about the embrace. On his face, I see what you never see on the faces of Nuevo dancers with all their disassociations. I see a face in love.

And it may be that Apostolos is in love with the embrace itself, or with his own feelings at this moment. It doesn't matter. It may be that tango is one massive musical exercise in emotional transference, and the Freudians are right, damn them. Seduction. Engagement. Rejection. Fall. Longing. Seduction.

It still doesn't matter. Tango Fever is a kind of love fever. This is all that matters.

And, with a painful stab, I realize that I'm envious of Apostolos, of Dana, of Juliette, of the Moldovan–American and the Canadian–Argentine, and of all the others who have ditched everything to be here, in the embrace. They have everything to lose, but also everything to gain.

I've never had the courage to give it all up for the dance. I would

give up everything to keep love, but right now I am no longer sure where I stand with that either. All I know is that I'm clutching a satin shoe-bag with my new Comme il Faut shoes, and I have a return ticket, and I don't know what awaits me.

'Tristeza Marina' is playing now, which reminds me of Marseilles and Hamadi four years ago. The meaty face of the DJ Horacio Godoy grins from his pulpit. He grins at life, at the flashing lights, at the heaving bodies on the dance floor. I feel delirious with unbelonging. When I get back to the hostel, Zoraida is asleep on her bench, her tango sandals still on.

In the kitchen the next morning, the inmates are drinking tea.

'I had a dream,' Dana is saying in between coughing fits. 'I dream that I am dancing, and trying to do a step, but I cannot. It is not working. I wanted to stop, I said to my dream, Dana, you have to stop dancing, you are tired. But I could not, I kept dancing badly, I was so tired and ashamed and I just wanted to lie down. But I could not stop. It was going to kill me, but I could not stop.'

The Turkish couple, Zoraida and Wim all smile politely. But in their crepuscular rooms full of damp shoes, they are all having that same fevered dream.

And me? I am just a visitor here. I can tango, or I can not tango.

'I can tango, or I can not tango,' I say to Carlos Rivarola on my last day. I'm murdering a steak the size of our table. He's murdering a lentil soup.

'Carlos, have you turned vegetarian, as well as Buddhist?'

'Look again, Kapkita. This is Argentina.' Large chunks of meat float in the stew.

Portraits of Piazzolla and Pugliese look down on us. A goitre-heavy golden bust of composer Aníbal Troilo glitters in the corner.

Time passes for all of us – except for Carlos. He is aging backwards. True, the stubble creeping up the sculpted cheeks is grey, but this only improves his looks.

'Well.' He scrutinizes my face. 'You seem happy.'

'I *am* happy.' I smile with a face full of steak.

'So, you've found what you were looking for in tango,' Carlos says.

'Yes. I've found love.' Suddenly, my eyes fill up. I put the steak down. 'Sorry.'

'It's OK, Kapkita.' He gives me a napkin that says EL OPERA and I wipe my nose with it. 'It's OK. Love never leaves us, but it must begin with yourself. It's the only way. Everything else is sand between the fingers.'

'Yes.' My eyes are leaking at an alarming rate. 'Except tango.'

'Except tango.' He squeezes my hand. 'Let's go and sit in the sun.'

We sit in Plaza de Mayo. It's Thursday so the Mothers of the Disappeared are here. They have been here every Thursday for the last thirty years, in their white headscarves – since their sons and daughters went missing.

'We are going to read the names of our beloved disappeared,' a tiny woman shrunk by age and grief says into a microphone. 'Not all of them, because they are too many. They are thirty thousand. We can only read a few hundred names every week.'

And off she goes. It's the letter L today.

'Lescano, Lucrecia Beria.'

'Presente!' another woman says.

'Lescano, Manuel Roberto.'

'Presente!'

The Casa Rosada, where people's lives were made and unmade, looms ahead of us in surreal pink. Toddlers feed the pigeons in the square. The afternoon is overcast.

'Lescano, Luis Alejandro.'

'Presente!'

'Lescano, Adriana Malvia.'

'Presente!'

I cover my ears.

'Carlos. It's the whole family. All of them.'

Behind his sunglasses, I can't see Carlos's eyes, but his stubble suddenly looks old.

'I was a young man when all this happened,' he says quietly. 'And I'm ashamed that I did nothing. It was all rumours. Unmarked sedans. Someone you knew disappeared, and you were afraid to ask questions because those asking questions went missing, too, like some of the mothers. And now I find out that those bastards played tangos during the torture, to drown out the screams.'

'Lescano, Roseria,' the woman continues.

'Presente!'

'The bastards killed the whole family!'

'They would be my age now,' Carlos says. 'And their children are your age. The lost generation. Some were adopted as babies by the generals, after the parents were killed. Yes, Kapkita, this, too, is Argentina's story.'

The names are still being read, and we stay until they finish, then we part with a hug. Carlos waves at me from the other end of the plaza with a sad smile. How I hate goodbyes. Every goodbye is a

potential adiós. And the women in white headscarves didn't even have the luxury of adiós. All they have is sorrow without end.

Back in Plaza Dorrego, I trip into the jewellery seller with Indian features who is asleep on the pavement, next to his merchandise. He wakes up.

'Ah, Kap-ka.' He gives me that troubling smile again. 'I dreamt that you were coming.'

I sit down next to him. This is not my first encounter with Juan, whose nickname in Quechua is Black Dog. I've talked to him every day for the past two weeks. He gave me a carton of juice when I was sick.

'I had a Bulgarian friend,' he said the first time, by way of introduction. 'She lived here in Buenos Aires. She died of a brain tumour, at twenty-five. I loved her.'

'That's terrible.'

'Yes.'

Black Dog is like that – he doesn't do small talk. He has long greying hair, some of it plaited with beads. His chiselled, ruined Indian face shines with warmth like a lantern in the falling dusk. He quickly diagnoses me with lower-back pain, and begins to administer reflexology on my hands, while we sit on the stone ground among the other feral-looking arts and crafts sellers.

'I can't explain the science, but I feel your pain,' he tells me as he presses into the part of my hand that represents my intestines and I feel a sharp stab.

'Ouch. I feel it too!'

'Kap-ka. I feel something bad, maybe tomorrow, maybe later.

Something very bad. But there is nothing you can do, *mi amor.*'

I find myself holding on to him, not wanting to let go.

Eventually, he prises my hand open and gives me a circular object made from flexible wire that can be twisted into twenty different shapes. Black Dog demonstrates with grubby fingers.

'You want the earth? Here's the earth. But if the earth is too much, here's a simple flower. You don't like flowers? Then chuck it in this bin. Oops, it's not a bin, it's a boat to take you down the Rio de la Plata. You're bored with the river? Look at the black hole from which everything begins. Look at Saturn with its ring, and here's the earth again, and in a tiny spot somewhere over here, we are sitting in Plaza Dorrego. Kap-ka and Black Dog. Strangers on this earth united for a brief moment in San Telmo, looking at this mandala, which now collapses in a flower again. What is a mandala, you ask? It's a dream in the shape of a circle. Good night, Kap-ka. I will see you in my dreams.'

Clutching Black Dog's gift in my pocket like a talisman, I return to Edinburgh.

★

Terry wasn't at the airport. He had forgotten that I was coming back. He opened the door of our flat, I looked into his eyes and I realized that he had forgotten much more than that. In his new monotone, he explained he was fine, it's just that he was now 'someone else'. That someone else, I discovered, had been cheating on me for months.

He left without saying goodbye, and moved in with a promiscuous Asian acquaintance from tango. She was already pregnant, perhaps even by Terry, so he married her instantly — after all, he had always been a nice guy.

Our five-year-long dream had overnight turned into a nightmare from which I wanted to wake up. Terry had appeared in my life suddenly, with an army rucksack, and he left just as suddenly, with the same rucksack. *Soñar y nada* fucking *más*.

In the raw dawn that follows catastrophic loss, when the world looks twisted out of shape and nothing will ever be the same, I walked around Edinburgh and talked to myself like a madwoman. Was this happening for real? Yes, it was, and, sadly, I wasn't mad. I was *only* heart-broken. I was *only* struggling to comprehend the magnitude of my loss, and the fact that without an adiós, without an explanation, without the luxury of what psychologists call 'closure', I had to bury Terry and our five-year-long dream.

But I'd loved him! Whoever he had been, I'd loved him. Past tense. In tango songs, all the good stuff is in the past tense.

My sanity and my life were saved by friends, family and my bando-neon, though not in this order.

'Between grief and nothing, you must choose grief, darling,' Sean said. 'You must grieve and move on, so that you can love again, one day.'

But the thing about grieving for the dead — which is what Terry was to me — is that you can't bear the finality of it. You want to *do something about it*. One night, I picked up my bandoneon and went up to the roof of the building. From here, I saw Arthur's Seat, the castle, the stony streets, the sea beyond, and it all shimmered in a nightmarish lurch, like a crime scene in a film that ends very badly. My beloved city had become uninhabitable.

Even in the last moment, I wasn't entirely sure which one of us was going to go, me or the bandoneon. I checked there was nobody

below and, after a brief hesitation, I heaved Malena over the edge, nearly tipping over with her weight. The sound of a bandoneon crashing five storeys below is an abomination. But it's nothing compared to the sight of a broken bandoneon, seen close up, when you pick up its perfect bone keys, like the teeth of some shattered animal, and know that the animal is you.

Yes, I was in a bad way. So bad that for a few weeks I continued on autopilot, as if nothing had happened. I even went dancing a few times. I laughed a bright, chiming laughter, like a breaking window. I taught a summer course and did publicity for my new book.

And then Terry started showing up at milongas with his pregnant bride. I quickly found out who my real friends were, but the rest of the tango family welcomed them. You see, the milonga doesn't judge. The milonga is not moralistic. The milonga is a casino – everybody's coins are welcome. The milonga loves all her children equally: the kind and the selfish, the exploitative and the giving, the callous and the heart-broken, those who are well and those who are not. Those with a five-year dream and those with a five-year plan. If you have a problem with someone, leave. If your sudden ex is turning up with a pregnant woman and dead eyes, leave. Such is the law of the milonga.

I had no choice but to accept that if I stayed, I might follow Malena from the roof of my building. But on my last night in town, I went dancing – where else could I go? I had no other home any more.

Joshua was smoking outside an old pub called The Merlin. Upstairs, I could see the couples revolving to Pugliese. As if nothing had changed in the world.

'It's my last milonga this year,' I said brightly, to break the silence. 'I'm going back to New Zealand.'

'That's nice. Why?'

Everyone else had heard and seen, but not Joshua.

'Terry's . . . well, we broke up. He's . . . he's someone else now.'

It sounded so absurd that I tried to laugh. But instead, an ugly sob-like noise came out. Joshua looked past me. He didn't say anything. It's as if nothing could surprise him because he'd already been through everything. He just shuffled closer and put his spade-like hand on my shoulder.

'Let's have a dance,' he said, and we went inside. For twelve minutes (actually, for an hour, but who's counting), in his arms, I forgot everything. When it ended, I remembered everything, and we said goodbye, thank you for the dance.

I said goodbye to my friends, and to the distant tango relations who didn't give a shit one way or another. I said *adiós muchachos* to my dysfunctional tango family, to the broken years of happiness, and I slammed the door of my former home like the lid of a coffin. I didn't know if I would come back. I was like the protagonist in that tango called 'Nada' ('Nothing'):

> *Nothing is left of my home, just sadness and despair,*
> *I walk away, I go I don't know where.*

CORTINA

KK: So, why do you tango?

Nathan: Because without it, my life is not complete.

Carlos Rivarola: Because it's all I've ever known.

Toby: Because it's the fountain of life.

Sean: Because it's a rehearsal for love.

Rodolfo Dinzel: Because – look at it – back, front, side . . . it's nothing.
And yet it gives me everything.

Mercedes: Because without it, all we have left is death and television.

TANDA FOUR

THE EMBRACE

In Search of Transcendence

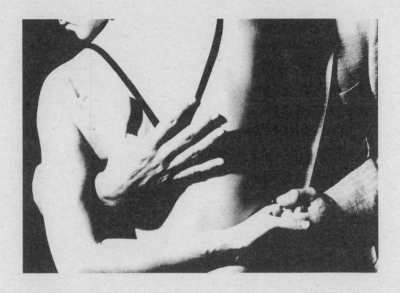

TEN

Laugh, Laugh, Don't Cry

TANGO LESSON: ECSTASY AND AGONY

'Fuck that for a joke, KK.' James is on his third glass of wine. 'It's like a bad tango song.' His long relationship with a European woman has just ended, too, and she has gone off to join some sect on a Pacific island. His minor-key mood matches mine perfectly.

'You're made of strong stuff. You'll survive this and laugh about it,' Geoff offers. *He* can laugh because he has a new girlfriend in America. They meet up in Argentina twice a year, and dance.

'Sexual healing, baby, that's what you need,' Anoush diagnoses me. 'There ain't a better cure than a new man.'

'I don't want a new man,' I say. 'I don't think I can fall in love again. Ever.'

Everyone at the table smiles.

'I was wondering why you cut your hair,' Geoff smirks. 'The first step to joining a convent . . .'

'I give you six months to recover,' Anoush cuts him off.

'Whoa, whoa, hold your horses,' James protests. 'She'll need two years before she's recovered . . .'

'Two years?' Anoush waves him away with tomato-red nails. 'Get outta here. Six months, I tell ya.'

Yes, it's Limon night on the waterfront. The owner, Murat, is looking after me with homemade lemonade on the house, and I feel as if I've only been away a few months, not a few years. The Auckland tango community has recovered from its internecine wars, and it's flourishing. You can dance four nights a week now, and the Comme il Faut shoe collection has reached these shores, thanks to Tim Sharp. In addition to the regular tango studios, an Argentinian guy and his Tahitian girlfriend are teaching and running a hip milonga in a converted warehouse. Jason has moved to Australia. Cecilia has moved to America. Silvester has just had a baby with his Korean girlfriend, who is not a dancer. I assume he has given up dancing.

But I'm wrong. Once a week, Silvester goes to a suburban dance studio, plugs in a portable stereo and dances alone.

'I'd rather enjoy the music and dance by myself than listen to Nuevo crap and dance with people who don't have an axis.'

In the vast studio, buzzing fans ripple my skirt like a hot breath.

'It's great to see you again,' Silvester says. 'You look on good form.'

I tell him I've been doing a lot of swimming in the ocean. His eyes disappear into the familiar dimpled smile. His hair has gone grey, but he still has the body of an Olympic swimmer.

Silvester makes no comments about why I've come back or what I've left behind. He just puts on a CD and raises his left arm. I raise my right arm, and to the tune of 'No quiero verte llorar', we dance.

No, I don't want to see you cry,
No, I don't want to see you suffer.

The chemistry is instant, as if we've never disengaged from our tangasmic first embrace eight years ago.

But, as we dance, something unfamiliar stabs at me: regret. I feel the regret of our missed chance, the regret of the fatal turn I took by choosing the unstable Jason and the even more unstable Terry over this honourable, rock-solid man. Jason wanted to be someone else. Terry didn't know who he was. And here is someone with tanguidad, self-knowledge and staying power.

In our twenties, we were still on the way to becoming something. Now, in our mid-thirties, we *have become* the choices we have made. Haven't we?

'No, Kapka, nothing is final in life, except death. We are always becoming something. There is always hope.'

'Yes,' I say, wiping the sweat from my face with the T-shirt he has just removed to change into another one. 'As Kafka said, there is hope – but not for us.'

He offers his arms again. Of the two of us, I am the one with the quotes. But he was always the one with the wisdom.

Anyway, dancing together, now, is the best Tango Relationship we could wish for. Beyond desire and expectation, beyond past and future, we dance. It's an act of loyalty and love, and I have no words to thank Silvester. He knows it and, as always, he asks for nothing except my presence in the studio once a week, for an afternoon, over the never-ending Antipodean summer.

When I'm not dancing, I am swimming in the ocean with my

father. For hours and miles at a time. My parents' doting care and fattening regime make it possible to have moments when I'm not completely wretched. 'You're fit and strong, and all your life is ahead of you,' my philosophical father points out, and pours us some Sauvignon, while my mother prepares yet another salmon and avocado salad with macadamia oil. I swallow everything like medicine. My parents don't condemn or lament, they just love me patiently, unconditionally. This puts any idea of romantic love into perspective, and it's not a good one.

(*Pausa*: On parents in Tango. The Mother crops up in tango songs as a subset of the vast rubric of Childhood, Home and Return. The Return is fraught because Childhood is lost for ever and, as we have already seen, *nothing is left of your home*. But there is some residual hope in the Mother, because, as one song reminds us:

> *Loves and kisses, friendships,*
> *Rosy dreams and pretty faces,*
> *There are plenty in this world, alas,*
> *But I only have one mother,*
> *And though I had forgotten her,*
> *Life taught me in the end,*
> *This is the love you return to.*

Fathers, however, are nowhere to be found in tango songs, which I put down to the Oedipal tendencies of the classic macho tango protagonist, for whom only three entities exist: the bandoneon (a friend), the lover (an enemy) and the mother (where you go to recover).)

★

Eventually, the summer does end. The ocean gets cold. The champagne with which I celebrate my thirty-fifth birthday has long gone flat. Again, I have no income. The enchantment of return has settled into everyday life, and I see just how empty my existence has become. Silvester goes to Korea with his family. The Argentinian-Polynesian couple go back to Europe and tango goes into a lull again. The humming of fridges in the dead of suburbia is deafening. Satellite dishes and Japanese cars glint in the sun like a migraine.

My life is not here, but I no longer know where it is. I still can't bear to dwell on the past, but I can't see the future either. Meanwhile, I can't go on living in the cotton wool of my parents' house for ever. And I'm terrified of returning to the scene of the crime.

Of course, I think of Buenos Aires, where I would fit right in with the other tango emigrants. I would even have my own nom de tango: la Bulgara. I would dance every night of the week. I would seek salvation and oblivion in the arms of strange men. I would rent a small room somewhere in San Telmo, if I can afford it. But I can't afford it. No, I can't afford to become Juliette.

I don't *want* to become Juliette. I don't want to run away, this time. I want to be one of those who remain; I've been transient too many times, in too many milongas, in too many cities.

Just then, an invitation for another travel-writing job comes up and nudges me into a decision. What have I got to lose? Nada. I pack up again, say a painful goodbye to my parents, to my old tango friends, to the ocean and the sky, and I cross the Pacific. I'm going east this time – to Ecuador – and my return ticket is to Scotland.

★

My task in Ecuador: to write about orchids, which requires going on an orchid safari with a team of orchid fanatics, who show me that orchids are to some what tango is to others. My aim: to forget everything for a month. My extracurricular activity: to find tango. Do they tango in Ecuador, too?

Of course they do. Twice a week, in a bohemian café in Quito, whose walls are plastered with tango paintings. The place is run by raven-haired Sylvia and pepper-bearded Gonzalo. They're an idealistic Ecuadorian couple who have invested all their savings into the venture. It isn't exactly making them a pot of money, but they're living the life they always wanted. Sylvia is a professional dancer and has the vague look of a woman who is always forgetting something ('I forget your name. Ah, yes, Kapka, dear . . .'). The interesting people of Quito rock up to Cafélibro sooner or later. The tango teacher, Rosario, is a bossy woman, and today's lesson is *volcadas*.

I'm sure I've done volcadas before, somewhere, some time. The volcada is when the woman shifts her weight while leaning on the man heavily, one foot mock-sweeping the floor forwards, like a fan. It's a move that requires trust, looks glamorous and feels lyrical – if you are Carlos Gavito and Marcela Duran and get it right. If you get it wrong . . .

'*Perdon!*' mutters the young guy with fierce mestizo features who is partnering me. 'I'm a beginner.'

Why is a beginner learning the volcada? He should be '*wolking!*', as Diego in Confitería Ideal instructed me all those years ago. But wait, this guy is a nice leader, and anyway, I haven't come all this way to be an uppity tango snob. I'm here to forget, remember? My dance partner, Ramon, is twenty-five and he is a tour guide. He

has thick lips, curly black hair and unhappy conquistador eyes.

At the end of the class, Rosario points at me.

'She dances close embrace, Argentinian style, with a touch of Europe. Watch carefully.'

Before I can recover from being singled out while trying to blend in, Rosario puts me into an iron grip, and in front of twenty people leads me into a dance to the sound of an Aníbal Troilo song called 'Tristezas de la calle Corrientes' ('The Sadness of Corrientes Street'). Ah, it's always Corrientes . . . you'd think there are no other streets in Buenos Aires.

But here we are, 3000 metres above sea level in the heart of the Andes: an Ecuadorian woman of fifty in black tango trainers, and a Bulgarian woman of thirty-five in red heels (a modest 7.5 centimetres), dancing tango. I'm taller than her. She's stronger than me – she's like an Inca fortress. We're not in Corrientes, and we're not sad, as she leads me into multiple volcadas, which requires a robust spine from both – thank God for all that swimming. No, we're not sad in the slightest. In fact, it's fair to say that – could this be right? – I'm feeling happy!

Even at the post-class milonga, when San Luis Tango, a visiting orchestra from provincial Argentina, plays live, and the oil-haired singer gazes dramatically across time and space, I'm still happy. Even if my eyes are brimming. The orchestra's modest agenda is 'to unite the universe with our music', the swarthy singer tells me later, but right now he's singing 'Cascabelito'.

Cascabel, cascabelito, ríe, ríe y no llores . . .

'Little jing-a-ling, laugh, laugh, don't cry . . . your crystal laughter, where is it? Laugh, laugh, don't cry.'

'Cascabelito' happens to be my new favourite song. It is one of the very few 'happy' songs of tango. The male protagonist addresses a young woman he glimpsed at some carnival, with her 'mysterious mask'. They kissed, her laughter rang like a crystal bell and they never saw each other again. But he will always carry her in his heart, his cascabelito, whatever happened to her – and what happened to her can't be good, because she's a carnival girl in the flower of her youth. It can only go downhill from there.

(*Pausa*: The carnival is an entire genre in tango songs. Songs like 'Carnival All Year Round', 'Always a Carnival', 'Colombina', and 'Laugh, Payaccio' sum up the spirit of tango. Carnival is a byword for round-the-clock dance party. Its spirit is desperate, its aim is oblivion, its loves are ephemeral; the girl glimpsed behind the mask will be lost for ever, and the clown is crying behind his make-up. We *know* it will end badly, and the confetti of today is the garbage of tomorrow – but isn't that the human condition, tango asks? And it gives the answer straight away: yes, but there *is* one thing we'll never run out of – music.)

'You'll be OK, cascabelito.' Gonzalo, the owner of Cafélibro, puts an arm around my shoulders, and Sylvia squeezes my hand.

'See that woman over there, Kapka, dear?' she points at the dusky forty-something beauty next table who is singing along to 'Laugh, Laugh, Don't Cry', her eyes also brimming.

'I forget her name . . .' Sylvia says. 'She lost her husband last year. Cancer. She's here every week now.'

Ramon is also sitting at our table.

'You're lucky you can cry,' he sneers. 'I haven't cried for years.'

'My friend, you've barely lived,' Gonzalo says. 'What have *you* got to cry about?'

Ramon clams up, and soon we dance to 'The Day that You Would Love Me'. When he's not attempting volcadas and simply walking with me, Ramon is displaying such talent that I don't even have the time to think about anything sad. I just dance. Ramon sees me back to my hotel in the deserted old town, and we drink blood-red tamarillo juice in the bar and talk into the small hours.

'Because I can't cry or get angry, I fear I'm gonna blow up one day, like the Pichincha volcano,' he says. We laugh, but last time the Pichincha erupted, ten years ago, nobody was laughing. There was a column of ash 15 kilometres high, and even on a sunny day the Pichincha casts a giant shadow over Quito.

'I was fifteen when it happened. My mother stocked up on cans, like in a disaster movie. We couldn't go outside for weeks. And you, where were you ten years ago?'

'I was twenty-five and I found tango,' I say. 'How did *you* find tango?'

He stares at the tamarillo juice for a moment.

'Three years ago, I met this girl. Her family was rich and ultra-conservative. They were opposed to our relationship because I'm nobody, and of course she was a virgin. After a year, I managed to ... you know, *persuade* her otherwise. After that, she was wracked with guilt. By then, I'd do anything to be with her. But it was like I was causing her all this pain. A few months later, her parents sent her to a religious retreat in Argentina, to get her as far away as possible. They knew I couldn't afford to visit. She wrote to me. But it was like

someone else writing. The letters were full of God. Like she had found another lover. I couldn't stop thinking about her. I saved like mad and went to Argentina to see her. When I saw her, I knew she was gone. It was in her eyes. It was like . . . she wasn't there any more . . . are you OK?'

I'm fine. It's just that I don't know if I'm crying for him or for myself. Ramon is embarrassed.

'You're a very emotional person. I wish I was, too. So . . . from the convent in the middle of nowhere, I took a bus to Buenos Aires. I stayed in a cheap hostel for a month, and started taking tango classes in Confitería Ideal. I went dancing every day and every night. To forget her. But I still can't forget her.'

At dawn, I find myself alone at my hotel window, staring at the giant, whitewashed wall of the Concepción Convent across the street. Behind it live a gaggle of nuns who never set foot outside. They make hand creams and medicinal potions for menstrual pains instead. I'm sorry that Ramon isn't here with me, to share the marble bath full of rose petals. Thanks to travel writing, I've graduated from grimy hostels to luxury boutique hotels, but it all seems wasted on a single person.

'*Ríe, ríe y no llores . . .*' I hum at my open window to the empty cobbled street below, but the nuns can't hear because there isn't a single window in their immaculate wall. Who knows, perhaps Ramon's cursed virgin is on the other side. At least she knows where she stands. Oh, how I envy her and her sister nuns for being wedded to a man who, despite being unavailable due to a crucifixion, will never let them down.

And then there is me, with my foolish belief in 'true love', which

now seems to have been neither true, nor love. And the day after tomorrow, it's bloody Valentine's Day.

'Have you heard the Ecuadorian expression *chulla vida*?' Julio Rivas takes a sip from his wine. 'It means, roughly: this is the only life we've got, may as well live it to the full. Oh, yes.'

I'm back at Cafélibro, and sharing a table with the distinguished-looking Professor Julio Rivas. He is not a dancer; he comes here once in a while to have a glass of wine and listen to tango.

'I often think of my two years in Buenos Aires. My mother's related to the great Bartolomé Mitre family. Buenos Aires is the universal city, and tango is the universal music! Oh, yes.'

With his twinkly eyes and polka-dotted cravat, Julio Rivas looks like a magician, but he is a historian and specialist guide. His speciality: the skyline of Quito. His rubbery face is given to laughter, and he has the expansive mood of a cosmopolitan bon-vivant, but in his small eyes I read a history of suffering that my younger, simpler self would not have noticed. Instead of drinking water and dancing that night, I share a bottle of wine with Julio.

The next day, we are walking near the clouds. He is taking me on a tour of church cupolas, and we are now up in the domes of San Francisco, the continent's biggest religious extravagance. It's bursting with restoration workers, cherubs, gold leaf and baroque follies of the gory Quito school of religious art. I feel dizzy.

'I know you're an atheist, but make a wish now, because the astral quality of Quito is exceptional,' Julio says. 'This is the middle of the Earth. The world's highest volcanoes are crossed by the equator here. Look at these domes that generations gave their lives to build.'

We are now inside the celestially beautiful Jesuit church La Compañía, whose dome is decorated with a giant sunburst.

'See that? The Incas venerated the sun. Christianity and the Incas married here. A gunshot wedding, obviously.'

And now we're outside, on top of La Compañía's roof.

'From here you can see how the churches of Quito are aligned along an imaginary sun-line. See? There.'

I nod and smile, drunk on clouds and mountain air and sunlight. And now it's sunset – it's always sunset at precisely 6 p.m. because this is the equator – and the church bells toll in brassy harmony. We're standing among palm trees, pigeons, dapper gentry and shoe-shiners in Plaza Grande, one of the continent's hotspots. Colonial Quito started here in the seventeenth century, and so did the first expedition into the Amazon.

And suddenly, Julio takes off his Panama hat and starts singing, '*Volveeer . . . sentir . . . vivir . . .*'

To return, to feel, to live. 'Volver' is Gardel's signature song from 1935, and it's about returning across 'the snows of time', *feeling* that twenty years are nothing and living among your demons.

Julio sings the entire song, verse after verse, stepping up and down benches and scaring the fat pigeons away. I laugh and sing along, not giving a damn that we're making a spectacle of ourselves: the gringa and the eccentric local patrician, both of us waving Panama hats. Everyone stops to watch: the shoe-shine boys, the gentry, the snogging teenagers, two bare-footed Franciscan monks in hemp robes, even the clouds over Quito stop moving.

'Gracias, Carlitos.' Julio tips his hat to the moody heavens, where the patron saint of sung tango dwells, kisses my hand and bows to

the plaza. We walk on, past the Convent of Concepción.

'You are like tango music itself, Kapka,' Julio says, catching his breath. 'You're the universal woman – wherever you go, you will always be a local and a stranger at the same time. Now let's go have dinner. I know it's Valentine's Day and you'd rather be with a young stud instead of wrinkly old me, but you can't leave Ecuador before you've had some *yaguarlocro* soup!'

I know this soup, and it's the culinary equivalent of a massacre: it's corn and blood pudding swimming in suspect broth, and it commemorates the battle of Yahuarcocha Lake in the north, when the lake turned red with the blood of the Quechua slaughtered by the Incas. Things were messy here even before the conquistadores stumbled ashore.

'I'd love to have some yaguarlocro,' I beam. I'd eat my own shoe soles if necessary, to be in Julio's company.

'But first.' Julio stops. 'Tell me, did you make a wish up there?'

'Yes. I did. Gracias, Julio.'

I will *return*, I will *feel*, I will *live* again.

'I thought so.' Julio's face crinkles into a smile. 'Ordinary girls surrender to circumstance, and eventually that becomes the sum of their life. But the universal woman makes her own way.'

★

I'm not entirely sure what a universal woman is, but with Julio's words in mind, the first thing I do on my return to Edinburgh is return to the universal dance.

On unsteady legs, with a lurching stomach, I stand at the red velvet curtains, wondering what I will find on the other side. I've been away

for six months. I'm tanned, fit, aglow with tropical juices – but, as we know from the four hundred tango songs that speak of it, the Return is never easy.

Toby Morris steps down from his DJ booth and gives me a long hug.

'Welcome home,' he says. No questions asked.

This *is* my home, after all; my life *is* here, in this theatre of make-believe. And it's a relief to find that when 'real' life crumbles, the illusion of the milonga is still going on inside the staunch Scottish stone building of the Counting House, under the Victorian glass-dome roof. At the door, three pound coins are still dropped into the box, to buy your trip across the Styx to the other side. The music is still playing. The couples are still dancing. The water jug is filled up next door, where shoes and gossip are still exchanged. The dysfunctional family is still gathered here, plus or minus a couple (thank God).

Someone familiar nods at me and shuffles over with baggy jeans and a smoker's cough. Joshua and I have stayed in touch over the last half-year.

'There are so many things I want to tell you . . .' he wrote, 'about tango.'

Our emails were always about tango. What music was playing at the Counting House on Sunday. What it's like to dance to the melody versus dance to the beat (he prefers dancing to the beat). What are my thoughts on dancing *on* the beat versus *behind* the beat (I don't have any, I just want to be led by an expert). Joshua has graduated to tango addict.

And now, six months after our dance of Adiós, I am dancing my first tango of Return with him. Then we go to the Monday-night

practica. And to the special weekend milonga workshops with a visiting couple. We are dancing the first ten, the middle fifteen and the last three. We are in multiple tangasm territory, and I am desperately reminding myself that tango is art, not sex. Yes, it is art made with your body and someone else's. But *not* sex.

(*Pausa*: A dancer who will remain unnamed told me that she once experienced an actual orgasm while dancing with a stranger in Paris. Not a tangasm − an orgasm. She was quite sure. I don't wish to split hairs of any kind, so let's leave it at this. Anyway, when it comes to the dance floor, the orgasm is an unfortunate subset of the tangasm, not vice versa.)

The music ends and we step apart.

'Thank you.' I smile at him. I shudder like someone possessed. 'That was very nice.'

'Thank you.' He smiles at the floor and pulls out his cigarette pack with trembling fingers. 'It was.'

And we shuffle back to our chairs at different ends of the room.

What follows is inevitable. Because this isn't just an attraction, it is Fatal Tango Attraction. What's the difference between attraction and fatal attraction? Ordinary attraction, when acted out, feels good. You tell your friends about it, and you are pleased. Fatal attraction, when acted out − and it's always acted out, otherwise it wouldn't be fatal − feels like trouble from the start. The kind of trouble you've always wanted but were afraid to ask for. And Fatal Tango Attraction? Well, it's just fatal attraction with the world's most beautiful soundtrack.

And now it is spring in Scotland − freezing blue skies and tender shoots. Joshua is helping me pack my previous life into boxes. Rather than continents, I'm moving flats, and some things get lost in the move,

for example Black Dog's mandala. Joshua is there to lend a hand, to hold me in his ropey arms, to cook for me. He appears at night before the milonga with bouquets of radishes, and leaves at dawn to tend his garden in the countryside. Then he comes back in the evening, too tired to stay awake, but never too tired to dance. Ours is a carnal love so primitive it's almost spiritual. When we walk the streets at midnight, after dancing, the trees are in wild blossom, the grass smells like the beginning of life, the spires of my newly beloved city dream high in the grey-pink sky. I'm bursting with rapture.

Here are the facts. We are both single. We are both wounded in our own ways. We are both gasping for love. We share tango. We are the perfect body fit. We are decent people who try our best. We are desperate for it to work out. Conditions are perfect for us to be happy. Are we happy?

Of course we are happy: ripping our clothes off every time we lay eyes on each other kind of happy. I can't stop thinking of you, but when I'm with you, I'm afflicted by exquisite sadness kind of happy. And when we dance? I close my eyes, and I discover that there *is* something beyond the tangasm. It is the perfect tango embrace.

If having a tangasm is like seeing God, having the perfect embrace with someone you're in love with is like *being* God. And if that sounds as if the influx of hormones has flushed out my brain altogether, let me rephrase. It's to be one with the divine, whatever the divine means to you. It's to be restored, for twelve minutes, to the original Platonic wholeness of our being, to the state of perfection and harmony that all human activity strives to achieve, one way or another, and fails. Except in tango's perfect embrace.

What we're dealing with is ecstasy. Ecstasy comes from two Greek

words: *ex* – outside; and *stasis* – ego, self. Ecstasy is to stand outside yourself. More than a point of no return, it's a point from which you *want* no return. What is the point of returning once you've tapped into the fountain of life? None whatsoever. The return can only be downhill.

Sally Potter nails this in her signature song to *The Tango Lesson*: 'Two is one and one is two'. You merge with the other, and the boundaries of self dissolve. It's an altered state. It's sublime. It's why people get addicted to tango – because they want to reach this moment with someone. If they haven't found it, they want to. If they have, they want to have it again. And again.

I remember my last conversation in Buenos Aires with Rodolfo the Sphinx: 'It's simple,' he said. 'Tango is all in the *embrace*. Without the embrace, there is no couple. Without a couple, there is no tango.'

Until this point in my tango life, I've been busy searching for tango on the floor (the feet stage), searching for intimacy on the floor (the heart stage), searching for my place among the cities and people of tango (the mind stage). I've had mixed success, but my chief failure is to have missed the key to tango bliss: the embrace. Or so it seems now.

Here are some of the things the Sphinx has found about the embrace, in between fags and dances.

1. Tango is not only the first dance based on improvisation (hence its chess-like infinity and its appeal to scientists and techno-nerds). It is also the first dance where the upper bodies are together and the lower bodies are independent. The couple are separate while staying together. They move while being still.

Each body is also doing this in its own right, and this disassociation of lower and upper body is certain proof of tango's African origins (about which more later).

2. The upper bodies are the couple's dramatic apparatus. The feet are the expressive apparatus. In the perfect embrace, you have a powerful emotional connection while also expressing yourself. You are fully yourself while being fully with the other. Neither the man nor the woman dominates. Their roles are in constant playful flux. The man can express his feminine energy (the anima), and the woman her masculine energy (the animus).

3. The embrace is a shared space – hence the look and feel of intimacy. The feet are a continuously invaded space – hence the look and feel of erotic pursuit.

Now we come to the crunch. We may well talk about 'leader' and 'follower' as if their sex didn't matter. But it matters. It matters like hell, and those tango nerds and tango bores who say otherwise are stunted in their personal development, even if they can execute a multiple sacada followed by a double volcada.

Here is the naked truth: our sexuality fits into the tango embrace like the foot fits into the dance shoe. Finding the perfect partner is (almost) as hard as finding the perfect shoe.

Now that we're clear about that, we are also closer to the edge of the abyss. Because, you see, at the heart of the perfect tango embrace is the lovers' merger. And the lovers' merger can only be fulfilled for a short time. It ends – with the final note of the tanda, with the uncoupling of the couple, at dawn. It was always so. Even the Bible reports that love only lasts 'Until the day break / And the shadows flee away'. And the knowledge of the ending lines the silky pleasure with

pain. That's why the perfect tango embrace, like the lovers' embrace, heals and shatters at once.

Now I understand why some people cry after the perfect tango dance. Why others (even men) close their eyes during a blissful dance. I understand *Lady Chatterley's Lover*. I understand Ramon's ex and why she chose Jesus over the pain of carnal bliss. My God, I finally understand *myself*.

Have you seen the film *Naked Tango*? Neither have I. But I don't need to see it, because I'm in it. I know all about naked tango, from the bedroom to the dance floor, and back to the bedroom, vertically, horizontally, then vertically again.

It's not just the end of the tanda that is the problem, though. From the first, with me and Joshua, it feels like all or nothing – either the ecstasy of physical union or the black hole of separation. Every moment is lit up by the twilight of an unspoken goodbye. Something tells me – and him – that these otherworldly moments will never amount to a life together in *this* world.

You see, socially, mentally and temperamentally, we are the world's worst-matched couple. This is evident to us and to everyone else. Outside of the embrace, communication breaks down between us before it begins. Outside of tango, and beyond our spiritual wounds, we have nothing in common. We don't laugh at the same things. In fact, Joshua doesn't laugh at all – his spiritual wounds are such that to him, any open expression of enjoyment is a personal insult. But when we dance, the wreckage of what doesn't work between us (everything) comes together into an instant body masterpiece.

(*Pausa*: This paradox is a tango classic. We've already seen, with Gavito and Marcela Duran, how the dancing was the high point of

their relationship – not vice versa. Here are two more examples out of hundreds. The swarthy, chubby working-class boy Miguel-Angel Zotto and the swan-necked ballerina Milena Plebs. As dancers, they were made for each other. In every other way, they were not. They broke up bitterly after thirteen years of dancing.

Maria Nieves and Juan Carlos Copes, modern tango's most legendary couple, were dance partners, lovers, spouses, friends, ex-spouses, ex-lovers and finally ex-friends. They were tango soulmates and he called her 'my Stradivarius'. But outside of the dance, they bickered non-stop for forty-five years. Eventually, they broke down in an acrimonious separation. Neither of them has found a new dance partner since.)

Forget forty-five years. Just a few months into our Fatal Tango Attraction, I sense that this is not about finding happiness – how could it be, when I've stopped laughing altogether, and now I'm crying every day? I cry when I'm with him because we just can't relate except by touch, and I cry when I'm without him because I miss his touch. My addiction to Joshua is inseparable from my addiction to tango; both are about holding on to fleeting moments of pleasure. And it's no good telling someone like me to snap out of it or be sensible. It's like telling a cocaine fiend to eat more vegetables. Because – let's see – what exactly *is* there in human existence that can lure you away from pleasure: peace of mind, a walk by the sea, moderation?

Stuff moderation, cries the Fatal Tango Attraction addict. I'd rather dance with him to 'Heaven and You'.

Unsurprisingly, abandon of the reckless kind features prominently in tango songs:

I want nothing, nothing more.

or

And after . . . but what do I care about the after?

or

And aflame with passion, shaking with anguish
I want to die in your arms.

And so, aflame with passion and shaking with anguish, Joshua and I are spiralling towards the edge of the abyss. Beyond the edge of the abyss, I can't see anything – except the shadow, of course. Every two people who form a true tango couple cast a shadow. The shadow is the third entity in the tango couple. It's the moving target. The shadow has our legs and our heads, but it's something else altogether. The Sphinx has called it, ominously, 'the third volume'. The shadow Joshua and I cast has become more voluminous and more solid than all the stone buildings of Edinburgh put together.

We dwell in darkness now. The shadow has swallowed us whole.

Eventually, it is precisely the tango embrace that breaks us apart. He is an unforgiving perfectionist, his moods change like the Scottish weather, and I've become terrified of making a mistake that will ruin the evening, so I start finding excuses not to go dancing. Of course, not dancing means not spending time together.

'You don't care about tango any more,' he concludes bleakly. 'We don't share anything now. Not even tango.'

To prove him wrong, I force myself to dance with him again, and dancing with someone who is causing you pain is a bit like trying to smile while having a tooth extracted.

The end comes in winter when I finally send Joshua away and he takes himself off to Argentina. I stop dancing and take refuge in snow and writing. The days are short, and the nights are long and terrible. But within weeks, I recover my spark and begin to feel myself again.

Not for long. Because when he returns, I make the mistake of going dancing again. It's been three months, I reason with myself, I *should* be fine.

Attraction of the fatal kind, *dear friends of tango*, isn't just blind. It's also deaf, dumb and retarded. You tell it a hundred times that it's not a good idea to get the infernal cycle going again, but it hangs around, goofy, sad-eyed and muttering tango lyrics like:

> *it's horrible to live without you . . .*

or

> *I want to see you one more time, beloved, I am so sad,*
> *I can't remember why you went away . . .*
> *I want to see you one more time, to soothe my agony,*
> *And in my corner of oblivion, more peacefully I'll die . . .*

or

I want you always like this, you're stuck in me like a
dagger in the flesh . . .

And other subtle stuff. Joshua tries to do the right thing and asks
me to dance. But – surprise – it doesn't work. Or, rather, it works too
well. After one tanda with wretched small talk in between songs (How
was your trip? Good, thank you. How have you been? Well. Good.), I
have a meltdown and rush to the bathroom. He looks like the end of
the world and leaves. I realize I'm a danger to him and to myself, and
stay away for another month.

When I venture out again, there is a new girl on the block, and in
his arms. She is a semi-professional tango dancer on a university
exchange from Uruguay. Her ripe behind twitches in a familiar joyful
way and . . . dear God, could this be? Yes, it's the Butt, from Porteño y
Bailarin two years ago. I hear dear Mercedes: 'Cha-cha-cha!' I also hear
Rupert the giant New Yorker: 'It's a small world.' A horribly small
world.

In the real world, you don't have to see your ex vertically copu-
lating with his new squeeze. In the tango world, it's compulsory. They
are doing it right here, before my eyes, to 'Heaven and You' – our song.
Except it's not our song any more, it's Heaven and You and Her. They
leave little to the imagination. They dance very closely, and eventually
let the tango embrace slip into a frank body wrap. I sit, blinded with
pain. Her twitching derriere is eclipsing my ability to think rationally.

I recall my acute tango loneliness with Jason in the year of bronca.
But that was nothing; that was just hanging out in some peripheral
waiting room, in order to get here, to Tango Hell Central. Because
nothing beats the absolute, cosmic loneliness of sitting on the sides of

the milonga while your no-longer-lover holds in close embrace some new woman. Here, you feel 100 per cent unheld and unloved. Here, your mind could be doing any number of things to make this bearable, but your guts understand that it isn't just *over* for you and him, it's also *beginning* for him and her.

But you must stay put and smile as if your insides aren't being sliced by the strings of those Di Sarli violins. You must behave as if this is the most normal thing. In the world of tango, it is. This is the terrible price you pay for dwelling, briefly, in the realm of the gods, with your tango soulmate. And this price will bankrupt you if you are: a) emotional, b) impractical, c) without defences and d) addicted to tango.

I am all of the above and a jibbering mess at the end of each milonga. Going dancing becomes a health and safety hazard. On the way to the milonga, I am so wracked with anxiety and hope (foolish hope that somehow, miraculously, we'll dance and everything will be put right) that I walk into traffic, collide with buildings and people and make my mascara run because I start crying in the street without noticing.

This is not tango's fault. Let's not blame tango for everything. This is me ocho-ing, again and again, across the fine line that divides stoicism from masochism. Or, simply said, and to quote Mercedes, this is me being an idiot.

(*Pausa*: When it comes to relationships, tango is a double whammy. On the one hand, you are drawn to tango because you're *complicated*. This usually means thin-skinned, too. Otherwise you drop out and move to some easier Latin dance where you can grin like a muppet and drink mojitos.

On the other hand, when you have a relationship with a fellow

254

dancer and it ends, you suffer hideously precisely *because* you are thin-skinned. You are hyper-aware of your ex-lover's presence in the room – who wouldn't be? You want to have thick skin, but you have no skin at all, just raw nerve endings. That's because body memory lasts a long time, possibly for ever. Your mind has no control over it.

Let's recap: to have a deep experience of tango, you need to *feel*. To enjoy social tango after a Tango Relationship ends, you need to *stop feeling*. But only for your ex. You still need to feel something to connect with others, because no-one wants to dance with a zombie.)

Cortina. I'm back the following week, dressed to kill. But I'm only killing myself, because Joshua is being very sensible and doesn't look at me; instead, he looks at the Butt, and I would like them both to die slowly of venereal disease. Being unhinged with jealousy is worse than being unhinged with grief (at least that's noble) or being unhinged by desire (at least that's exciting). Jealousy, however, is just a fast-track to madness.

Tango and jealousy go a long way, of course. You know that scene in Baz Luhrmann's film *Moulin Rouge* where the cabaret pimp sings 'Roxanne' and Ewan McGregor joins in, while stockinged legs flash in the background and Nicole Kidman is being drooled on by the creepy count?

'Jealousy, jealousy, yes jealousy / Jealousy will drive you MAAAAD!'

If you haven't been driven mad by jealousy, you just laugh because it's so operatically over the top – as I did when I first saw it. Now I'm not laughing.

There is also that revenge-dream sequence in Saura's *Tango, no me dejes nunca*, where our old friend Carlos Rivarola dances an erotic

Barbarous Tango of silhouettes with the cruel-faced Cecilia Narova. Her jilted husband watches from the sides until he cracks up and stabs her in the heart, repeatedly. No, it's not overdone. It's restrained.

Jealousy, it turns out, is one of tango's favourite perversions. Some statistics: the most recurring words in tango lyrics are love, passion, sadness, betrayal, abandon, wreckage, wound, pain, torment, punishment, suffering, obsession, hate, the past and never more. There is a song called simply 'I Hate You'; another song opens with 'I am angry / For the impotence in which I live / I am angry / For our love has died a death', and we've already done 'Rancour' and 'Humiliation'. In fact, the more tango poetry I read (and I'm reading an awful lot, because it was all written specifically for my condition), the more I see that the bulk of it is not about the erotic encounter at all. It's about the *aftermath* of the erotic encounter.

It goes like this. The encounter was brief, blissful and doomed. The aftermath is long, terrible and ruinous. As with other types of grassroots music like blues, fado and flamenco, much of tango is about the perennial theme of 'my baby left me'.

Here are some motifs from the rich tapestry of jealousy-unhinged tango protagonists. They are usually male, but that's only because the writers of tango songs were men. In that classic scenario, the fickle women broke the men's hearts. The men then loved and hated, wept and waited, desired and killed the women, sometimes all at the same time.

In fact, the crime of passion – narrowly avoided or sumptuously executed – is the subject of several key songs. 'Tomo y obligo' ('Have a Drink on Me') is one of tango's oldest favourites. It was first performed with typical breeziness by Gardel in the 1931 film *The Lights*

of Buenos Aires. It was the last song he ever sang, before he boarded the Colombian plane that made him immortal. And what is the song about? A man who is getting drunk 'to kill the memory' of seeing his ex under a tree, kissing her new man:

> *And to see her besmirched by the hands of another,*
> *Was like a dagger in my guts, jealousy blinded me,*
> *And I swear, I can't fathom why,*
> *I didn't kill her on the spot.*

In 'Contramarca', a broken-hearted gaucho addresses his ex, a 'China cruel'. In tango slang, *Chino* or *China* stands for anyone with indigenous features, but confusingly, in the lunfardo slang of Buenos Aires, 'China' means just any woman. Anyway, our gaucho explains to his China why he slashed a flower into her face with his knife: so that she would never forget how she betrayed him, leaving him feeling 'poorer than a spider'.

It gets worse. In the song 'At Candle-light' (most dramatic rendition: Pugliese), a guy called Alberto Arenas explains to the policeman why he is carrying, in a bag, the hair of his ex-lover and the heart of his friend. Why, officer, they betrayed me, he says, so I had to kill them. I can see his point.

But I'm not betrayed, and I'm not jilted, not this time. My condition is more perverse than that. I'm hanging on to my memory of the embrace, and along with it my grief and my desire, because I can't face the alternative: letting go. Letting go would be like death. It would be like nothing. Nada. And I've already been there. I don't want to go again.

'Between grief and nothing, I choose grief,' I explain to dear Sean one night at the Counting House when I'm in such a sorry state that I can't dance without breaking down. The monk-faced Aussie designer is giving me a shoulder massage, and Rose the Kiwi artist is holding my hand.

(*Pausa*: In times of distress, the tango family gives you what erotic love has taken away. That's one reason why we're all still there. The ex-couples outnumber the couples by ten to one, at any given time. I'm not the only one suffering here. DJ Al and his German girlfriend have just broken up after three years together. They sit at opposite ends of the room, avoiding each other's eyes, their faces like wet concrete.

But there is another, darker reason why we're still here: ego. Gavito said that the most beautiful thing about tango is that it doesn't belong to anyone. It doesn't, but we'd like it to. We'd like to own it, each of us individually. We are all fiercely territorial about it. By being here despite the pain of it, we're saying: I'm holding my ground. I've invested years of my life in tango, and you won't budge me from my chair by the DJ's booth. You can break my heart, but don't think you can take *this* away from me!)

'He has replaced me with the Butt overnight,' I say bitterly to Sean.

'He hasn't replaced you with anyone, darling,' Sean offers. 'He's replaced you with tango. He did from the start. That's why you're not together.'

Gladys sits beside me, her eyes full of tears. We've confided in each other throughout our private crises. She has just broken up with the handsome Scotsman and is dancing with Joshua a lot. I'm pleased to see this, because it seems to make her less unhappy, and because I'm

afraid that if she becomes too unhappy, she'll go back to Argentina. I also trust her to keep the boundaries with Joshua more than I trust myself. She has the kind of self-possession that I lack.

'What you felt for him was lust, not love,' Gladys says. 'One of life's lessons.'

'But I *did* love him!' I croak. It's my refrain, my broken record.

'Darling, you're like Don Quixote with the windmills . . .' Sean strokes my head. His eyes are sad because he is just like me. 'You think in absolutes. You need a grand ideal. But there is no grand ideal for you here, just men with problems. You went from one kind of darkness to another, in the space of two years. You have to lay your burden down now and fly again.'

I'm grateful to my friends, but they can't save me from myself. No-one can. I'm too far gone into the neurotic cycle. No, not the one we know. The next one, the *aftermath* one, which has been helpfully outlined by the same tango psychoanalyst:

1. anger / rancour
2. lament
3. the celebration of hysterical longing.

Once again, the Freudians are spot on. After all, what is 'My Sad Night', tango's first modern song, about – weddings, puppies and family Christmas around the tree? No, it's about urban loneliness and the anguish of loss, featuring lines like 'You loved me / In the best moment of my life'. It's about 'the thorn in my heart'. In other words, the destructive inability to let go.

(*Pausa*: First performed in 1915 in the 'Moulin Rouge' cabaret of Montevideo, 'Mi noche triste' was in fact the happy night when

modern tango found its words and moved from the body to the mind. It was the first existential tango lyric and, for better or for worse, it defined tango metaphysics for the next century – and to this day.)

My own Sad Night broke some records in the celebration of hysterical longing category, even by tango's standards, before it ended suddenly on the evening of the Edinburgh International Tango Festival.

Three hundred people are in the Gothic Hub ballroom in the medieval Royal Mile. All the tango family are here, and lots of glammed-up European visitors. I'm wearing a slinky black-and-silver dress and a new pair of sparkling heels, but after months of self-torture, I feel – and look – like a shadow of myself.

Then suddenly, I see Joshua dancing with Gladys in a peculiar way. She has her eyes closed. The woman sitting next to me informs me that Gladys and Joshua are now together.

Who makes up this shitty script? It's so implausible that I should be laughing. But I'm not laughing. I've lost my sense of humour. As the foundations of my world crack again, I'm leaning on my heels this way and that, like the Tower of Pisa in an earthquake. My sense of loss has doubled in just a few seconds. I suddenly recall a line from a 1940s song called 'Why I Sing':

> *Tango smells of life,*
> *Tango tastes of death.*

The truth of it hits me like a blow to the teeth.

It must be yet another one of 'life's lessons', as Gladys calls them,

that nothing lasts in tango, not even friendship. It must be one of tango's lessons, *dear ex-friends and ex-lovers*, that everything is taken away from us, and we are suddenly alone. Not even our past belongs to us. Because, remember, the milonga is like the casino: it is timeless. It desperately wants to laugh, laugh, not cry. It wants to have no memory. It wants to turn the wheel of the roulette and play innocently, like a child.

I see it now, with brutal clarity: the world of the milonga is not innocent at all. It keeps us amused for as long as we play along, for as long as we kiss-kiss and smile with faces like wet concrete, until one night, it devours one of us, her own children, then another one. It's nobody's fault. It's just the nature of the tango beast, as Darío had said all those years ago. Everybody's turn will come, if you hang around long enough.

By coming here, I have colluded in my own recreation – and in my own destruction. I have returned to the scene of the crime again and again, these past couple of years, looking for something that would heal me. I have been in dire need of therapy, but, like almost everyone here, I have been a consenting player in a game of sadomasochism, and the pain is not exquisite any more. This time it isn't the Freudians speaking – it's me. I must take charge and become my own therapist now.

I have memories. I have feelings. I have a past. I want to own them again, instead of surrender them to the grinding machine of the milonga and watch it mangle them twice a week to a maudlin soundtrack. To quote dear James for a moment: fuck that for a joke, KK.

I'm going now because I don't want to be Malena. I don't want to be Cascabelito. I just want to be myself again.

261

'Let's get out of here. I'll walk home with you.' Rose has seen me and clocked my state, and is already bringing my jacket. 'This place is toxic.'

I nod, unable to speak.

'Would you like to dance?' says a tall guy from Oslo called Sven. I watched him earlier and admired his subtle lead and complete absorption in his partners. Dancing with him must be wonderful.

'Yes,' I croak. 'I do. But not now. Not here. Keep a space free for me?'

And I picked myself up, took off my shoes and, with a little help from my remaining friends, I left Edinburgh tango, this time without looking back.

Tell Me What Happened

TANGO LESSON: FREEDOM

To leave without looking back is a good line in a song, but in reality, you have to have *somewhere* to go. I am like Evita in her own musical, in the bit where Madonna sings, 'So what happens now? Where am I going to?' Evita always found a way, and it always passed through a man's bed – starting with the tango singer Augustín Magaldi, and ending with General Perón – thus confirming her as Argentina's greatest triumph of female upward mobility.

But I'm nobody's fake blonde, and I want to find my own way again. I have a brain and it's time I started using it.

'You're a solo traveller, kid,' Clive says. 'You don't even need a guy. You give men too much credit, anyway. You fall for a guy thinking he's a poet. Wanna know the sad truth? *You're* the poet. You're the one with the imagination.'

I'm sunk with the sad truth into Clive's leather couch in London,

in a warren of overloaded shelves holding a tonne of books in six languages.

'One of these days, the books will crash on top of me. They'll have to excavate me from under the Russian section.'

Ashtrays, unopened bills and more stacks of books. We are puffing on Ecuadorian cigars and eating sweet Japanese bean-cakes. Above us, his tango studio sits unused.

'Clive, is there tango after the perfect embrace?'

'Are you kidding me? There are lots more perfect embraces. In tango and out of tango. You just have to want them.' He is coughing like a locomotive.

'I thought you were giving up smoking,' I say.

'Yeah. I did give up, last month. Boy, that was a long month.'

'Clive, I want to be like Piazzolla. He said he never looked back.'

'He never looked back because there was always some blonde with a poodle in front of him.'

This is one reason why I love Clive so much: he is Oscar Wilde, the genius of the sad clown.

'Why do good people do wretched things to each other? I don't understand.'

'Hormones, kid. Everyone follows their hormones. I've got about one hormone left, and I follow it everywhere.'

'But it's put me off tango men. And women. Worse, it's put me off tango! And I want to enjoy dancing again.'

'Don't let anyone put you off tango. It's not tango's fault that people behave like pigs. It's easy, kiddo – go dance somewhere else. I'd come with you if I could, but the doctors say I can't fly. God, I'd give years of my life to dance in BA again. I *have* given years of my life, puffing

on these things . . .' He stubs out his cigar in a fresh fit of coughing.

'You're making yourself sick.'

'I'm not making myself sick, I *am* sick. Mmm, yes, these bean-cakes have the texture of pudenda.' He munches on one. 'Trust the Japanese to come up with this.'

Clive has just turned seventy, I've turned thirty-six, and this is our unofficial celebration.

'I feel like no matter what I do, I'm damned,' I say. 'I know this sounds melodramatic, but . . .'

'It's not melodramatic. It's realistic. The beautiful and the damned. Hurray for us!'

'I knew I was out of control these last couple of years, and I couldn't stop myself.'

'Couple of years, huh? You got off lightly.'

'But I want to be *sensible*.'

'Don't be silly. Any dullard can do sensible. But get this: you're *free*. Freedom is the greatest gift to the artist. Don't waste it. Go to Buenos Aires. Eat some steak. Get a fresh perspective on things.'

So I did. I packed a suitcase, took a month's leave from my university job and rented a room in the house of DJ Os.

Os and I had lost touch after our brief meeting at London's Zero Hour all those years ago, but I heard through the tango grapevine that he had returned to Buenos Aires. His house is in an old southern suburb called Parque Patricios, famous for its hospitals, slaughterhouses and lorry depots.

'If you keep going along Avenida Caseros, eventually you get robbed,' the taxi driver from the airport sums it up for me. His

company is called Taxi Tango, and there is a dancing couple on their business cards. 'Yep,' he sighs. 'As Borges said, we porteños are united not by love, but by hate.'

Ah, Buenos Aires, the city where taxi drivers quote Borges. But Borges was a dreadful snob, and anyway Avenida Caseros turns out to be the genuine neighbourhood article. I can't see a single tourist here – it's a world away from San Telmo and the trendy districts in the north. It's leafy and lined with grocers like El Jamón Histérico (The Hysterical Ham), which is packed with translucent blocks of quince and guava jelly, to go with rolls of cheese big as millstones. The slaughterhouses are now restaurants where you can order spinach tortilla for one, and the dignified waiter in a waistcoat will bring you a tortilla the size of your plate, proudly explaining that 'we don't do portions'. In the actual park of Parque Patricios, milongueros have reported birthday tango parties back in the 1930s that lasted a week. Dancers would just lie down under the plane trees when they got tired and nap for a couple of hours. Everybody would bring booze and meat for the giant barbecue.

'I can't believe this is your fourth time in our city' – the taxi driver delivers me outside Os's house – 'and your heart still hasn't been won by a porteño. Maybe this time?'

'No, thanks,' I say, jet-lagged but keen to practise my rusty Spanish. 'My heart is not a prize cow to be won at the weekend market.'

'*Bueno*,' the man smiles. 'Go well, and don't break too many hearts.'

If only he knew, I think to myself. And here is Os's welcoming colonial-style house, with its inner courtyard and dark, empty rooms. Upstairs, Os and his dog Daisy reside among hundreds of records, music equipment and a chaos of laundry, ashtrays, potted plants and

rooftop sunsets. Downstairs, it's just me among terracotta tiles and funky old furniture.

'Sit down and tell me what happened with you since that time at Zero Hour.' Os shoves aside a pile of clean laundry to make a space for me on the couch. 'And I'll make us a little lunch. I have a bit of meat here, don't know if it's enough . . .'

He has a kilogram of steak, which by Argentinian standards is only just enough for two, plus bones for the dog. We spend the afternoon munching, and I tell him about my life. I mention Joshua.

'Joshua?' Os looks at me across the devastation of bones. 'English guy, smoker, kind of unhappy?'

'That's him!'

'He was here a few months ago. He stayed in your room. See this bone? He bought it for Daisy.'

I stare at Daisy and the bone.

'Os, are you telling me that I come all this way to get away from him, and in a city of twelve million people, I end up sleeping in the same bed as him?'

'That's the tango world for you.' Os shrugs. He seems immune to surprises. 'It's not twelve million anyway, it's very small. And you can be sure I didn't buy bunches of fresh jasmine for *him* every morning like I do for you! But, hey, give yourself a break. You've been suffering with this tango business. You don't *have* to dance all the time, you know. I started dancing because I was in love. Biljana was a Bosnian refugee in London at the time. Much younger than me. She was crazy about tango, and I was crazy about her, so I went along to tango lessons. When we broke up, I didn't dance for two years. I just listened to the music at home. I still don't dance much. But listen to this . . .'

267

He selects an iTune on his computer. It's Uruguayan singer Alfredo Zitarrosa, just a warm voice and guitar.

'But that's not tango,' I say.

'No, it's *milonga campera*. But listen to the syncopation.'

'So, you didn't dance for two years.'

'Two years can be a blink. I knew this French woman, Juliette, who moved here to live the tango dream. It lasted three years. She burnt out. Before she left, she said to me, "Os, three years of my life . . . I don't know where they've gone."'

'I know her!' I cry, startling Daisy from her siesta. 'Where is she now?'

'Don't know. She went travelling and never came back. It's a common story these days. Especially for women in their thirties. Coming to BA, living the tango dream, falling in love with a dancer, you know . . . the package. It's always the romantic types. They usually last two to three years. Then their relationship ends, they can't keep the lifestyle going, the sleepless nights. Tango chews them up and spits them out, you know . . .'

I know. Because I've always known this: even though I will never be Juliette, Juliette was me. Yes, it's always the romantic types . . .

It doesn't help that Os is playing a tune called 'The Guitar' from Gotan Project's first album, about a man who can't sleep because he has '*una pena extraordinaria*', an uncommon sorrow, and who is like a solitary bird with his guitar.

'Oh, for God's sake!' I reach to turn the volume down.

'Hey, don't be sad.' Os smiles his slit-eyed smile. He seems scatty, but nothing escapes him. 'Not all dreams get broken. We all need dreams. Let me get rid of this song. Now, *this* one's for you.' And he puts

on another tune. It's Zitarrosa again, with a happy-sad song called 'Milonga for a Girl'.

I can offer you consolation, but I know you won't accept it, girl,

the *payador* says;

That's why I've made this song for you.

DJ Os speaks with songs because he has tango in his blood. His grandfather Sebastian, alias Alma Noble, was the last of the payadores, a species of professional dancers, poets and layabouts who mooched around the countryside composing soulful ballads and ribald couplets. They competed with each other at improvised challenges that turned drunk or political, or both, and sometimes ended in knife fights. They were the troubadours of the New World. Clearly, a payador was not good husband material, so when Osvaldo's mother was born and the drunk poet dropped the baby on its head, he was not welcome in the house any more. 'Noble Soul' went back on the road, where he drank and sang his life away. Thirty years later, when he lay dying, his last wish was to see his long-lost wife. She had loved him all this time, of course. She sat beside his bed and held his hand. 'Aurelita, my love, you've come back!' he beamed at her and died.

'The payadores and the *caudillos* were the country cousins of the urban tango compadritos,' Os fills me in. 'They were desperados, like the gauchos. Always in trouble, always dispossessed. Their blood was mixed: Indian, mestizo, black. And out of their troubles grew the milonga campera, the *malambo* . . .'

'What's malambo?'

'It's this – look.'

Os demonstrates barefoot taps on his kitchen floor.

'Toes, heel, plant-of-foot. Toes, heel, plant-of-foot. Toes, heel, plant-of-foot. A simple country dance from the Pampa. A solo dance for men. Now, of course, women dance it, too.'

It's the middle of the night and city sirens wail in the distance. I'm not dancing tonight. I don't feel like turning up at milongas every night, dolled up and half-hearted. I'd rather eat artery-clogging grilled meat on Os's rooftop terrace.

'Kapka, are you listening or am I talking to Daisy? So, I was saying, the milonga came from the malambo, but it was syncopated and the steps were staggered. And the tango owes its rhythmic quality to the milonga. See?'

'Yeah.' I *sort of* see. 'But when did tango *become* tango, Os?'

'Aha, I knew you'd ask. Nobody knows exactly. But there's one instrument that was crucial.'

'The bandoneon!'

'No, the bandoneon came later. It's the organito, the cylinder organ. It's how tango music spread across the city. I remember the last organitos here in the 'burbs. Tingilingilin, the fat man pushed it around. There are even songs dedicated to the organito. Then little tango bands got together. The compadritos practised steps in the backstreets, and took those steps to the brothels. It's a rags-to-riches story, you know. Tango belonged in the underworld, and now look at it – ultra-trendy, ultra-international.'

★

And so it is. The mainstream milongas of Buenos Aires are heaving with sparkling stilettos, resident tango gringos who have given up their lives back home and haunt the dark halls with the look of patients in need of an emergency transfusion, and performances by rising or risen tango stars that redefine the laws of gravity and the brevity of lingerie.

At the trendy Practica X, under a giant neon X, the beautiful people of the new generation execute perfect open-embrace figures in slacker jeans and trainers (the men) and baggy trousers and string-tops (the women). The performing couple tonight are all in silver-white, like angel exterminators. He is diminutive and sports a self-consciously sculpted beard (sculpted beards these days are code for 'cool tango maestro'). His baggy trousers are large enough to fit her as well. But she isn't anywhere near him. She's floating above him and embroidering multiple ochos in the air. It's no longer enough to embroider on the floor.

At Salon Canning, where 50 per cent of dancers are now foreign, the navigation has gone to hell, and the dance floor resembles a Buenos Aires intersection at peak hour.

'My God, Darío, I know I sound like an old fogey, but what's happening to tango?'

Darío is balder and more single than ever.

'Money, that's what. It's gone commercial.'

'But some of these performances are not even tango!'

''Course they're tango. Tango kitsch. What kitsch does is, it gives you a single image of the thing. But not the essence of the thing. Speaking of essence, that's a Tanturi tanda. Come on, let's dance.'

Darío still dances one, two, three nights a week.

'OK, let's be honest here,' he specifies. 'I never dance just once a

week. What's the point of only dancing once a week? You may as well not bother.'

I look for other familiar faces. El Tano, the grapevine tells me, is in jail, though his principal offence was not so much dealing as dealing in dud drugs. Mario the car dealer only dances once a week. Mercedes has stopped going to the milongas, and the tango grapevine is silent. Even Mario doesn't know what's become of her, which saddens me because I thought they were great friends. And they were: they were great *milonga friends*. As I have recently discovered, there is a crucial difference between the two that you disregard at your own peril. Great friends are loyal to each other; great milonga friends are loyal to the milonga and whatever its latest offering is.

For the first time, I see that the original back-alley prostitute and pimp of tango live in *all* of us here. Some will sell their bodies (the taxi-dancers), others will cash in an old friend for a new lover. Some will exchange their health for an expired dream (me, in the last couple of years), and others will swap bed-mates in businesslike transactions, mere human pawns on tango's chessboard.

Somewhere along the way, we will sell a little bit of our souls, in order to continue the carnival.

But I came here to forget my dark thoughts, and anyway, here is Rupert Newton from New York, with his new Argentinian wife. She is quite tall and comes up all the way to his neck. They look happy to be living between cities and languages. Her English is elemental, but much better than his Spanish. How do you understand each other? I ask Rupert.

'Tengow, por supuestow,' he grins, but we don't have time to

catch up because a man is asking me to dance. He looks familiar.

'Guillermo!'

'Ah! My dear Kapka!'

We hug like old friends. My God, we *are* old friends. It's been that long. Then we dance, a little painfully because, remember, he is self-taught. But I'm thrilled to see Guillermo again. The next day, I visit him in his studio.

La Boca drips with colour and rain, and tango blasts out of every restaurant. A young couple in black and red dance a kitsch tango on a little street platform. Inside every café, there's an identical little couple with frozen faces, dancing an identical kitsch tango.

Guillermo wipes his hands on a rag.

'My dear, dear future ex-friend,' he exclaims.

'Why do you say that?' But I'm laughing already.

'Because it's in the way of things. This, for instance.' He shows me a poetry book with his art on the cover. It's a couple dancing. 'This is me with my future ex-wife.'

'It's so horrible when you put it that way!'

Some of us become more eccentric with time.

'My dear Kapka. Sit down. I'll make tea. It's only horrible if you hear these things before you are ready. But it's the nature of things. Now, tell me what's been happening with you.'

I tell him.

'What I can't understand, Guillermo, is how it's possible to get heaven and hell with the same person. Where is the truth?'

'The truth is in both, at the same time. That's why tango took off the way it did. Because it sums up the human paradox. And, and! Because it's one of the few ways a man with problems and no power

in the real world can get a woman to notice him. That's how it started, and that's how it's continued. You laugh, but you know it's true.'

'Do you still paint with your feet?'

'No. Now I paint bodies. Perishable art. You see, everyone wants to leave a mark. Every lover wants to be remembered as the best, the most important, even if he knows it will be over tomorrow. This is what my body painting is about. Dancing is not enough for me. I need to step back from the fray of the dance floor and make something lasting from it.'

I spot a paradox there – didn't he just say that painting bodies is perishable art, just like tango? – but maybe the paradox is part of his artistic vision. Maybe only that which is perishable is truly lasting, and we are back to the intangible essence of tango here.

Guillermo sees me off at the bus stop, and we hug in the drizzle.

'You always have a home here, in La Boca. And remember, it's OK not to dance like a maniac. Tango is not just a dance. It's our human condition. To everyone who loves tango, it's what art is to the artist. A way to connect past and future. But you already know this, my dear. You already know all you need about tango, to go on from here.'

'Yes, I do,' I blubber dubiously, suddenly sentimental in the rain. Do I?

I wave to his dwindling figure from the damp bus.

Back in Salon Canning (it's Friday), the performing couple tonight are a diminutive gay man with the face of Quasimodo, and a platinum blonde. They move so fast, I can't see what they are doing, except that they look like unisex androids while doing it. Open embrace, open

274

like an abyss. They hold each other at an arm's length, but there is no eye contact.

'Yes.' Darío slumps down in his seat while the crowd stand on chairs and crane their necks. 'This couple is perfect in every way. Except that it's dead.'

But let's suspend our purism for a moment, and look at the couples at Villa Malcolm later on tonight, where a practica called Tangocool takes place.

There are fifty couples on the floor right now, all under the age of forty-five. These really are the beautiful people. But look again, and you see why they are beautiful. Not because they are physically perfect. Far from it. There are women with large Italian noses here, and some of the smaller men are the size of the noses. No, it's the way they move.

For the first time in my ten years of tango, I see clearly that Argentinian dancers move differently from the rest of us. There is one word to describe it and that's *feline*. The men's sleekness, quickness, smoothness and roundness makes you think of Maradona. The women's velvet-soft paddedness of heel, suppleness of body and gracefulness of leg-flick makes you think of Botticelli. The couple they form – close or open embrace – makes your eyes water. It's like gazing at some distant Piazzollan galaxy where both the human body and the human soul have achieved a perfect state of grace.

Many of the professional tango kids come from humble backgrounds. They are not readers of Borges. They are not in therapy. They may look like stars, but they are the salt of this tango earth. In them lives *the art* of tango. Not the sport or the fantasy of tango, as in Europe or America. You have to see them dance to understand the difference. The difference is intangible because it's in their blood. And their blood

is the blood of the Italian immigrant, the dispossessed gaucho, the black slave, the football player, the drunk payador, the cabaret girl, the woman with nothing to lose. Today's top tango class are the children of yesterday's underclass. *La revancha del tango!*

'Dancing?'

I am. I most definitely am, because this is Niño Bien milonga and the invitation comes from a familiar sun-toasted face with peppery beard and tweed jacket. He folds up his glasses and puts them in his jacket pocket.

'We last danced two years ago.' I beam at the landscape painter.

'Ah,' he smiles ascetically. 'It's possible.' He doesn't remember my face at all. His lead is intimate as ever. I close my eyes because I don't want anyone to intrude on us. I want to store this moment in my memory.

'I remember you,' he smiles warmly after the first song. 'You are the writer. Born in Bulgaria.'

'I thought you didn't recognize me!'

'I remember your dancing. You see, the body has a memory. That is tango's great gift to us.'

We dance on. There is nothing more to say.

'Thank you. Until next time,' he says at the end, and I have the sudden feeling that I know this man really well, although I don't know where he lives, whether he is married or single or widowed, or what his paintings look like. I don't even know his name.

'I don't know *anybody's* name,' Darío declares back at our table. 'I don't come here to network. I come to dance, and for that, you don't need names.'

'I like the style of dancing here,' I say.

Darío nods. 'Typical of the south. Small steps. Changes of direction. Like doodling on the dance floor. Changes of weight in the woman.'

'Like Gavito did with Marcela Duran!' It's finally all beginning to make sense now. The different styles in different salons and parts of the city.

'Careful not to confuse things!' Darío raises a cautionary finger. 'That was stage tango. Socially, this is a *simpatico* style, unpretentious. Nothing to do with deep Gavito leans.' He wipes his face with a stained hanky.

'People confuse social tango with performance tango, you know,' he continues. 'I'm delighted that we have lots of international people here now, it gives me work. But they bring confusion. They want to dazzle and shine with crazy shit instead of just walk and enjoy simple steps, which is the real art. So you end up with dance floors like slaughterhouses. Canning — you can't dance there any more . . .'

(*Pausa*: Performance tango, or *escenario*, began in 1904, quite spontaneously, with a dancer known as el Turco. He would grab a woman and the dance floor would empty. Everyone wanted to watch him. The current confusion between show and social dancing can be blamed on Europe's obsession with glamour and the stage. Here in Buenos Aires, social tango has always been around. Show tango is seen as something less authentic, a product 'for export'. But many non-Argentines don't get this, hence the dance-floor slaughter, the botched-up special effects and the continued global reign of barbarous tango. Ah, how easy and how infuriating it is now to see the barbarians, from my ten-years-high horse!)

'But you do still dance in Canning,' I point out. 'Twice a week.'

'Sometimes three times,' Darío admits. 'I love it there. Can't help it. I love the unpredictability. That's it: you never know who and what you're gonna find in Canning. In the traditional milongas, it's all chronicle of a death foretold.'

Suddenly, there is a commotion on the dance floor. A murmur goes around, and the couples stop in their tracks.

'Man on the floor,' Darío declares, and we go to have a look along with two hundred others. A man in a corduroy jacket is on the floor, lying very still.

'A foreigner, a foreigner,' the milonga murmurs. I can't see his face, but I can see he is still young, and I pray it isn't the nice Frenchman from Nice who dreamt of dying in Buenos Aires. Dreams shouldn't come true before their time.

'A doctor, is there a doctor?' the milonga host calls over the microphone. There are two nurses and one doctor among the dancers, and an ambulance is called. But somehow, the milonga already knows the diagnosis. Massive heart attack.

'Let's go.' Darío sees my upset. We grab our shoe-bags and head out the door. 'Tango people are dropping like flies. It's becoming trendy. Let's move to salsa, Kapka. I'm sure they don't die in salsa!'

We flee through the usual blizzard of leaflets at the entrance advertising classes, milongas, practicas, festivals, marathons, shoes, clothes and yoga.

'Don't be sad,' Darío says outside.

I'm waiting for a taxi, and he's setting off on foot.

'You see, Kapka, everything comes and goes, but tango is always there. Lovers, professions, seasons – they all come and go. Empires,

historical eras, revolutions – they all fail. But tango remains. Take the Roman Empire, for example. It fell because there was no tango. They had no outlet. No embrace. All they had was sex, violence and vomitoriums. Here's your taxi.'

All this glitz and dying puts me off dancing (for a couple of nights).

So I sit in the milongas and watch those struck by Tango Fever like someone on the other side of a glass door. And it's helpful that I don't want to dance, because tonight I'm at one of the city's most famous traditional milongas, the Sunderland. Two things are happening to me.

One, I am not being asked to dance because nobody knows me, and the degree of pride here is such that *no* risks are taken with outsiders.

Two, I see the world's most elegant style of tango. It's called Villa Urquiza style, after the northern district where it originated, and its most beloved orchestra is Di Sarli. Why? Because the drawn-out violins (yes, the ones that sliced through my insides in Edinburgh last month) match the elongated strides of the dancers. The legs of Villa Urquiza dancers, anatomically speaking, are stumpy. But tangamente speaking, they are the longest legs in the world.

The explanation for this paradox comes down to floor space. You see, the milongas of Villa Urquiza, like this one, are traditionally held in huge gyms and football clubs (the Sunderland is named after the English team), which allowed the space for tango *longueurs*. Gyms are ugly, echoey places, but the milongas are packed with three generations of dancers and tango lovers.

Tonight there are hundreds of people here, dancing over the basketball lines drawn on the floor.

Take the salida, our basic exit step. In the Villa Urquiza style, the man takes two or three steps to every four beats. In other words, he dances to the violins (which provide the melody), not to the bandoneon (which provides the beat). This is a kind of tango luxury. It says: 'I can afford to dance to the melody, because I'm cool. I'm not counting the petty beats. I'm a poet.'

The woman dances in long, elastic, regal strides. Her legs move as if they begin in her ribcage. She is always on her toes, literally and figuratively, because the Villa Urquiza style loves sudden breaks and changes of weight and direction. Just like in soccer. There's even a term for it – *amagar* – which means to make as if you're going in one direction, but then suddenly go in another. Then 'Gooooal!'

Earlier in the day, I'd taken a class with one of this style's most famous proponents, Horacio Godoy – the DJ of La Viruta. He'd picked up a chair to demonstrate slow and sudden movements. Slow: he danced around the room as if on eggshells. Sudden: he tipped a chair to the floor with a swift, suave movement, then brought it up again. This is the movement with which you dip the woman. You don't *drop* her, you *dip* her. And you don't put her back out, you *suggest* the movement in a firm yet loose manner. You are 100 per cent in control, therefore she feels 100 per cent safe. But the sexy surprise of the break is always just round the corner of your playful foot. When Horacio and Cecilia dance, your eyes water. They look like liquid gold. They are tango's only couple who dance even when they are not moving. Their tango is at a cellular level. In them lives the genius of modern tango. Forget traditional, forget Nuevo. This is tango in the blood.

But tell this to British immigration officials. At Heathrow, Horacio and Cecilia were suspected of secretly wanting to *emigrate*. So they made history by dancing for immigration, to prove they really were visiting tango dancers.

Back at Sunderland, the moving ocean of the floor is shored up by a hinterland of tables. Grannies with fake diamond rings tuck into steaks without batting an eyelid. Next to them are liver-spotted men of eighty with heavy watches and an eye for a good ankle. There are young stags with pomade in their hair and easily offended pride. There are party girls with playful behinds, silver-coin laughter and a roaming eye. And this is absurd, but here is, dear God, my old friend, the Butt. I see her in the arms of a stag with pomaded hair. And this time, I actually laugh. I don't mind her any more.

'I don't believe this,' I say to Os at our table. But he can.

'It's normal. Just forget about her. Now, wait till you hear Roxana Fontan.' Os nods torwards a neighbouring table. 'She's one of the best tango singers of the new generation. You will love it.'

A woman stands up, statuesque in thin black trousers, and spontaneously delivers a shattering a cappella performance of 'Malena'. My flesh crawls with goose-pimples and memories. Me and Malena: we go a long way back.

Roxana is both Malena, who has bandoneon blues, and the love-struck narrator, who has Malena blues.

'Who was the real Malena?' I ask Os. He shrugs.

'Probably not one single woman. I think she was all the women the poet Homero Manzi loved and lost. I can relate to him, you know.'

Os smiles with slitty eyes. He is a true romantic – a man who hasn't given up on the idea of love, even after a lifetime of expired relationships.

I think back to my Malena moment in Edinburgh, and realize that I no longer feel that rage or that grief. I have finally dumped Malena. I even pick up the courage to go and talk to Roxana at her table. I ask her how she gets under Malena's skin – musically and emotionally.

'I draw.' She smiles with an intelligent face naked of make-up. No fake bleach or bling, because she's one of the tango elite. 'I draw Malena the orphan, Malena the woman. I try to feel her through the drawing. Otherwise I couldn't sing her. She would only break my heart.'

Roxana is the daughter of a bandoneon player. She is not a milonguera, but she is most definitely a Woman of Tango.

Here we are. It has taken me ten years, but finally the question comes to me: who are the women of tango? I recall Carlos Rivarola saying that tango is nothing without the woman, and I recall Gavito saying that the man who cannot make the woman feel like a queen on the dance floor will never be king.

I've met an awful lot of the men of tango, I've met *too many* of them, in fact. But not enough of the women.

'You need to meet my friend, Giovanna Tango,' Os says as we arrive home. 'Yep, that's her name. She's in Montevideo and there's a ferry at eight o'clock tomorrow. I'll tell her you're coming. And look for candombe.'

It's 3 a.m. and I don't know if I can face the ferry first thing tomorrow. 'God, Os, these sleepless tango nights aren't what they used to be ten years ago.'

'I know, you've got a couple of hours' sleep left, but listen to this.' Os puts an old track on. He is shedding ash from his cigarette all over his laptop. 'It's called "Tango de los Negros". 1907. It's about selling

crap and being poor. That's what I'm saying. You've got to go down to the black roots before you can look up to the sky.'

On his leathery neck Os wears an African mask pendant. I've glimpsed strange titles on his shelves, with words like 'orisha' and 'Candomblé'. But he isn't letting much on.

'Now go to bed,' he says. 'You'll figure it all out in Montevideo.'

Montevideo: a ferry's ride across the Rio de la Plata, the silver river, except there is nothing silver about it; it is sewage-brown and torpid.

Likewise, there is nothing splendid about the Hotel Splendido where I pitch up among musty carpets and blankets, retro furniture and frisky gay receptionists. At night, I lay my head by the scary 1960s brown wallpaper, and listen to the distant throb of African drums. Candombe.

This is the only place in the world where you hear the hot beat of the candombe at night, and it's not coming from a nightclub. It's coming from the streets.

Montevideo is a sleepy hollow that never sleeps. This may have something to do with the vast quantities of mate consumed here. As well as making your teeth yellow, mate is a stimulant, and will keep you awake all night. I've bought myself a gourd, a flask, a packet of the finest mate and I'm trying to blend in. I appear to be the only tourist in town, and a Judgement Day kind of rain falls over the ghostly streets and ornate colonial buildings, turning the city into a blur.

But how can I not love being here, in the home city of 'La Cumparsita', the most famous tango song of all time! I am standing in front of the Palacio Salvo, a neo-Gothic monster that looms night-marishly over the Plaza Independencia and occupies the site of the

old Gran Café y Confitería Girasol. Here, 'La Cumparsita' was first performed in 1917 by Roberto Firpo's orchestra.

'La Cumparsita' is now establishment, but, like all genuine tango things, it started as anti-establishment. In fact, it started on a carnival Sunday with a bunch of students bumming along with the *murga*, or procession, in the main avenue. They'd pause at café tables to sing semi-obscene songs, to the patrons' delight. Their banner said 'La cumparsita', which was a misspelt diminutive of *comparsa*, the term for a band of Afro-Uruguayan drummers playing candombe in a street carnival.

A little march-like tune started up on the students' *tamboriles* or drums. It stuck. Pam-pam-pam-pam, tararararara, tam-pam-pam-pam . . . One of the students was twenty-year-old Gerardo Hernan Matos Rodriguez, son of the proprietor of the local nightclub, Moulin Rouge. Gerardo was a failed student of architecture, but he was also a self-taught pianist, and later played the catchy little 'march' on a yellowed piano, which was the only piece of furniture remaining at the HQ of the Uruguayan Student Association after everything else had been confiscated for unpaid rent. His mates accompanied him with drumming on old boxes and upturned chairs.

'Guys, it's not a march,' Gerardo said after he'd played it. 'It's a tango.'

Everybody stopped drumming and stared at him. Was it a tango? Well, it was a 2/4 beat anyway. They called it 'La Cumparsita' and, soon after, it was picked up by the famous orchestra of Roberto Firpo. It shot to international fame.

So this humble, rebellious tango not only outlived its creators, its debut café, fascism, military dictatorships, economic meltdown and the entire twentieth century, it got to travel the world, too.

★

I have arranged to meet Os's friend Giovanna Tango in a café in central Montevideo where we're now eating fatty *morcilla* or blood sausage. Her friend Valeria has joined us.

'If you're under fifty and serious about tango, and you don't like being shoved around, you either go to La Musas milonga, or get on the ferry and go back across the river,' Valeria tells me.

'She should know,' Giovanna says. 'Valeria is the best tango dancer in Uruguay.'

And I believe her, even though Valeria is plump and un-diva-like, and doesn't dance any more.

I've only known Giovanna for five minutes and already I'm under her spell. Giovanna is a genuine Woman of Tango. She lives in a big bohemian house with her family. Not her blood family; her tango family. They are a rag-tag army of musicians, all of them talented, alternative and very young – Giovanna's boyfriend is a bandoneonist in his twenties.

Giovanna Tango is grubby-complexioned, with dark eyebrows and a mess of red hair, like Pippi Longstocking; she even wears coloured stockings. Her clothes are covered in pet hairs, and she has no age – she could be fourteen or forty. What she has instead is personality. So much of it that the eatery feels full, although there are only three of us and she has a tiny frame. There is a look in her small darting eyes that tells me she knows things I don't know. She takes me under her wing, because I'm a friend of Os's, and probably because, when she asks me what I'm looking for here, all I manage to say is: 'Um, tango,' and she takes pity on me, because looking for tango in Buenos Aires or Montevideo is like looking for fish in the Rio de la Plata. It's a sign of general confusion.

'They make the tastiest morcilla in the world here,' Giovanna declares now, and I believe that, too. Giovanna has brought me to this homely café with undisguised pride.

'OK.' Giovanna wipes her shiny mouth with a paper napkin. Valeria has gone. 'Let's go see the market. And tonight I'm singing, if you'd like to come along.'

Would I like to! I'd jump through hoops while wearing stilettos if Giovanna was doing it too. I tag along beside her as she pushes through the market, which is huge, chaotic and desolate. The street stalls spill their dented goods over a whole neighbourhood. For sale are rusted number plates from defunct automobiles, bags made from endangered species (including one with a baby crocodile's stunned head as a clasp), puppies with round eyes, flowers real and unreal, reupholstered period chairs and erotic photographs from the 1920s of women with cellulite thighs. 'The dates are shown, too,' the toothless seller tries to engage us. His jacket is threadbare, like his goods.

We run into a small crowd gathered around a musical trio. The three men are singing with veins bulging at their necks. Guitar, accordion and a lead singer, all of them with battered faces and voices like caramel.

They're singing a song called 'Canto a la vida' ('A Song to Life'). It's sad in that special uplifting way of South American popular songs.

'I think I've heard it before,' I say to Giovanna.

'Yeah?' she says vaguely.

But I haven't heard it before. I've heard others like it during the ten years of my tango life. They're sung by the evergreen voices of popular song and popular resistance against right-wing dictatorships. They are not tango voices, but somehow they're the same blood group. *Pasillo*

286

from Ecuador, milonga campera from Argentina and Uruguay, people's *cantos* from Chile and Peru, bossa nova from Brazil.

Like the delicate hymn to life 'Gracias a la vida', by Chilean singer Violeta Parra, who killed herself because of a broken heart. Like the fearless Mercedes Sosa, Argentina's greatest (and largest) popular singer, forced into political exile. Like Atahualpa Yupanqui, Argentina's country-music genius who was incarcerated many times under Perón and exiled in France under the generals of the 1970s. Like Uruguayan singer Alfredo Zitarrosa, whose voice makes you smile even though something in you is hurting, and who was forced into exile by the militaries. Like the singer-guitarist Victor Jara, whose hands were crushed by Pinochet's torturers before they executed him in 1973, the year of my birth.

Two years before that, when Giovanna was three years old, her *guerillero* father was taken by the military junta and tortured to death. Her mother, twenty-six and also involved in the resistance, fled Montevideo for the countryside, where she raised her only child in hiding.

'Did she ever remarry?' I ask Giovanna.

'Never. *Nunca*.' Giovanna shakes her mess of red hair. 'She remained true to him all her life.'

The three men are still singing like there's no tomorrow.

> *Life puts you to the test, to see if you love it enough,*
> *Life only comes once, and it doesn't come back.*

It's as if all our lost yesterdays have poured into the swollen arteries of their necks, on this hopeful rainy Sunday, at this poor man's market. But Giovanna Tango is not sentimental.

'Early milongas and tangos started right here,' she's saying now. 'With popular folk songs like these. It's all related. It's all part of the same original matrix.' She's pushing her way through the crowd.

That evening I go to a bar to see Giovanna sing. Her hair is unwashed, her mouth is crazy red like her hair. Her orange-stockinged legs are long. She is the voice of an entire people. She is a Woman of Tango through and through.

The tango life is not a fantasy for her. It's in her blood, in the blood of her country, in the blood of her martyred father and mourning mother. She is not dancing, she is not posing, she is not trying to impress anyone. With her voice of grit, sorrow, guts and rebellion, she is just speaking the truth.

When Giovanna sings, her voice feels like it's coming from inside my head, like something from my own life. It *is* from my own life – it's from everybody's life who has lived with tango for so many years.

And now I understand: you don't need to dance to make room for the soul of tango inside you. You need to have loved and lost. You need hope, which is just another word for love. You need to live without holding back. Without fear.

Looking at Giovanna's grimacing face, I have a eureka moment. In my ten years of tango, men have given me almost everything: passion, friendship, loyalty, a sense of belonging. Except one thing: a legacy. Even though I've been dancing with the men, talking to the men, befriending the men, wanting the men and sometimes losing the men, I've been surrounded, supported and sustained by the women.

★

Unlike the men of tango, the women of tango are hard to define. The Woman of Tango can be a dancer, a singer, a milonga fixture. She can be the shadow of a great dancer, like Carmencita, the first famous woman dancer and lifelong partner of the legendary Cachafaz. She was, in the grand macho tradition, thirty years his junior, and nothing without him.

She can be half of a long-standing couple, like Gloria Dinzel with Rodolfo the Sphinx – even though Gloria is a diva because she is with Rodolfo.

She can be a tough-headed professional, like Maria Nieves, who hasn't stopped dancing even after her half-century partnership with Juan Carlos Copes ended.

She can be fiercely independent, like Astor Piazzolla's one-time lover Amelita Baltar, whose gravelly voice inspired all of his songs. After Piazzolla, Amelita went on to do other brilliant things, and can be seen today sporting an orange tan and singing tangos as far out of the usual circuit as Morocco. But after Amelita, Astor stopped writing songs.

She can be the statuesque Roxana Fontan, who will never be Malena, except for twelve minutes on stage. She sings of tango's fortunes and misfortunes, but she doesn't succumb to them.

She can be Giovanna, who is nobody's wife or mistress. She doesn't use men to get anywhere because her passion is with something intangible. It's with the soul of tango.

To be a woman like Giovanna, you have to have a soul, as well as guts. If you do, there is nothing to fear. The worst may have already happened, but the best is yet to come. For Giovanna. For me. For Os. For the people we have loved and lost. For all of us who have

the tango . . . what is it? It's not the tango *dream* any more − it's the tango *life*.

This is it, there's only one of it; one chulla vida. Make it true. Shed your illusions. Stop clinging to the past. Dare to be your truest self. This is what Giovanna Tango says to me with her twisted mouth.

The following night, I sit next to her and her gang in the Teatro Solís, a glorious edifice built with Russian pine, Italian gold and marble from everywhere else. It's the smaller, more perfectly formed twin of Teatro Colón in Buenos Aires. We're about to hear a Piazzolla concert by the Orquesta del Tango de Buenos Aires. It's an event so important in a country so small that the newly elected Uruguayan president is here tonight.

'*El presidente de la República*,' Giovanna says to me, and claps along with the entire audience. It's not a polite bureaucratic clapping. It's a standing ovation from the heart, because el presidente isn't some toff with a hairpiece and a Swiss bank account. José Mujica is a rotund, quiet man with a moustache and no bodyguard. He lives on a small farm with his wife, grows flowers, drives a Volkswagen Beetle and gives much of his salary to charity. He was a guerillero with the popular movement Tupamaros, and for that, he spent fourteen years in a military jail. For two of those years he was kept at the bottom of a well.

'Can you imagine what he's been through to be here tonight in a suit?' Giovanna says in her matter-of-fact voice. I can't. None of our generation can. But what Giovanna and her young gang *can* do is carry the torch.

The orchestra is playing Piazzolla's four seasons, and as the Spring of Buenos Aires arrives in Montevideo by way of violins inside and

rain outside, I go back to the Teatro Colón with James, ten years ago.

Has it really been ten years? In the best tango moments, as in dreams, time doesn't exist. An unreasonable urge comes over me. I want to put my arms not just around Giovanna, her bandoneonist boyfriend and the other dreadlocked musicians in our row, but also around el presidente, and all the Montevideans sitting here in their best clothes, listening with bated breath. True, I am not one of them. True, my story is not their story. True, the road I've travelled is different from Giovanna's. She is a Woman of Tango. I am not.

But I no longer feel the pain of being on the outside, as I did ten years ago in Buenos Aires. Now, I feel gratitude and love for this land of tango and everything it has given me.

Giovanna clocks my exalted state and her eyes dart my way.

'There's only one Piazzolla,' she says, and squeezes my hand.

On my last Sunday, Giovanna calls and informs me in a hungover voice:

'Tonight there might be *tambores*. Isla de Flores. We'll go together. Don't carry anything except money for the taxi. No camera.'

Candombe gatherings are always on Sundays, just after sundown. They're always spontaneous, and always in the black, out-of-the way *barrio sur*.

'This is where slavery began,' Giovanna says casually as we walk up the hilly Isla de Flores street towards the drumming of tambores. The low tenement buildings are borderline derelict, but the walls explode with graffiti art. A huge African flag overlooks a wall painting of a candombe-dancing black woman with mega-buttocks. She's dancing in the street because the street was, and still is, candombe's only home.

In other words, it had no home except in the heart of the black community. And the black community started with the heartbreak of the slaves.

We're only a few blocks from the colonial pomp of Plaza Independencia, but we may as well be in Havana. This is another, secret world. It was *kept* secret by the colonial establishment. When independence from Spain came to Uruguay, slavery ended here. One of the heroes of the independence movement was a black musician known as Ansina, and one of the ruined tenements here, once the hub of the candombe community, carries his name. Ansina is also the name of one of two famous candombe bands. The other is the Brazilian-sounding Cuareim, named after another tenement across the street.

And right now, the beat of drums at the top of the street is like a call of the blood.

'It's not *like* a call, it *is* a call,' Giovanna points out. The very word for the start of the candombe procession is *llamada*, call.

We've reached the drummers when the procession suddenly stops. A fire is lit in a street ditch from old rags, newspapers and tyres. The men hold their drums near the flame. Everyone else stands around chatting. What's going on?

'We're toning the hide 'cause it's damp,' a guy in a black vest supporting a paunch informs us. His drum is called *piano* and it's the biggest of the drums.

After half an hour of smoke, chat, drinking of mate and the smell of animal hides drying, we set off. The men hold their giant drums at the front by sweat-worn shoulder straps. There are about thirty of us revellers, and about thirty drummers: black, mestizo, white, native Indian, or all of the above at once. People lean in doorways and

windows to watch and move on the spot with the beat. Some join the procession.

It's physically impossible to stay still once the thirty drums get going. The beat gets directly under your skin and you start moving. No alcohol and no previous experience are required.

ta-ta-ta-ta ta-ta-ta-ta
ta-ta-ta-ta ta-ta-ta-ta

You just do what everyone else is doing. A hundred souls, drummers and revellers, shuffle as one. We step once to every two drum beats, which sounds like slowing down, but in fact it's a controlled acceleration. The drumming is frenetic, monotonous and constant, and it goes on for an hour. Like this, rhythmically stepping to every two hand-beats with steps that root our feet to the ground, we travel the length of the street, whose name changes to Gardel. No words, just the deep beat of thirty drums under the hands of thirty meaty men. In their blood is the conquistador, the slave, the European immigrant, the Indian.

And in my feet is . . . my God, what is this? Milonga, that's what. It's the staggered, shuffling, cheeky, sexy double-step of the milonga. The singer Caseres sings it, and now I'm *feeling* it in my body:

> *Milonga is daughter of candombe,*
> *And tango is son of the milonga.*

Leading the carnival is a café-au-lait transvestite with long hair and a face like Nefertiti. He dances, trance-like, just like the painted woman with the mega-buttocks. In fact, the young guy has a traditional role here: he is the *escobero* who leads the procession. And the

fat mama is not just a pair of buttocks, she's the *mama vieja*, a staple of candombe processions. Traditionally, she wears a floral homemade dress, and accompanies the *gramillero*, a jolly old man with a beard and painted face. Tonight, a woman in her thirties with monumental haunches stands in for the mama vieja. She moves fast in tight leggings.

Gay or straight, black or white or in between, the point is that everyone is welcome here *as they are*. Fun has no censorship, except the rain.

I open my umbrella, the only one in the crowd. It has a tartan pattern.

'I can't believe you brought an umbrella!' Giovanna grins. 'How English of you.'

'Scottish,' I say, but who cares about the English–Scottish schism here, where even tango schisms are made redundant by the beat of the blood. And under the collective beat of drums and my tartan umbrella, my feet shuffling automatically, I fall into a spell.

ta-ta-ta-ta *ta-ta-ta-ta*

ta-ta-ta-ta *ta-ta-ta-ta*

I forget where I am. I could be any place. Brazilian samba. Ecuadorian marimba. Cuban salsa . . .

But I'm here, inside candombe. Candombe goes back to when African slaves were shipped into Montevideo's port from a region of Africa so vast that the millions who ended up here (as opposed to the millions who died en route) spoke seventy different dialects. The only thing that united them, apart from suffering, was music. The music these souls brought with them became collectively known as candombe. Candombe was the body and soul's expression of suffering, but also of the subversive, irrepressible black spirit. And guess what the drums were called in colonial times.

Tangó (with the accent on the end syllable) – from the Bantu African word for drum, *tambor*. The places where spontaneous and clandestine candombe gatherings happened, like tonight, were *cabildos* – also known as tangós. The sensual dancing to the beat of tambores started solo, grew into trance-like states, and sometimes ended in couples or groups.

The tangó cabildo was a place for sex and prayer, God and the body. Better yet, God *was* the body. No wonder the upright citizens of Montevideo – the same citizens who were happy to bend the backs of people violently torn from their homeland – saw these paganistic gatherings as a threat to their 'morality'. Candombe was the devil's music.

It doesn't help that it is only one letter away from another Afro-Latin creation, Candomblé. This is a hugely popular voodoo-like practice that started in Brazil and spread all over the black world. It's a pure example of syncretism, which is the mixing of cultures, spiritual beliefs and symbols. Candomblé may use crucifixes if it pleases and, yes, candombe-like beats and dancing that induce trance, hypnosis, shaking of bodies and other orgiastic states.

The founders of the first big Candomblé 'nations' in Brazil were all women, and the deities of Candomblé are called *Orishas* – often feminine anima spirits that represent different aspects of our psyche. Except the chief Orisha, who is male and stands for all things carnal, destructive and (pro)creative. This contradictory, human-like spirit is called Shangó. To rhyme with tangó. And to show how the blasphemous was in fact divine.

And so tango grew from these deep, strong black roots, in the dark, sorrowful soil of rootlessness itself. Tango got under the skin – and it's

palpable still, with its voice of sex and death, the body and the soul. Only the orgiastic coupling of Africa, Europe and Latin America could have given us the tango. Here it is, in the thump of drums and feet down Isla de Flores, down the street where slavery ended:

ta-ta-ta-ta ta-ta-ta-ta

ta-ta-ta-ta ta-ta-ta-ta (two lots of four beats)

Here, under the drums' freshly toned hides, the chant of the Biafran slaves still rings in the ship's gallows:

Ne-ia ne-ia cumaia-nagata

Ne-ia ne-ia cumaia-nagata (two lots of four syllables)

Here, in the hides of the drums and under your skin, the joy and the lament, the agony and the ecstasy are all one sound thumping in the collective viscera. And this is the true 'revancha del tango'. The return of the original tangó.

Os is waiting for me at the ferry terminal back in Puerto Madero, with Daisy at his feet and a sprig of fresh jasmine flowers in his hands. I hug him, speechless.

I remember that day when Jason mistook another woman for me, right here. It seems to me now that I was caught in a time trap. Today, I'm finally that other woman. Not a girl any more. Not really a Woman of Tango like Giovanna or Roxana. Just myself.

As a farewell present, Os gives me a CD of indigenous folk icon Atahualpa Yupanqui. The song that sticks with me is called 'Brothers', and the refrain goes like this:

> *I have so many brothers, I cannot count them all,*
> *In the valley, in the mountain, in the country, in the sea.*

I have so many brothers, I cannot count them all,
And a beautiful lover called freedom.

Other things happened back in Buenos Aires. I danced some more. I bought gold-threaded tango shoes from Madreselva, because Comme il Faut are not *comme il faut* any more, they are getting wider every year, or else my feet are losing weight. And I met someone who made me see something in tango that I'd never seen before.

Ignacio L. C. is tall, handsome and unnerving to dance with, because he is observing me the whole time across the gap of our open embrace. Yes, Ignacio is yet another tango-dancing psychoanalyst. I'm relieved to establish that he isn't a Freudian or a Lacanian, and so I feel it's safe to ask the question that has been bothering me for years.

'Do you believe that there are two types of people at tango: the therapists and those in need of therapy?' I ask.

His grey eyes twinkle, amused.

'No, I don't. We're *all* in need of therapy. That's why tango is for everyone. Without exception.'

Ignacio is a pioneering tango psychologist. He is a disciple of the Sphinx, and has created a practice called *psicotango*. I know, it sounds like tango for psychos, and in some cases, it is. But in essence, it's a way of taking tango far beyond the salon, the milonga, the couple and the beautiful people – to those who are mad, sad and bad.

Ignacio L. C. does tango in groups. Tango for the blind. Tango for Parkinson's patients. Tango for homicidal psychotics. Tango for the depressed. Tango for the obsessive-compulsive. Tango for young delinquents. And tango for the merely neurotic (all of us). Except Ignacio

L. C. doesn't call them all these things. He has gone past psychobabble and to the heart of the matter, which is . . .

'Healing people's suffering,' he says. 'We all suffer. Sometimes we don't even realize how much suffering we carry.'

It's Pugliese time, which means the couples are moving slowly. Pugliese is for lovers, and everyone is dancing except me and Ignacio L. C.

'It's not just for lovers,' he says. 'Tango is a collective dance. Look: everybody here is dancing together. They aren't dancing at home. They've come to dance here. Why? Because they want to be part of this collective experience. Imagine being a bird and looking down at the dance floor. What do you see?'

I hesitate. Lots of bald pates and fake blondes is not the right answer.

'A whirlpool,' I say. 'Concentric circles.'

He hesitates. 'Not bad. So you see a cosmic pattern. A mandala.'

I remember Black Dog's gift from last time. Later, I look up the definition of mandala: it's a shape based on real cosmic patterns, and the main ritualistic symbol in Buddhism and Hinduism, often used in meditation to induce trance-like states.

'Carl Jung believed that the mandala represents the unconscious self,' Ignacio L. C. tells me, 'and he used drawings of mandalas to work with patients with fragmented personality. In dreams, the mandala represents our spirit striving for wholeness.'

I stare at the dark dance floor. It now looks like a vat of dark chocolate stirred by a slow hand. It feels like a dream.

'Kapka.' Ignacio L. C. leans over. 'You came to tango because you were an immigrant, no? A dispossessed soul.'

I nod.

'You thought you could run away from it. But you found that in tango, everybody is an immigrant, everyone is on the periphery. It's the human condition. And longing to be in the centre.'

'The centre of what?'

'Of the whirlpool, as you put it. Of the mandala.'

'And what's at the centre of the mandala?'

I realize I'm staring at his mouth. Not because I like it, but because the answer is so important to me.

'Nothing,' he sits back. 'The mandala has no easy answers. It's not like mainstream religions. That's why all these people are dancing around the centre, towards it, but never inside it. Because the centre is empty. In the centre, there is uprootedness, loneliness, dispossession . . . the things we run away from.'

A cold shiver runs through me.

'You make it sound hopeless.'

He smiles. The smile of a Jungian tango psychoanalyst at three in the morning, in a dark dance hall, is a strange thing.

'It's not hopeless,' he says. 'The dance floor is a sacred space. Anything could happen there – from tangasm and love, to healing, meditation and nirvana. What's hopeless about that?'

I relax a little.

'Nirvana . . . that sounds like something to look forward to,' I say.

He nods vaguely, and for a second, he looks like a sitting Buddha.

But there is one thing that bugs me: the centre of the tango universe *cannot* be empty. I won't take emptiness for an answer, not from Ignacio, not from Carl Jung, not even from the Buddha.

★

299

On my last afternoon in Buenos Aires, I walk over to Plaza Dorrego in the sunshine.

'Ah, Kap-ka!' Black Dog sits up on the spread he's been lying on. 'I dreamed you're coming.'

'You said that last time, too.' We hug. 'Two years ago.'

His tan has deepened, like his wrinkles, and his jewellery is more twisty now. But his dreadlocks are the same, and his smile, too. He looks like one of Atahualpa Yupanqui's handsome brothers.

'Kap-ka, time is nothing. Two years was yesterday. Ten years was yesterday. Ten years ago, you walked across this square and you had long, long hair, and you didn't know what you were looking for.'

I stare at him. He laughs.

'That's right, you didn't know me then, but I saw this girl with a face that could be from anywhere. She was looking for something.'

He lights up a joint. I decline – I'm through with addictions. OK, maybe just a little puff.

'How do you know . . . stuff about people?' I say.

He shrugs and squints in the smoky sunlight of late autumn. *Otoño porteño*. He takes hold of my hands gently, and feels my palms.

'Kap-ka, I'm old and battered. I don't understand tango. I've never danced in my whole life. But I understand your road 'cause Black Dog is on the same road. The road of those with lost roots. It's long, with shadows. But look, here we are in Plaza Dorrego.'

A tango starts playing in the square.

'El Indio,' Black Dog says. 'It must be Sunday.'

El Indio and his boys start unrolling the portable dance floor. The sun has set, people have gathered for the milonga and I haven't noticed a thing until now. El Indio stands by the giant speakers, his waist-long

black hair tied in a loose ponytail, and then he begins to dance, some foreign girl circling him in her stilettos and smiling up at him. I've been watching him from an admiring distance for ten years. Always surrounded by admiring women, he is always alone.

'But you're blessed, *mi amor*,' Black Dog continues. 'And I don't mean in a religious way, not any of that crap.'

'You mean it tangamente,' I say, light–headed from the cloud of joint smoke. He laughs.

'Tangamente, sí. The sun always rises for you, in the end, and you scatter light wherever you pass, like gold dust.'

I snort, embarrassed, which makes me cough on the smoke.

'You lost that mandala I gave you, right?' He squints at me, amused. I stare at him again, then I just nod.

'Ah, but you haven't really lost it. Here it is.' Black Dog produces a wiry shape and twists it with one big magician's hand. 'And at the centre of the mandala, what do we have?'

'Nada?' I offer. Nothing.

'No way, nada!' he tosses his dreadlocks. 'No, mi amor. At the centre of the mandala, there is the thing that hardly no-one has seen.'

'What thing?'

'The thing that doesn't lie.'

'But what *is* that thing?'

'Calm down, mi amor.' Black Dog is still pressing on my palms with fingers of iron. 'The pain in your lower back is gone. This makes me happy.'

Then he adds:

'You'll soon find what you're looking for, you'll see. Just you don't give up.'

TWELVE

Just a Tango

TANGO LESSON: LOVE

Back in Edinburgh, I don't return to the Counting House. My twelve minutes there are up. Too many shadows in the corners, too much blood on the floor – and not just my own. I have too much information about the village and its inhabitants to drink from its well freely and spontaneously. I can't undo what time and intrigue have done to us all.

Psychologically speaking, I'd like to think that wisdom has replaced my illusions. But tangamente speaking, I know that something has expired here for me, in this particular arena – perhaps my younger, gladiatorial, robust self, the carnival girl self ready to fight for her right to party and kiss-kiss, at all costs. The milonga has marked time for me, like a giant clock, and I have no desire to tamper with its hands, or with anybody else's body parts for that matter. All I want now is peace and permanence, tangible things and true friends.

And yet, and yet . . . I am still curious to see how tango itself has

changed, in Europe and beyond, since I started my concentric journey around the dance floor ten years ago. *Just* in case I have a sudden urge in the future to travel out of town and even out of the country in order to dance again freely and spontaneously.

And so, as I find myself joining various online networks and groups, I discover a tango match-making website called Tango Partner. As soon as I see the tagline of the website, inscribed alluringly beside a sultry couple in black and white who appear to be embracing on top of some Greek fishing village, all the alarm bells of tango-hell start ringing in my head:

'You love the dance, the close embrace, the musical tales of yearning and the intimate, silent conversation between you and your partner. After just a short introduction to our online community, you'll quickly discover how a mutual passion can blossom into a delightful dance affair!'

I *have* discovered that delightful dance affair. I know all about passions blossoming, and I know a thing or two about wilting. But I sign up anyway. Curiosity gets the better of me – you see, on Tango Partner, you can share tango calendars with 40,000 other dancers around the world, and according to height, dance-style preferences and level of obsessive-compulsive disorder, you can book yourself a partner or five for your next tango festival, marathon, practilonga or camp. I am not going anywhere yet, and I am certainly not discussing my plans with strangers, but even with my lurking online status, within a week I have received virtual cabeceos from complete strangers who want to know where I'm dancing next. They are from Padua in Italy, Albuquerque in the US, Bielsko in Poland, Bogotá, Lesbos and Cairo . . . so, this is how you tango in the early twenty-first century.

Forget tangomania, forget Tango Fever. International tango is now doing everything at once, like someone on speed *and* with just a few days left to live. Think of a city in the world – any city, even one surrounded by water – and chances are that tango will have sprouted there, too, in some local hothouse of passions, egos and giros. Some examples: Tango Oriental in Manila, the Hong Kong Tango Academy, the Taipei Tango Association, Tango Down Under in Brisbane, Tango Social Club in Canberra, Tasmania Club de Tango, TangoBaliClub, Tango Dubai, Casa Tango Shanghai, Tbilisi Tango. I'm delighted to learn that Beirut and Wuppertal have their own tango festivals, too.

And here are some of the more extreme tango activities that go on at any given time, at a venue near you.

Tango marathons

From Bulgaria to Basel, and from Pradamano to Ljubljana via Oslo, tango marathons are distinguished from other Olympic sport events by two things: one, a constant soundtrack, and two, high heels. Otherwise, they work on the same principle: everybody moves at a competitive pace, until injury and disqualification occur or the weekend ends, whichever comes first.

There is a tango marathon look: dance-trainers for the men, several changes of clothing, towels, water bottles and an intense, focused look that says, 'Don't think I'm a lightweight, I take tango very seriously, otherwise I wouldn't be here,' and the kind of glint in the eye by which Ignacio L. C. (PhD in psychiatry) must distinguish the mere neurotics from the psychotics among his patients. But even this ultra-modern

tango phenomenon has its roots in tradition: remember the week-long party in Parque Patricios, back in the 1930s.

RaTs (Random Acts of Tango) and Tango Flashmobs

In theory, 'spontaneous' acts in the Dada tradition like RaTs and Flashmobs aim to subvert, provoke and do something unusual in a public space. In practice, they are a bunch of tangueros with a CD player and an irrepressible desire for an audience. They wreck their expensive shoes on the pavement while passers-by watch, perplexed. But for one of those onlookers, this is bound to become their 'bitten by the tango bug' moment. This may be the beginning of a tango story for someone – perhaps you.

Tango empires

These are outfits run by a dancer or a group of tango activists who live, breathe, dance and organize tango events. The oldest and most perfectly formed tango empire in Europe is in Nijmegen in the Netherlands, and it's the aptly named El Corte. King of the Cut is the Hollywood-faced, sinewy-bodied, immaculately trousered Eric. Eric doesn't have a permanent dance partner – partly because he is gay and mainstream tango is still a heterosexual dance, and partly because he likes it that way. When he travels, he teaches with local dancers. When he doesn't travel, he presides over Europe's most popular weekend dance salons: Orange Salon, Summerdaze Salon and Chained Salon, which is so popular that no more than 250 people are admitted, to avoid stilettoed stampedes. The Court's concept is that here, you will find

'a complete way of *dealing* [my italics] with the Argentine tango: discover it yourself, and find out that you can dance, study, watch, dream, eat, speak, laugh, taste, cry, learn, do, curse and live tango!'

Sounds familiar.

Tango camps

Tango camps are a cross between a yoga retreat, a boot camp, and a therapy session, with some of the characteristics of a cult: remote location, separation from normal society, ritualistic structure to the days and nights (class, practica milonga, milonga, practica, class), and sometimes extreme devotional behaviours such as the 'tango amoeba', brainchild of German dancers. The tango amoeba is a group hug at the end of a long milonga where everyone pulses together in one big, amoebic love-in. The tango disciples eat, sleep, and find solace under the same roof, like in a kibbutz. The tango teachers live in separate quarters, as all self-respecting gurus should. Every female disciple pants for access to the male guru, and every man desires the female guru – on the dance floor, of course. I have avoided tango camps all over the world: from small islands in New Zealand and the Crimea in Ukraine, to deepest Devon in England, and let's not forget the Tango Mini Boot Camp in Shepperton, with the specification that it's 'only for serious tango dancers'. I am definitely not serious enough for this.

Tango festivals

We have already encountered these, and so has every other tango nut, which is why, in their desperation to be original and to distinguish

themselves from the rival operation in the same city, tango festivals sound increasingly like speed-language lessons for people who are too busy dancing to get any language right: Danubiando in Budapest, Berlin Tango High, Chocotango in Perugia, Tangotoño in Innsbruck, Tangosutra in Washington, Planetango in Moscow, Day and Night Ritual in Istanbul (related to but not identical to TangoLoong in Istanbul), TexelTango on the Dutch island of Texel, Wintertango (pronounced with a V) in a Norwegian place called Hornsjø, Invasion Tango in Galway and Tangoxposed in Denpassar.

It's late summer when I find myself in a gay resort on Spain's Costa Brava. This is Sitges, which is home to the Sitges International Tango Festival and its bitter rival, Tango Sitges. I am here for the former, which is Europe's oldest, biggest and most glamorous festival. It's so famous that the several hundred people who fail to buy festival passes on time are forced to secede to an alternative milonga on the beach. There, the hardcore are found at dawn by gay revellers stumbling out of bars in G-strings.

I rock up to Sitges with two pairs of shoes and a vague sense that I'm coming to the end of something. I check into a boutique hotel called Romantic, and within an hour of arriving discover that another Edinburgh dancer is here – not just in the town but in the hotel. That's right: after ten years of dancing, it's impossible to remain anonymous. Thank God that he turns out to be Al, my lawyer pal, come here to heal from his recent break-up.

On the first night, I spot several other familiar faces, and one of them is Sven, the guy from Oslo with whom I didn't dance in Edinburgh. He is lost in an embrace with a leathery woman in a transparent floral dress.

At the teachers' table, I see Chicho, heftier and grumpier than ever, with his sublime partner Juana – but hang on, the tango grapevine tells me they are now together *only* on the dance floor. The grapevine also tells me that Chicho's bedmate now seems to be the equally sublime Mariana, the ex-girlfriend of the other maestro here, Sebastian, who wears a silver gangster's jacket and a conquistador's goatee. It's not unrealistic to hope that the grapevine is wrong – experience tells us that it often is – but, on the other hand, it's impossible to ignore the fact that Sebastian is fondling his pretty new girlfriend from Moscow.

'Boy, the revolving doors of tango,' I say to Al, who stands beside me, nursing a wan look and a cocktail called Obsession. He knows exactly what I mean.

'Yep. Before you can say "ocho cortado", the couple is over. *Salud!*' he raises his glass. 'To the day that she would love me.'

Then I lose him in the crowd who have gathered to watch Sebastian and Mariana perform to their trademark 'La melodia del corazón' ('The Melody of the Heart') – even though they're no longer together, they still teach and perform as a couple because, like Chicho and Juana, they are each other's brand name and livelihood. The exquisite beauty of their art, coupled with the pragmatism of their business arrangement, fills me with almost unbearable sadness.

You see, *they* seem fine with their revolving doors, but *I'm* not. Even after everything that has happened in my life, I am still a hopeless idealist. This world of exes and disposable loves, all moving to the sound of 'The Melody of the Heart', looks to me less and less like magic, and more and more like a transaction with a soundtrack.

So, here I am in my gold-threaded nine-centimetre stilettos and backless dress, standing on the fringe of this giant dance floor in the

Jardin de Prado. I am shadowed by giant trees and surrounded by six hundred tango people from Europe, Asia, Australia, Hawaii, the Americas and Israel. Twenty-five Russians with feline bodies and fawn-print skirts. Thirty Romanian and Bulgarian women who all look like Modigliani paintings. I glimpse a tattoo on a woman's shoulder: TANGO. Another woman flashes a boleo – her calf is tattooed with a stocking seam.

I dance with the Sicilian contingent, who are good-looking in a suitably dodgy way, with keen eyes, hair pomade and violent volcadas.

I dance (though, alas, not simultaneously) with three men from Porto who are so duskily handsome, courteous and over-educated, it must be a conspiracy.

For five sleepless nights, the beautiful people of tango strut like pure-bred horses at a race. They shake their tassels, they parade their shiny buttocks under silky fabrics, they display their muscular calves and lean thighs, their intelligent, noble snouts, their long-lashed eyes, their PhDs, their multiple languages, their exotic accents, their neuroses and their complicated relationship statuses. They demonstrate their tango pedigree from every possible angle, under the scrutiny of rivals.

This is the elite of the dance world. Here in this fair of the vanities, it's easy to get caught up in the glitz and the competitiveness. Everyone is reaching for the stars above the Costa Brava and unable to give up the dream, whatever their dream is.

But one thing is certain: everyone here – the amateurs, the professionals, the in-betweens, the maniacs, the tangoholics and the beginners, the musicians and the DJs, the posers and the organizers, the bushy-tailed and the bereft, the delusional and the damned – we all *feel something* when we move to this music. God only knows what it is

that each of us feels, and you can accuse us of every tango sin under the sun — but you can't accuse us of *not feeling*.

Love comes and then goes. Hearts break and heal. Babies are born and illusions die. Governments rise and fall. You move countries. Friends get married and divorced. The seasons change. Shit happens. The sun rises again. *Verano porteño*. The true tangueros are those who, through it all, in laughter and in tears, in sickness and in health, in the cruellest winter and in the happiest spring, don't give up the dream. Even if their dancing is not very good. Even if it is just in their own heads.

And I now see that the act of being here and dancing, even though the man you loved to distraction is squeezing some stumpy woman, and the woman you adored is snogging some geezer with ridiculous trousers — the act of being here is the ultimate sacrifice on the altar of tango. Being here wounds us and heals us at once, and that is the nature of tango.

That evening, while I watch the reconfiguring couples, I finally understand my tango story. I came to tango wanting everything, and it *has* given me everything. True, I didn't 'meet someone', fall in love, get married, have babies and settle down to the rest of my life, finally achieving normality. But that isn't what I wanted. I wanted tango to keep *promising* everything to me, every time I heard the music and took the first step with a man — every man. I wanted to keep yearning for that which can be felt for twelve minutes but can't be possessed, because it doesn't belong to any one of us. I also wanted the parting at the end of the night, so that the dream can continue. I wanted the dream over and over, and I wanted none of the reality. Because,

remember, what is the point of reality unless you can *do something interesting* with it? In tango, I have found my perfect match.

Dear friends of tango, get this: tango is not a commodity. It can't buy us anything. It can't save us from ourselves and our real lives. It has taken me ten years to understand this: tango *is* just a dance. But what a dance!

'Dancing?'

It's Sven from Oslo. From my last night in Edinburgh. He has kept a space for me.

The world's best tango orchestra – Color Tango – is playing 'Just a Tango'. My head is against Sven's chest, and music swallows us whole. I close my eyes and tune in. Sven dances with small steps, and every cell in his body feels the music – and me. We flow like water from the spring. His touch on my back feels like wings. Time stops.

I can't describe what is happening, except to say that people take drugs to have such experiences, join cults and speak in tongues. The Freudians, Jungians and Lacanians might point out that this is exactly what I've done with tango. But I have no time for them, because right now, pressed among the other couples, I'm simultaneously in Sven's arms and levitating above the dance floor. We are moving somewhere between God and nothingness.

I suddenly recall that Borges story, 'The Aleph', where a cynical narrator discovers, under an old staircase, a point in space-time that contains all other points, and weeps with wonderment. I recall the aleph because right here, with preternatural clarity as if a veil has lifted, I see something magnificent and terrible. I see tango's big bang at the centre of the mandala.

311

I see the whole of tango, all the couples from the beginning till now. I see everyone I know and also the thousands of strangers who lived, loved, drank and died with tango. They are dancing in concentric circles with me and Sven, and I feel the sorrow of our collective farewells, the wreckage of time and the hope of new buds. I see the garden of love which is also a graveyard. I see the carefully made-up faces of women and then their make-up running at the end of the night, and the shadows of old age in my future face. I hear bandoneons opening and closing like ribcages in the hands of men who smoke, and I see Joshua in his garden and Terry with his guitar. I see an empty dance floor at mid-afternoon and the same dance floor at midnight, crammed with couples. I see the leafy streets of Buenos Aires and all the disappeared youth of Argentina standing at corners, like poor ghosts in the rain, and I see the waters of Rio de la Plata rising with silent music and dirty secrets. I see frosty nights of full moon, and I feel the clammy embrace of sleeping lovers, their skeletons still in an embrace. I see Giovanna as a toddler holding her parents' hands, and some anonymous couple tangoing in a tiled courtyard in San Telmo. I see Jason with his blurry tattoo as an old man, and I see my friend Sean with his black coat and alcohol-blue eyes leaving the milonga. I see my young grandmother with a cigarette listening to 'La Cumparsita' on the radio, and then a black woman I don't know in an alleyway in Montevideo, waiting for someone. I see Os with his DJ's headphones, and I see all the women waiting at the edges of milongas, towns, war ruins, and I know their dance shoes, their face powder, their hope. I am them, and I am also the men who dream of things and women they can't have.

I see the before and I see the after. I am everyone here tonight,

with their heartbeats and heartaches, their breaths and blood, their hopes tonight and their departures tomorrow. I am embraced by all of them, and I embrace them all. *Together, we are tango*.

At the end of our twelve minutes, or is it twelve tandas, I look at Sven. He looks the way I feel.

Like me, he knows that this feeling is more – infinitely more – than any of us here could have hoped to 'get' out of tango.

'Thank you,' he says.

'Thank you,' I say.

And we go back to our different corners of the hall, like strangers.

CORTINA

So, why do you tango?

KK: Who, me?

Yes, you. I don't see anyone else here.

AFTER-LONGA

What becomes of the tango-hearted?

Jason lives in Australia and dances from time to time. We exchange occasional friendly updates.

Silvester still practises in that suburban studio, alone. We dance once a year, in London or Auckland.

Terry wrote me a sad, disjointed letter two years after the end. He sounded like a man with a broken soul.

Joshua and I have never danced together again and that is exactly how it should be.

James still drinks wine on Wednesday nights. Anoush, Geoff and the Limon lot are still going strong, with Murat's blessing.

Os still runs his tango house in Buenos Aires under the name 'Lo de Os'.

Rose dances less in the village these days, for reasons of emotional hygiene similar to my own.

Sean will always be a poet and a philosopher, and therefore a dear friend.

And me? When I got back from Sitges, I knew I didn't need physically to inhabit the land of tango any more, because tango has taken permanent residence inside me. Its music and poetry run in my veins. Its shadow is my own shadow, and it follows me everywhere.

I bought a car and left the city every weekend. Out there, in the Scottish Lowlands, I had no memories and no horizons hemming me in.

One evening, I drove out of town for no particular reason except to see the white northern summer night that wouldn't fall. I stopped the car at some point, to pick berries by the side of the road. After a while, a Land Rover pulled over, and a Highlander got out. How did I know he was a Highlander? I just knew. He wore suede boots and faded jeans. His ash-coloured hair fell about his rugged face. He moved like the three musketeers rolled into one.

'Oh, hello!' he said with an awkward wave. 'Are you broken down?'

'No.' I took the headphones out of my ears. 'I'm picking berries.'

My heart skipped a beat, and I felt as if I'd seen him before. But I hadn't.

'Ach, I thought so. But didn't like to think there's a lady stuck on the road with no-one to help.' He put his big blond hands in his jean pockets and suddenly looked embarrassed.

'What are you listening to?' he asked. Closer up, I saw that his eyes were shockingly blue, like Highland lochs.

'Piazzolla,' I said, strangely apologetic. 'Tango.'

'Oh, you dance the tango!'

'Yeah . . .'

'Aye,' he sighed. 'I have two left feet.'

317

This was music to my ears. We looked at our dusty shoes. The milky night sky travelled fast towards the future. A faint rainbow arched over the hills.

'Look over there,' I said. 'I can't see the other end.'

We squinted.

'Moonbows are always like that,' he said in his sing-a-song voice.

'What's a moonbow?'

'A rainbow made by the moon, obviously.'

I couldn't help smiling with all my teeth. A shabby spaniel stuck its head out of the passenger seat.

'Oh,' he said, and pointed at the car. 'That's Peploe, my dog. Like Samuel Peploe, the artist. She's a lady but she suits the name.'

He was an art dealer.

'Ach, well,' he said. 'If you're ever up in the Highlands, come and see my gallery. Not as glamorous as tango, but who knows, you might like it.'

'Yes!' I almost shouted. 'I will!'

He walked back to the Land Rover and the dog, and waved to me with a smile like a cracked sunrise. I was sad to see him go. The road was empty. When I got back into the car and checked my face in the mirror, I saw that the berries had stained my lips and teeth bright purple.

We stayed in touch. It took me six months and some courage to get there. His gallery, a converted church, stood in the middle of the other-worldly Highlands. Light poured in through the stained-glass windows onto the paintings inside.

He put on some music. It was Piazzolla's 'Resurrection of the Angel'. He had done his research!

'I'm glad you're not playing "Death of the Angel"!' I said.

He put awkward arms around me, here at the end of Europe, at the end of my long, long road. And my God, the perfect embrace does exist outside of tango.

'But, please,' he said, 'please don't ask me to learn to tango.'

'You know what,' I said, 'I hope you never do.'

And I meant it in the best possible way. But this, *dear friends of tango*, is another story.

ACKNOWLEDGEMENTS

For the dances, the friendship without borders, the love without *rencor*, the conversations, the books and the lessons in humanity – thank you: John Cranna, Iain Shaw, Toby Morris, Osvaldo Miranda, Carlos Rivarola, Carlos Lopez Larroquet, Andrew Graham-Yooll, Leo Ghertner, Preston Hatcher, Miriam Cooperman, Carl Robson, Cecilia Valeiras, Husito Ciawi, Nikolai Stoikow, Fanna Kolarova, Andrea Ross, Roberto Rabinovich, Alastair Smith, Catriona McInnes, Claudia Esslinger, Brian Moretta, Dani Iannarelli, Julio Rivas, Dominika Bijos, Ivo and Nadia of TanguerIN in Sofia, Sylvia and Gonzalo at Cafélibro in Quito, and komshu Murat at Café Limon in Auckland. And Rodolfo Dinzel.

I owe a wealth of intangible things to Clive James, who has been friend, mentor, and an inspiration for life.

For her unstinting support and faith, and for her poetic flair, Isobel Dixon, my agent at Blake Friedmann, has my deep gratitude and affection.

For the visionary ideas, inspired editing and high spirits, a huge thank

you and hats off to my editor extraordinaire Laura Barber. I owe this book to her, and for once this is no hyperbole.

Many thanks to Steve Cook and David Swinburne at the Royal Literary Fund, a rare and precious organisation that genuinely works for writers.

I am very grateful to Creative New Zealand for the generous Berlin Writer's Residency, during which I failed to complete the novel set in Paraguay, but without which the Berlin chapter of this book would not exist.

I have found the following books on tango essential: *Tango: The Art History of Love* by Robert Farris Thompson, *The Meaning of Tango* by Christine Denniston, *Historia del baile* by Sergio Pujol, *El tango: una danza* by Rodolfo Dinzel, *Tangoanalisis* by Gustavo Hurtado, *Tango: una danza interior* by Ignacio Lavalle Cobo, *Viaje al corazón del tango* by Ricardo Ostuni, *Exilios y tangueces* by Margarita Guerra, *El tango* by Horacio Salas, *El bazar de los abrazos* by Sonia Abadi, *Damas y milongueras del tango* by Estela dos Santos, *Borges y el tango* by Ricardo Ostuni, *Astor* by Diana Piazzolla. And the brilliant classic memoir about Argentina's dirty war by Andrew Graham-Yooll, *A State of Fear*.

All song lyrics that I have quoted appear in my own translation, so the errors will be mine too. I have quoted from a 2004 interview with Carlos Gavito, reprinted in *La Milonga argentina* magazine, issue 47, 2010.

Tango's best specialist website – www.todotango.com – has been an invaluable source of stories, lyrics and tunes, and great company at all hours of the day and night. Gracias to those in Buenos Aires who keep it alive for the rest of us.

T. D. – thank you for not dancing and yet doing it so beautifully tangamente.

PLAYLIST

My tango affair has been as much with the music as with the dance. This playlist includes some of the many songs that shaped this tango story.

Here are twenty classic tangos from the 1920s, 1930s, 1940s, 1980s, 1990s and 2000s. Some of them have given my chapters their titles. With the old tangos (which is all of them except the tracks by Piazzolla, Gotan Project, Melingo and Bajofondo), many interpretations exist by various orchestras, but these are my favourites.

1. 'Así se baila el tango' (Ricardo Tanturi), from *Tangos Para Bailar: Documentos Tango*
2. 'Una vez' (Osvaldo Pugliese), from *Edición Aniversario (1905–2005): Osvaldo Pugliese*
3. 'Bahia Blanca' (Carlos Di Sarli), from *The History of Tango, Vol. 4: Los mejores tangos instrumentales!*
4. 'Milonga de mis amores' (Juan D'Arienzo), from *The Tango Lesson*
5. 'Milonga vieja milonga' (Juan D'Arienzo), from *Milonga Vieja Milonga*

6. 'Narigón' (Daniel Melingo), from *Santa Milonga*

7. 'Otoño porteño' (Astor Piazzolla), from *Piazzolla en Suite*

8. 'Vuelvo al sur' (Gotan Project), from *La Revancha del Tango*

9. 'Oblivion' (Astor Piazzolla), from *Piazzolla en Suite*

10. 'El día que me quieras' (Carlos Gardel)

11. 'La melodia del corazón' (Edgardo Donato), from *The Best of Argentine Tango, Vol. 3: 78 rpm recordings 1927–1957*

12. 'Soñar y nada más' (Aníbal Troilo), from *Valses & Milongas: Recordings 1941–1944*

13. 'Malena' (Roxana Fontan)

14. 'No quiero verte llorar' (Osvaldo Pugliese), from Osvaldo Fresedo, *El Once*

15. 'Tú, el cielo y tú' (Francisco Canaro), from *Sentimiento Gaucho*

16. 'Cascabelito' (Osvaldo Pugliese), from *Ausencia*

17. 'Solamente ella' (Lucio Demare), from *Grandes del Tango 27*

18. 'Zitarrosa' (Bajofondo), from *Mar Dulce*

19. 'Poema' (Francisco Canaro), from *Poema*

20. 'Un tango y nada más' (Alfredo De Angelis), from *Grandes del Tango 11*

To download the playlist via iTunes, and for those who just can't get enough of this stuff, visit www.twelveminutesoflove.com.